PANORAMA OF WORLD ART

———

ART OF ISLAM

ART OF ISLAM

Text by CAREL J. DU RY

HARRY N. ABRAMS, INC. Publishers NEW YORK

Front end papers:

Interior of the Great Mosque in Cordova. Begun by 'Abd ar-Rahman I
and enlarged by al-Hakam II

Back end papers:

The fort in Gwalior. Restored in the eighteenth century in the tradition
of the forts built by the Mogul emperors in Agra and Fatihpur Sikri

Translated from the Dutch by Alexis Brown

Standard Book Number: 8109-8014-2
Library of Congress Catalogue Card Number: 72-92914

Contents

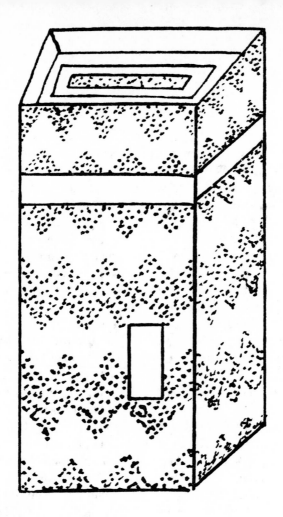

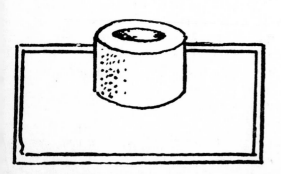

The Prophet praying before the Ka'bah. Drawing after a leaf from the Turkish version of the *Sirat Rasul Allah* (Life of the Prophet). Sixteenth century. Topkapı Sarayı Museum, Istanbul

Introduction

If we wish to understand the art of Islam, every comparison with the idea of art as the Western world conceives it should be looked at through different eyes. In Islam, art and faith are inseparably bound together; but within the framework of strict laws, sufficient liberty is left for artists to arrive at creative works which, while possibly they may not fascinate the Westerner at first glance, will ultimately end by enthralling him. Anyone with the patience to follow the artist in Allah's service through the labyrinth of geometric decorations will become captivated by the beauty of its artistic logic. The axiom for Islam's essentially anaturalistic art was laid down in the teachings of the great Prophet Muhammad, in which he counseled against the representation of men and animals. Although only the most orthodox, in fact, heeded this maxim, its influences have constantly affected even the most emancipated artists. Islamic art consequently acquired an aspect of its own which, weathered by sun and drought, strife and tradition, quickly matured and became easily recognizable among the countless other aspects of art in the world.

For a better understanding of Islamic art, it will be useful to consider first a few historical facts against the background of the religion. The origin of Islam, a word meaning "submission to God," lies in Mecca, formerly a caravan town on the trade route between Syria and South Arabia. The events which gave rise to the birth of Islam lie hidden in the somewhat complicated history of the earliest Arabs. We first find the Arabs mentioned in the annals of the Assyrian kings, beginning with Shalmanasar III in 853 B.C. A commentary on particular historical events concerning the Assyrians is often to be found in the Bible, too, and this is also the case with regard to the Arabs. Both sources mention the names of numerous Arab princes who had been obliged to become tributaries of the Assyrians. After the fall of Nineveh in 612 B.C., relations with the North improved, to such an extent even that hospitality was granted to the Babylonian king Nabonidus when he withdrew to voluntary exile in Taima, an important oasis in the sixth century B.C., situated on the so-called Incense Road. This road formed the link between North and South Arabia, where two different cultures had been established. In the north of Saudi Arabia reigned the Nabataeans; in the south the Sabaeans, Minaeans, Qatabani, Hadramati, and, later, the Himyarites, wrestled for power. Eventually, the Nabataeans were held in check by the Romans, while, in early Christian times, the South Arabians came under the control of the Ethiopians; later, the Persians were to impose their dominion over all.

Numerous points of difference can be shown between the northerners and the southerners: contrasts already accentuated by the natural barrier of the immense desert which separates the regions of Arabia Felix and Arabia Deserta. The fourteenth-century Arab historian Ibn Khaldun pointed out the distinction between the Bedouin of the North, mainly nomads, and the town dwellers of the South, whose attention was focused on farming and trade. The South was an affluent state, in which spiritual institutions were becoming more and more dominated by materialist influences. An ideal religious conviction could no more develop to full growth in the fertile South than a cactus in a soil too rich and moist. The gods of the South Arabian pantheon were less numerous than in the rest of the pre-Christian civilizations of the Near East, although, judging by the shrines and cult objects found in Arabia Felix, the gods were certainly not neglected. Yet the somewhat ascetic existence of the northern, seminomadic Arabs proved a better soil for nurturing religious practices, although not many traces have been discovered there from pre-Islamic times.

The ancient Semitic framework, in which the gods of many nations had been given their appointed place, was also employed in Arabia Deserta, though in a somewhat different pattern. The male moon-god Sin of the South Arabians is missing, but other astral deities are present in both lands, such as Allat, a female form of the sun-god, and al-'Uzza, who represents Venus. We also know of Manat, the goddess of fate and death, and Wadd, the god of love. Just as in the remote past, local deities were also important, and in Mecca this was especially true of Hubal. The people of Mecca made still further variations on the national theme by asserting that Allat, al-'Uzza, and Manat were daughters of Allah, the supreme god, who, however, did not enjoy the same respect everywhere in the land.

The "liturgy" was based on the veneration of rocks, stones, trees, and wells in which the divinities had assumed their earthly form. Offerings, which in all probability included human sacrifices, were brought to these holy places. Ritual acts were performed with the blood that dripped from the altar stones, and in this atmosphere concepts of blood relationship and blood vengeance acquired a central significance. The notion that good or evil spirits inhabit trees is not peculiar to the Near East: this superstition is to be found in all parts of the world. Even the custom of tying rags of all sorts to the branches as a prophylactic against diseases, which can be observed to this very day in the lands of the Fertile Crescent, is also known elsewhere. A few years ago, in a village near Nijmegen in Holland, the author came across a tree hung with such tatters.

In this atmosphere of folk customs and charlatanry, dominated by sorcerers and soothsayers, a focal group must have come into existence amidst those idealists among the Arabs who desired a religion based on complete conviction. Roused by the inescapable influences of Judaism and Christianity around them, this group, which called itself the Hanif, endeavored to find a monotheism grafted upon the traditions of their own race and stripped of what they considered dogmatic trimmings. They were not to find their ideal religion, but they may well have been the catalyst for the great religious reaction which, as it were by a sudden explosion, precipitated the wishful dreams of the Hanif into substantial form by means of the Prophet Muhammad, who was born at the moment when the reaction came about.

Muslims make the birth coincide with a historical event which became surrounded with legends, the advance of the Ethiopian ruler Abraha out of Yemen. Abraha's campaign was the last convulsive twitch of the Ethiopian hegemony in South Arabia, and within five years of his defeat the empire had crumbled, after which the Persians took over power. Abraha marched toward the north at the head of a considerable army and a platoon of elephants. All resistance by the Arab tribes was overcome without difficulty, to the point where he appeared before the walls of Mecca. The Arabs had abandoned all hope and had fled to the surrounding hills. However, 'Abd al-Muttalib, grandfather of the Prophet, prayed to Allah, the supreme god of the people of Mecca, imploring him to spare the city. His prayer was heard, for Allah sent a great flock of birds, each carrying three stones—one in the beak and one in each claw. Down they swooped, hurling their missiles on the Abyssinians, all of whom died on being struck by the stones.

So much for the legend; in point of fact, it appears that Abraha's army was overcome by a smallpox epidemic, and, with drastically decimated forces, he was obliged to retreat with his imposing "cavalry" and abandon the siege of Mecca. This episode is mentioned in a *surah* of the Koran, further emphasizing the importance attached to the event. For Allah alone had hearkened to the prayer of Muhammad's grandfather, thus giving the people to understand that they were on the right path in their monotheistic way of thought. At the same time, the story illustrates the sources of Muhammad's doctrine of Islam.

Although the exact date of Muhammad's birth is uncertain, we do know that he was born in Mecca, probably between A.D. 570 and 580. The most reliable, but certainly not the most circumstantial, biography of the Prophet is the Koran, the Book of Books for the Muslim. The Koran is the word of God, transmitted to Muhammad through the Archangel Gabriel in the moments of meditation and trance which first

Retreat of the Abyssinians under a hail of stones dropped by miraculous birds. Drawing after a leaf from the Turkish version of the *Sirat Rasul Allah*. Sixteenth century. Topkapı Sarayı Museum, Istanbul

manifested themselves in 611. Originally the text would have been written down on available material such as palm leaves and the scapulae of camels, while a considerable portion was handed down by word of mouth. The text was revised and standardized during the reign of Othman, the third caliph. The Koran consists of 114 sections or *surahs*, which are divided according to the length of their verses, the short verses coming last. Style and language in the Koran show considerable variation, and it is particularly suited to the custom of recitation, so that certain thoughts are repeated again and again.

As we have said, the Koran does not give a great deal of information regarding the Prophet himself, and we are obliged to turn to the biographies written in the first century after his death, which emerged from a tradition strongly colored by legend. The man Muhammad was idealized as a model to be imitated; such a portrait, of course, loses in historical value, but the illumination of the ideal side of the figure of Muhammad is certainly of interest, and many matters are explained in this way. The tradition—or Hadith, as the Arabs themselves called it—frequently provides a kind of supplement to the Koran. An example of this which is of interest in connection with Islamic art is the dictum on the portrayal of living beings, which is stated as a prohibition in the Hadith only, and not in the Koran.

Changes came about in Muhammad's life quite soon after his birth: his father had already died before he came into the world, and his mother died when he was still a small child. He was therefore brought up by relations, first by his grandfather, after whose death he was cared for by his uncle, Abu Talib. When he was twenty-five years old and had already been some time in her employment, he married Khadijah, a rich widow fifteen years his senior, whose caravans journeyed to and from Syria. Six children were born of this union, two sons and four daughters. The boys died in infancy, while of the girls, Ruqayyah, married Othman, who was to become the third caliph, and Fatimah married 'Ali, who was to be Othman's successor.

The married state gave Muhammad the opportunity to devote himself to contemplation and researches into the true faith. Every year he withdrew for a month's seclusion in the cave of Hira, near Mecca, in order to meditate. At the outset, it was the Jewish and Christian sources that enlightened his desire for a monotheistic solution. Did not the Jews say that Ibrahim (Abraham) was the forefather of the Arabs, and that he worshiped one god only? Ibrahim could not keep them from becoming lax and once more lapsing into pantheism, or rather paganism, and therefore time and again God sent prophets—such as Musa (Moses) and Da'ud (David) —to keep His people in the way of righteousness. In like manner, the Christians, too, were sustained by means of Isa (Jesus) the son of Maryam, "... whom Allah has chosen and purified above the women of the world" (*Surah* 3–42).

Earlier there had also been typically Arab prophets, such as Salih and Hud, but that had been long ago. Once more, the people had erred too long; it was time that a new prophet should arise. In 611, Muhammad received a vision of the archangel Jibril (Gabriel), who revealed to him the first verses of the Koran and thus marked him as the "messenger of Allah." Then Muhammad began his preaching, which for nine years long gained him no followers other than a few of his closest relations. He encountered terrible difficulties and was threatened on many sides, but the family tie was strong, and, despite differences of opinion, the clan Muhammad stood firm.

Finally, in 619, when he lost his uncle and protector Abu Talib and his wife Khadijah, he could hold out in Mecca no longer. In 622, he moved to Yathrib, which later was to be called Medina, that is to say, the City (of the Prophet). There the difficulties began in earnest, for from now on he was no longer simply the preaching prophet, but rather the founder of the Islamic state. In Medina, Muhammad received greater attention than he had enjoyed in Mecca. He went about much more and gained a growing political and spiritual ascendancy over the Arabs, behaving with increasing intolerance toward the Jews and even persecuting them. His attention was focused above all on Mecca, which he determined to conquer—a wish that was

The Revelation of God through the Archangel Gabriel; blinded by the Light of God, Muhammad saw, wherever he turned, the face of Gabriel. Drawing after a leaf from the Turkish version of the *Sirat Rasul Allah*. Sixteenth century. Topkapı Sarayı Museum, Istanbul

FRANCE Franks

Venice
Ravenna
Pisa

Black Sea

Loire

ZARAGOZA
Ebro
Zaragoza

PORTUGAL
SPAIN
Toledo
Tagus
Valencia
Madinat az-Zahra
Cordova
Granada
Seville
Almeria
Malaga

ITALY

GREECE

Edirne

Constantinople
(Istanbul)
Iznik

Bursa

ANATOLIA

Divrigi

EAST ROMAN
EMPIRE

Smyrna

Konya

Qubadabad

Euphrates

Kayf

Algiers
Tunis
Qairawan
Sousse (Susa)
al-Mahdiyyah

Palermo

Mediterranean Sea

CRETE

CYPRUS

Aleppo
Raq
Qasr al-Hair

Rabat

MAGHRIB

SYRIA
Dama

Marrakesh

Tripoli

Ain-Jalut
Jericho
Jerusalem

Jordan

Qusa
Msha

Berbers

Alexandria
Cairo

El Minya

EGYPT

Nile

Red Sea

Med

SAHARA

Me

ARABIA at the time of Muhammad, 622–632

Conquests under the first caliphs, 632–661

Conquests under the Umayyads, 661–750

Mongols

Turfan●

Miran●

CHINA

Aral Sea

Syr Darya (Jaxartes)

Uzbegs

Amu Darya (Oxus)

TURKESTAN

Samarkand●

Bukhara●

Karshi●

CAUCASUS

Caspian Sea

●Kubachi

MENIA

Manzikert

Van

akir

Tabriz● ●Ardabil

Sultaniyah●

Gunbad-i Qabus●

Meshed●

Merv●

Mosul

Qazvin●

Teheran●

Nishapur●

KHURASAN

OPOTAMIA

ra

Saveh● ●Rayy ●Damghan

Varamin●

Nayin●

Herat●

Hamadan● ●

Sultanabad●

●Kashan

PERSIA

Baghdad● ●Gulpayagan

●Ardistan

RAQ

idir

Isfahan●

AFGHANISTAN

TIBET

mara

●Basra

Kufah●

Yezd●

Indus

NEPAL

●Shiraz

Kirman●

Delhi●

Tughlakabad●

Agra●

Jaunpur●

Persian Gulf

Fatihpur Sikri●

Ganges

BENGAL

ARABIA

INDIA

Arabian Sea

CEYLON

13

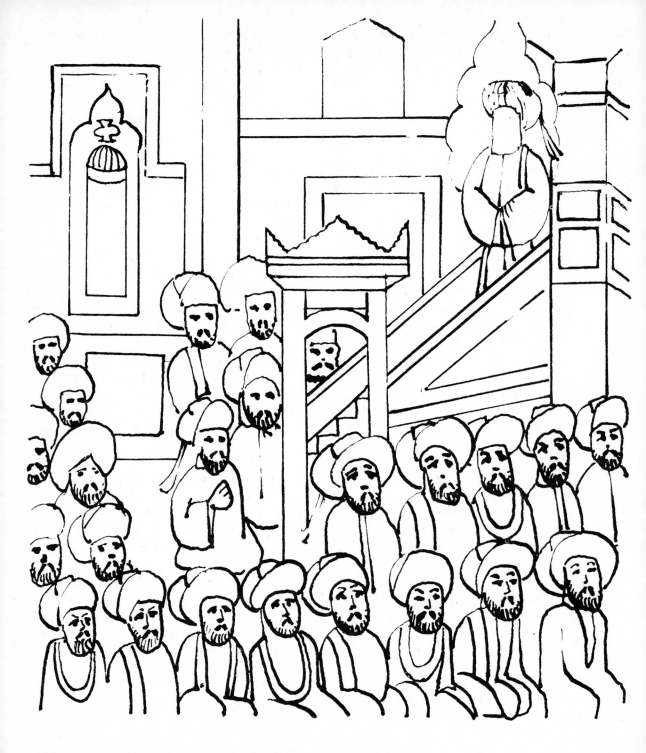

Muhammad preaching his last sermon. Drawing after a leaf from the Turkish version of the *Sirat Rasul Allah*. Sixteenth century. Topkapı Sarayı Museum, Istanbul

finally to be fulfilled eight years later. Muhammad, however, continued to live in Medina after the complete surrender and conversion of Mecca. In 632, he returned once more to his birthplace on a pilgrimage, which we know as the "*Hajj* of Leave-taking." This was to be Muhammad's last *hajj*, for he died in Medina in the same year; but for all Muslims after him it was the foundation of the pilgrimages which form one of the five pillars of the Islamic faith. These five commands are: 1) the belief in one God, Allah, and the teaching of Muhammad, His Prophet; 2) the daily prayers; 3) almsgiving; 4) fasting; 5) the pilgrimage to Mecca. These commands are binding on every Muslim, to whatever sect he may belong and in whatever country he may live.

Almost immediately after the death of the Prophet, political troubles arose among his followers, which, through the deep-rooted nature of the Islamic faith, were difficult to separate from theological problems. Islam was split into different sects, of which some have survived to the present day but many have been swallowed up in the mainstreams of Islamic thought, just as the numerous heresies in Christianity have been superseded and have faded away.

As successor to the Prophet, the Helpers in Medina wanted to choose someone out of their own midst, but Muhammad himself, as a member of the Quraish tribe, had already looked in those circles and had designated Abu Bakr as the future *khalifah*, or successor. Not only had Abu Bakr been one of his oldest and stanchest friends but he was also Muhammad's father-in-law, since, after Khadijah's death, having married Sauda, he became betrothed to 'A'ishah, Abu Bakr's daughter. The next three caliphs were also related to Muhammad. Othman, the third caliph, who married the Prophet's daughter Ruqayyah, was a member of the Umayyad family who, until he came into power, had never set themselves up as sympathizers of Islam. Othman was a gentle and kindly man who did not possess sufficient talent to control a rising world empire and keep it on the right course. Opposition to him finally resulted in his assassination in 625, at the age of eighty-two. The Quraishites then chose 'Ali as successor, but the Umayyads wanted another of their line to rule, and chose Mu'awiyah, governor of Syria. From this clash, which provoked a cruel civil war, resulted a schism which has lasted to this day.

At first, it looked as though the dispute would be decided in favor of 'Ali, but a group of extremists who could not concur with 'Ali's patient behavior toward Mu'awiyah, decided to murder both leaders. They succeeded in killing 'Ali, but Mu'awiyah survived and established his caliphate in Syria. The supporters of 'Ali refused to recognize Mu'awiyah, and proclaimed Hasan, 'Ali's eldest son, as caliph. Hasan and Mu'awiyah concluded an agreement whereby the executive power and the government were kept by the latter, while Hasan was to return from Kufah to Medina. Mu'awiyah chose Damascus for his residence, where he established the dynasty of the Umayyads.

Through all these skirmishes Kufah, a town on the Euphrates, had been a center for the partisans of 'Ali. It is therefore not surprising that, after Mu'awiyah's death, 'Ali's youngest son Husain wished to march to Kufah to reestablish his caliphate. The government troops, now under the command of Yazid, son of the deceased caliph, barred his entry into the city. Husain withdrew to Karbala, some twenty-five miles from Kufah, where he and his followers, weakened by thirst, were murdered by their adversaries. Only a few women and Husain's little son managed to escape. Public opinion, shocked by this event, turned against Yazid. Nationalist feeling, together with propaganda against the caliph, played into the hands of the Persians, for the mother of 'Ali al-Asghar, Husain's son, had been the daughter of the last Sassanian king, Yazdagird III, who had been defeated by the Arabs at Nihavand in 642. These factors led to the Persians' giving 'Ali al-Asghar, in 690, the title of *imam* as the equivalent of the caliph, whom from then on they no longer recognized. The imam, or leader, became the recognized head of state and the separatists were called by the Arabs the *Shiahs*. The sect flourished and commands a very numerous following to this day. The

original group, the orthodox majority in Islam, is formed by the *Sunni* (adherents of the *Sunnah*, or tradition). Besides these two major groups, there are more than thirty other sects, but these are outside the scope of a book devoted to art history.

Evidently, the spread of Islam was very rapid and very wide, and we shall return more closely to its history as far as the world of the Middle East is concerned. To follow the path of Islam and the expressions of art associated with it to every place where this religion has had its effect would not be of benefit in a general consideration of the character of Islamic art. The discussion would take us to Spain, Algeria, Morocco, Tunisia, Libya, Egypt, Sudan, Jordan, Syria, Lebanon, Turkey, the Balkans, Iraq, Iran, Afghanistan, Pakistan, Malaysia, Indonesia, Yemen, and Saudi Arabia, not to mention other regions with an Islamic minority where there are also further interesting details to observe. Our purpose, however, is to give a picture of those regions where Islam has made history.

THE UMAYYADS

For too long the Western world has underestimated the value of the Islamic contribution to the fine arts, Western vision having the tendency to focus myopically on its own direct surroundings. The only products of the Islamic artists to be eagerly purchased were the "Oriental" textiles, and even these possibly more from utilitarian than from aesthetic considerations. Textiles form only a very small portion of the Muslims' artistic heritage, the growth of which can be followed more closely than in any other civilization.

At the source of all artistic expressions stood the Ka'bah, a simple cube-shaped building of stone and wood, having in its eastern corner the sacred meteorite we know by the name of the Black Stone. Even today, in imitation of earlier ritual acts performed by the Prophet himself, pilgrims must circumambulate the Ka'bah seven times, kissing the Black Stone, which is set in one of the walls, during the procession. After completing the circumambulations, the pilgrim must hasten on between the hills of Safa and Marwa and thence to Mount Arafat. On the return journey, offerings of sheep and camels are made at Al Mina, where the ceremonial stoning of the devil also takes place. The Ka'bah is thus the beginning and end of the obligatory ritual of the Muslim pilgrim.

The Ka'bah in Mecca, like the Dome of the Rock in Jerusalem and Muhammad's house in Medina, was called by the Arabs *masjid*, meaning a place of prayer, from which we derive the word "mosque." Muhammad's house served as the model for building the first mosque. The basic plan consisted of a walled enclosure containing a central court, with a portico whose pillars shaded the various apartments built against the inner side of the mud-brick wall. In this arcade the great Prophet used to discourse with his faithful followers. In the cloisters of the later mosque the teachers gave religious instruction and texts of the Koran were studied and interpreted.

One of the earliest mosques we can trace is that of Kufah in Iraq, which is known to have been founded in 638. It was rebuilt in 670 under the direction of Ziyad ibn Abihi, the energetic governor of Basra, who summoned skilled masons "of the Days of Ignorance" (i.e., non-Muslims) because he wished to erect a building without equal. The roof was to be forty-nine feet high, which suggests the imposing dimensions of the building. According to Ibn Jubair, who saw the mosque in 1184, it did not fail to impress: "Nowhere have I seen a mosque of which the columns are so long or the ceiling so elevated." Jubair may perhaps have seen the *apadana*, the Hall of Columns of the Achaemenian kings at Persepolis; Ziyad must certainly have known of it, if only from hearsay, for when he saw the colonnade he cried out: "That is what I desired, but I could not express it."

Soon new elements were involved in the building of a mosque. Proceeding from the idea that the sacred well of Zemzem beside the Ka'bah, with its medicinal water, was indispensable for ritual ceremonies, it was desired to place a substitute for this well in the inner court of the mosque. From this came the pool near the entrance of the court, not only for ritual ablutions, but also as a symbol of one of the most important elements and blessings of a desert people.

Originally the mosques were provided with very little interior adornment. The Prophet desired modest living and abhorred all the vanity which had led the unbelievers into idolatry. A simple, bare wall—in the early days of Islam facing Jerusalem, but later turned toward Mecca—indicated the direction of prayer, and was known as the *qiblah*. Little by little the original form of the mosque changed. Into the holy wall was built a niche called the *mihrab*, which was meant to point like an arrow toward Mecca, and which at the same time served as a special place from where the leader could exhort the faithful to prayer.

The oldest Islamic place of worship to remain intact to this day is the Dome of the Rock in Jerusalem, and it immediately proves an exception to the type of early mosque that we have just described. The term

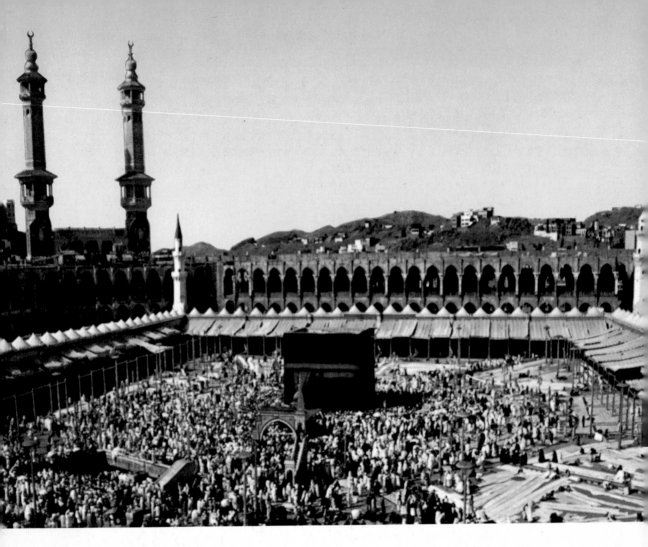

The Ka'bah in Mecca

Mosaic showing the city of Jerusalem in the central portion. Early Christian period, c. sixth century. From Madaba in ▶
Jordan

"mosque" is, in fact, inaccurate for this magnificent building. We might rather refer to it as a place of pilgrimage or as a rock sanctuary. The Jews revered the site as the place to which Abraham had been made to bring his son Isaac as a sacrifice to God. The Arabs regard the same rock, the summit of Mount Moriah, as the actual spot from which the Prophet ascended to heaven.

On account of rivalries within the Umayyad dynasty, Caliph 'Abd al-Malik wished to diminish the importance of Mecca in the minds of the faithful. The historian Ya'qubi (874) records that he managed to prevent further pilgrimages to Mecca, substituting the holy Rock, or as-Sakhrah, in Jerusalem as the center for the Muslims' ritual circumambulations, in place of the Ka'bah. Beneath the rock is a cave about fifteen feet square, with a hole in the roof about three feet in diameter. This is declared by the Arabs to be the "navel of the world," while for the Jews it is the site of the "pit under the Altar of Burnt Offering," which received the blood of the victims mixed with the water of ablution.

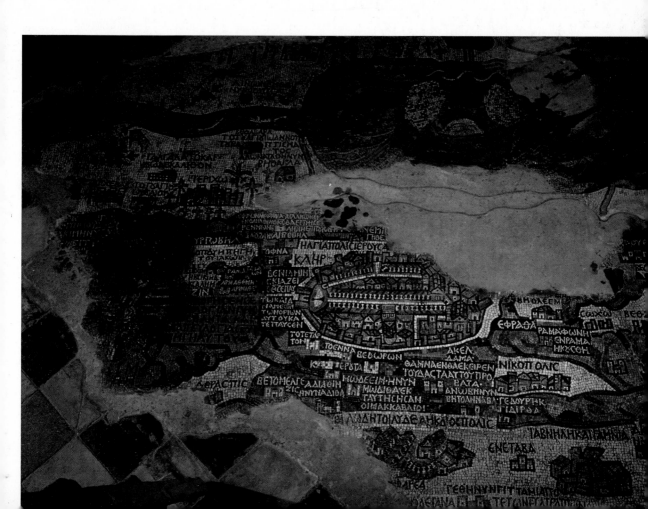

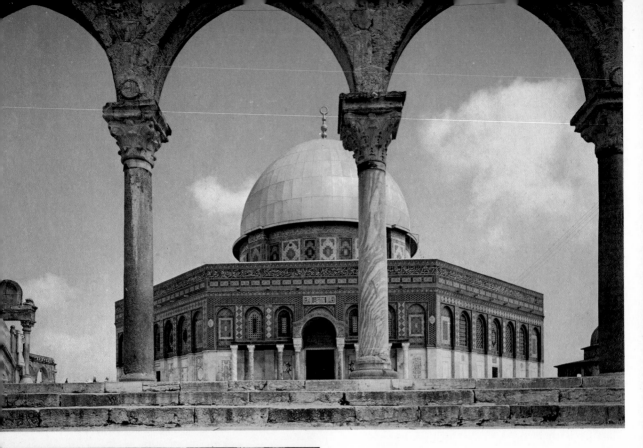

The Qubbat as-Sakhrah or Dome of the Rock, Jerusalem. Completed 691–92

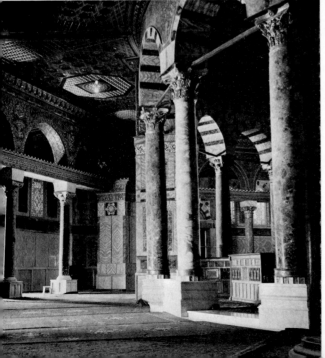

Interior of the Dome of the Rock, in which mosaic motifs clearly show Hellenistic and Sassanian influences

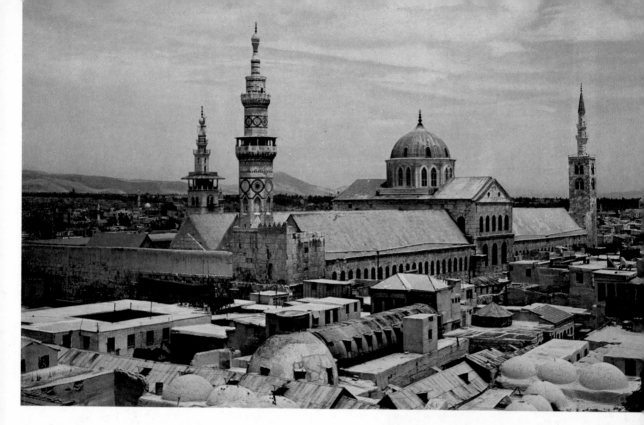

The Great Mosque in Damascus. 715

Interior of the Great Mosque in Damascus,
showing marble decoration in geometric patterns

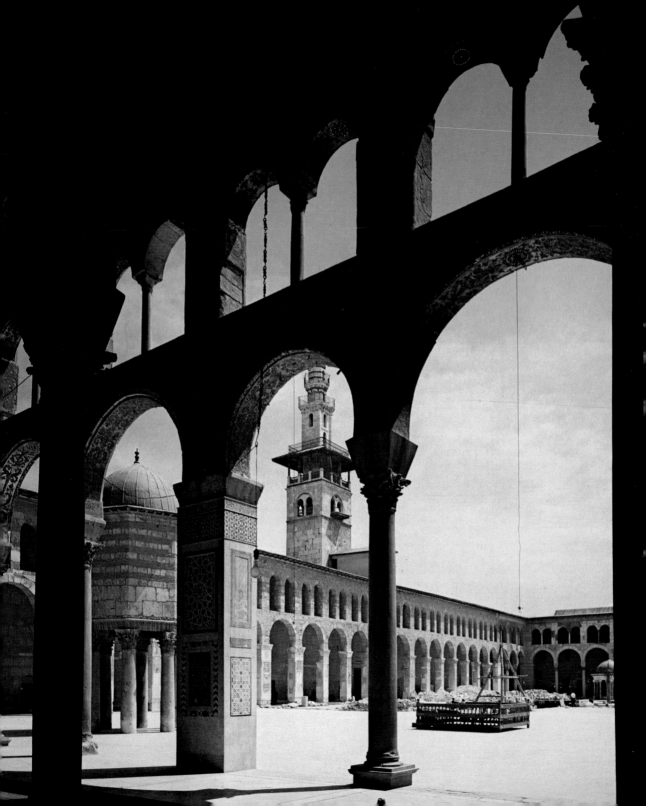

Mosaic decorations, inspired by fantasy, in
the court of the Great Mosque in Damascus

Although the date when building began is uncertain, it is known that the Dome of the Rock was completed
in 691–92. Compared with the mosques previously mentioned, its design is revolutionary. Obviously, the
nature of the sanctuary and the intention for ceremonial circumambulation of the sacred Rock furthered
the construction of an annular building, but it is above all the sudden architectural richness, making such
a marked contrast to the bare simplicity of the earliest places of worship, that takes us by storm. The
motives for this sudden forsaking of the principle of simplicity are explained by the historian al-Muqaddasi
(985) when he says: "Caliph 'Abd al-Malik, noting the greatness of the Church of the Holy Sepulcher and
its magnificence, was moved lest it should dazzle the minds of the Muslims, and hence erected above the
Rock the dome which is now to be seen there." This is only one of many reasons which may have been
factors in the matter, but in any case the break with orthodox isolation is important in the development
of art. Foreign influences were not only tolerated but were adopted and elaborated to an individual style.

Inner court of the Great Mosque in Damascus,
with the square minaret in the background

The dominating Byzantine influences which characterize the Dome of the Rock also govern the architectural style of the rest of the typically Umayyad buildings; but later, in the time of the 'Abbasids, they have largely disappeared.

The greatest architect of the Umayyad dynasty, both literally and figuratively, was Caliph al-Walid. In the latter sense, this was because, during his reign, the boundaries of the Islamic Empire came to extend from Transoxiana and Sind in the east to Gibraltar in the west. He was, moreover, literally a great architect because, among other things, he ordered the building of the Great Mosque in Damascus, capital of the caliphate, which in its day was justly known as "the third wonder of the world" (pages 21 ff.). The mosque was built within the ancient *temenos*, or sacred enclosure, of an old pagan complex. Within these walls, trapezoid in shape and measuring about 420 by 335 yards, there had originally stood a temple sacred to the Roman god Jupiter Dolichenus, which had later been transformed into a church dedicated to St. John the Baptist. An architectural innovation is the broad transept, running from north to south, which cuts the arcades of the sanctuary into two nearly equal halves and leads to the *mihrab*. The four great fires which ravaged the mosque, in 1069, 1400, 1479, and finally in 1893, have left us with nothing but vestiges of al-Walid's building, but fortunately numerous decorative fragments have survived to give us an idea of its splendors.

The desert palace of Qusair Amra, Jordan

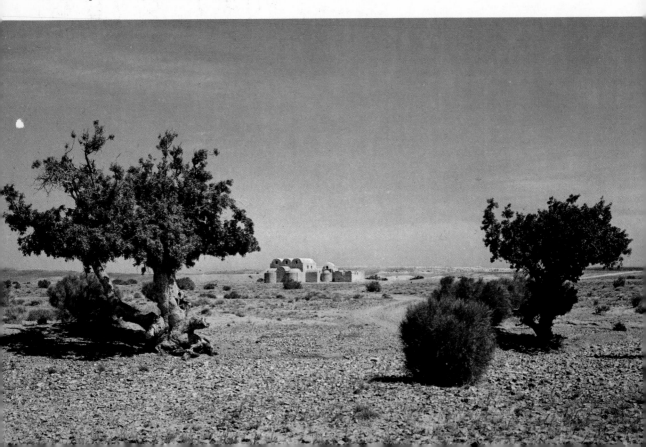

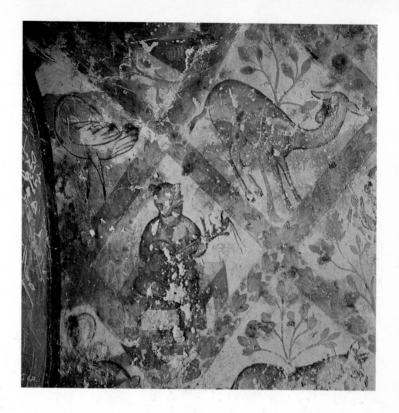

Detail of a fresco showing animal and human figures in a diaper pattern. Interior of Qusair Amra, Jordan

In this connection we must mention a further essential element in Islamic architecture, the minaret. The square towers at the four corners of the *temenos*, which originally were nothing more than watchtowers, were left by al-Walid in their old condition, with only their purpose changed. They thus became the first functional minarets, from which the muezzin gave the call to prayer. One of the towers can still be seen today.

Understandably, the Damascus mosque has served as a model, either wholly or in part, for numerous other buildings, both sacred and profane. Thus we find its influence in the Great Mosque in Aleppo, almost a faithful copy, and in the mosque of Qasr al-Hair, on a reduced scale. The mosques in Hamah in Syria and Cordova in Spain show many features in common with that of Damascus, while the plans of the North African mosques of Zaituna in Tunis and of Sidi 'Uqbah in Qairawan also show signs of its influence.

The nucleus of the Islamic explosion in Umayyad times was to be found in Damascus, so naturally the most interesting discoveries for this period are to be expected in that city and its immediate vicinity. The Umayyad caliphs particularly distinguished themselves in the field of secular architecture, more from the point of view of art than in respect of Islamic discipline, which evidently was not always maintained. In addition to the ruins of palaces, bathhouses, hunting lodges, and pleasure gardens, which have been known for a considerable time, a complete Umayyad city was quite recently discovered at Anjar, on the road from Damascus to Beirut on the Syro-Lebanese border. As has often been the case, stone material and building fragments were dragged off from an older site and used for the new buildings. In this case, not only was the material of a nearby Roman settlement employed, but part of the architectural style was also adopted.

The sculptured decoration, however, is clearly of Umayyad origin, and resembles that of the famous desert fortress of Mshatta. Mshatta (literally, winter residence), the date of which has posed difficult problems for the archaeologists, occupies a position apart among the desert palaces. Chronologically and typologically, the sequence could be stated as follows: a) Hunting pavilion with bathhouse: Qusair Amra and Hammam as-Sarakh; b) Detached fortress: Qasr al-Abyad, Muwaqqar, Qastal; c) Palace complex: Qasr at-Tubah; d) Mosque and/or *caravanseray* complex: Khirbat al-Minya, Khirbat al-Mafjar; e) Great residence: Qasr al-Hair ash-Sharqi, Qasr al-Hair al-Gharbi, Djabal Sais and Rusafa-Sergiopolis, and Mshatta—with which we have named the most important examples of architecture.

The builder of Qusair Amra, or the "little red palace," (pages 24, 25) was probably al-Walid I. Built of red sandstone in the vicinity of a spring still frequented by gazelles, this hunting pavilion gives us to some extent a picture of the luxury to which these desert dwellers aspired, especially if we consider the interior decoration and the appointments of the baths. For that matter, the castle of Khirbat al-Minya near Tiberias might also serve as the prototype of a dream palace, as indeed could that of Khirbat al-Mafjar. Both are situated in fertile surroundings, the former by Lake Gennesareth and the latter by the Dead Sea. Both are of one story, the rooms having decorations of great magnificence and refinement, and each palace has a mosque.

◄ Detail of a floor mosaic in the throne room. Palace of Khirbat al-Mafjar, Jordan. Built by Caliph al-Walid II, 743–44

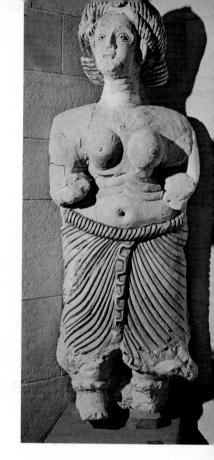

Dancer, one of the oldest examples of freestanding sculpture in Islamic art. Stucco. c. 743. Khirbat al-Mafjar, Jordan

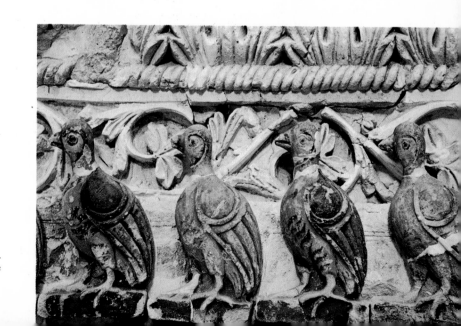

Frieze with partridges. Stucco. Detail from lowest register of the dome of Khirbat al-Mafjar

The great complex of Qasr al-Hair consists, in fact, of two separate palaces: the western, known as al-Gharbi, and the eastern, called ash-Sharqi. Al-Gharbi, by far the smaller of the two, is of one story and has a gateway between two round towers and most beautifully ornamented corridors. The whole has been reconstructed with great scientific care in the National Museum of Damascus. The larger palace, ash-Sharqi, bears an inscription of Caliph Hisham from the year A.H. 110 (i.e., A.D. 728/29). This building is given particular charm by the use of brick as a decorative element (as had been customary with the Byzantines), but according to the Mesopotamian technique and using bricks and mortar probably from the neighborhood of Raqqah.

Qasr al-Kharanah, Jordan. One of the few desert fortresses surviving from the Umayyad period

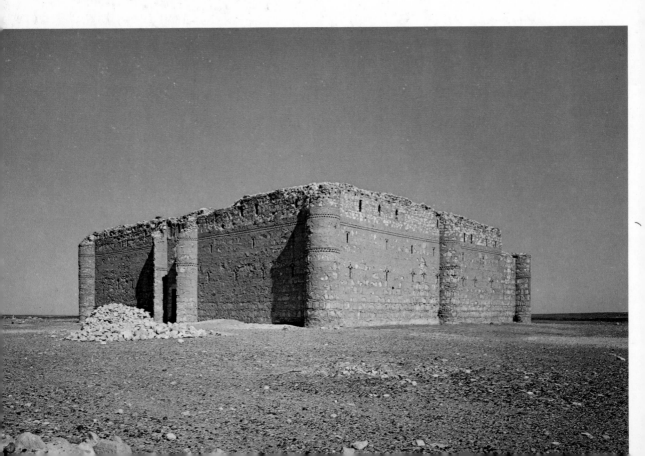

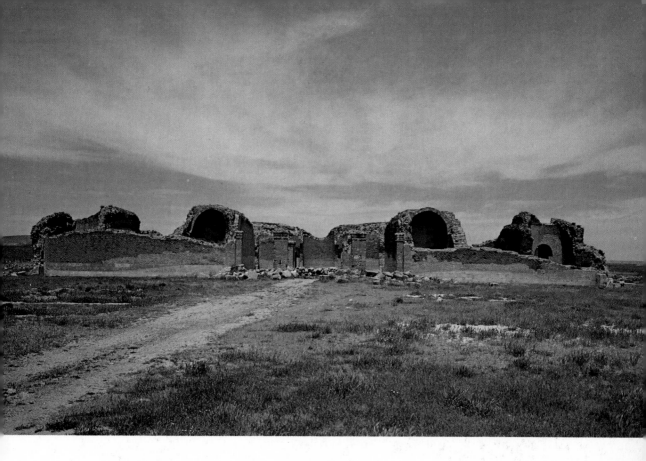

The throne-room quarter of the great
desert palace of Mshatta, Jordan. 743–44

Finally we come to Mshatta (above), a palace containing many characteristics of foreign influence. The great walled enclosure is 473 feet square, suggesting the dimensions of a Roman *castrum*. The construction of the complex itself shows a remarkable resemblance to Sassanian palaces. The throne room, however, reveals Byzantine influences. Finally, certain indigenous influences of Syria and Mesopotamia have made their effect, so that Mshatta holds an entirely distinct position in the architecture of the Umayyad period.

We have already touched on this subject in certain cases while discussing the buildings themselves. For work on the interiors, too, the help of foreign craftsmen was sought, who, in addition to their own material, also brought along their own style. Mindful of the ideas of the great Prophet, mosques were at first very soberly decorated, the adornment consisting of a simple intarsia of stones. This technique was soon supplanted by mosaics, with which, for example, the Dome of the Rock and the Great Mosque of Damascus were richly embellished. By far the most interesting ornamentation is to be found in and around the palaces, and here wall paintings form no exception. For that matter, the technique had already been

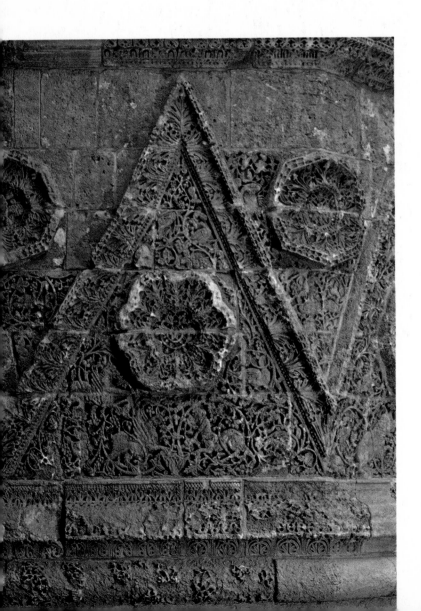

Detail of facade. Limestone. 743–44. From Mshatta. Staatliche Museen, Berlin

Ewer. Bronze, height 16¹/₈″. Umayyad period, c. 750. From the Fayyum, Egypt. Arabic Museum, Cairo. This beautiful jug probably belonged to the last Umayyad caliph, Marwan II, who was killed in 750, fleeing before the ʿAbbasids from his capital of Harran in North Mesopotamia

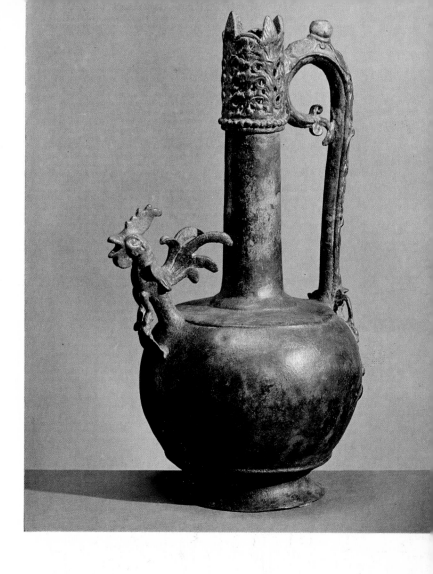

known to the Sassanians, who left their mark on this form of decoration. The decorators of the palaces proved unsurpassed masters in the ornamental use of stone, brickwork, and stucco. The limestone facade of Mshatta is sumptuously adorned with a zigzag frieze of upright and inverted triangles containing rosettes and acanthus leaves. An important part of this frieze was presented by Sultan ʿAbd ül-Hamid II to Kaiser Wilhelm II, and may be seen today in the Berlin State Museums. Good evidence of mastery in stucco relief decoration is seen in the pillars of the inner court in Khirbat al-Mafjar. In this same palace were found stucco sculptures in the round (page 27). One of these statues probably represents Caliph Hisham, who was not, however, the builder of this palace, that honor having been left to al-Walid II.

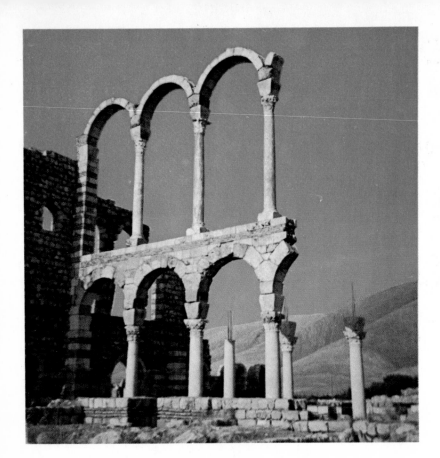

Arches in one of the streets of Anjar, Lebanon, an Umayyad city clearly built under Roman influences

UMAYYAD ARTS AND CRAFTS

In this phase of Islamic history, applied art was already leading an independent existence and skilled craftsmen could expect commissions for employment in both religious and secular work. In this sector there is scarcely any distinction to make between sacred and profane works, since no special objects were formally set apart for use in religious ceremonies, except for the necessary pulpit. The *minbar*, or pulpit, is an invention of the Umayyad period. In essence, it consists of two flat triangular shapes on either side of a flight of steps which lead to a seat at the top, a form which is still to be found at the present day. Its appointed place is on the right beside the *mihrab*, or prayer niche. Originally Muhammad is said to have sat in the mosque at Medina on an ebony seat with six steps, but this material did not become a prerequisite for subsequent pulpits. In addition to various kinds of wood, marble and stone were used, and gradually the height of the pulpit conformed to its architectural setting. The oldest known example is in the Sidi 'Uqbah mosque in Qairawan, Tunisia, dating from the ninth century. Although made in the 'Abbasid period, according to some scholars its mode of decoration might be considered as Umayyad.

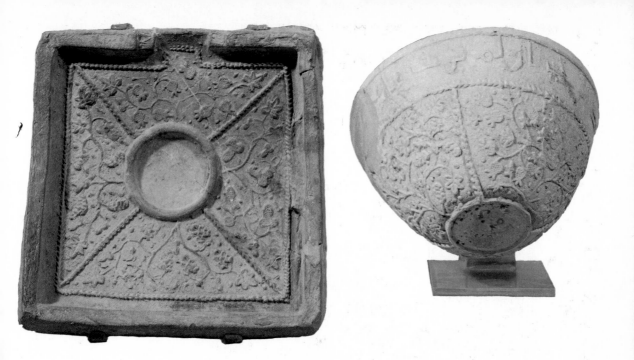

Cup and saucer. White, unglazed earthenware, cup height 2³/₈″, saucer width 4¹/₂″. Eighth century. From Susa. The Louvre, Paris

Other objects of religious association would have been the Korans and the desks on which they rested, and also the prayer mats, but nothing of the kind has survived from this period. There is no suggestion of any other specifically Umayyad forms of minor art. There is no reason for fixing an Umayyad label on the ordinary useful products of a craftsmanship faithful to tradition. Sassanian forms are continued in the pottery, and the bronzes, although occasionally distinguishable as Umayyad, give no evidence of a new style. This is not the case with ivory carving, which, perhaps inspired by the elegant architectural ornamentation, does indeed emulate such decoration on a small scale.

Again, the chessmen from this period are not new inventions of the caliphate, though to some extent they characterize the mode of life of a court that preferred to live in the desert pavilions, and thus gradually withdrew from its duties in Damascus. As the empire of the Umayyads expanded, so in fact it lost its inner control. Strong bonds were needed to hold together the numerous nations which the great conquests had brought under the Umayyad regime. Toward the middle of the eighth century, however, the bonds had already begun to fray, and it did not cost Abu al-ʿAbbas too much trouble to sever them altogether. After three years of active struggle, in 750 he managed to seize power in Persia. Meanwhile, North Africa had made use of the opportunity to restore its autonomy in some measure, and ʿAbd ar-Rahman, the grandson of the Umayyad caliph Hisham, had fled to Spain, where he was to found a new dynasty. After this reshuffling of the cards, the Islamic world could once more continue its battle against unbelievers and rebels.

Chessman, with a king enthroned on an elephant. Ivory. Eighth–ninth century. Bibliothèque Nationale, Paris. Although this piece bears the signature of an Arab ivory carver, it is completely Indian in conception

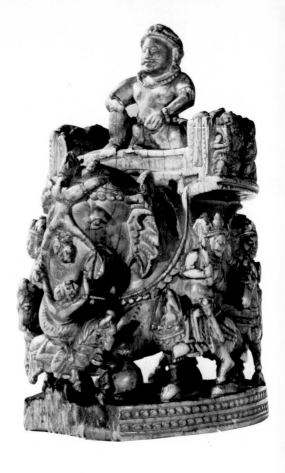

Detail of a console. Wood. A.D. 780. From the al-Aqsa Mosque, Jerusalem

THE 'ABBASIDS

With power in the hands of the 'Abbasids, new impulses were felt not only in politics but also in art. The removal of the capital from Damascus to Baghdad meant that backs were turned on the Mediterranean world and attention was largely focused upon Asia. Once in a while, there was a divergence from this course. The renowned Caliph Harun ar-Rashid managed to strike a certain bond of friendship with Charlemagne, which even led to an exchange of gifts. The purpose of this, however, was not so much to do Charlemagne a favor as to seal an alliance against their common enemy, Byzantium.

In Baghdad, far more noticeably than in Damascus, the closeness of the Sassanian spirit made itself felt, until at length Persian influence began to have too marked an effect on manners, habits, and government for the caliphs' liking. The intention had been that Islam should remain preeminently an Arab concern, at least from the administrative point of view, and therefore the 'Abbasids surrounded themselves with Turkish bodyguards in order to keep the Persians at a certain distance. The artistic reaction followed in the steps of political events. At first the Sassanian style persisted despite the Turkish infiltration, though slowly but surely the tide turned and the Turkish element became dominant. The protectors became the rulers. An attempt was made to reverse the roles once more, when the Buwaihids sought to restore the old order in Persia by means of a military dictatorship; but a rising dynasty of nomadic Turkomans, known to history as the Seljuks, put an end to all 'Abbasid illusions.

As we have said, Baghdad became the capital of the 'Abbasid Empire. Caliph al-Mansur made it into a strategically impregnable fortress. The city was enclosed within two concentric circular walls, pierced by four equidistant gateways, and at the heart of the city, within a spacious central area surrounded by a ring road, stood the palace and the mosque. At regular distances, like spokes in a wheel, streets radiated outward from the ring road to the wall. According to Arabic chronicles, the Round City of al-Mansur was unique, and an invention of this caliph. From examples of ancient times, such as certain Assyrian military camps and Parthian cities nearer to Baghdad such as Ctesiphon, we know that this assertion is far from being the case.

In the preceding period, we encountered the use of brickwork. In Baghdad, burned bricks were used for the vaulted passages and the domes. The walls, however, were made of mud bricks. In a country lacking in natural building stone, bricks were obviously of essential importance. Improvements in design were constantly being sought. The second city that al-Mansur built, at Raqqah on the Euphrates, has become an object lesson in the use of burned and sun-dried bricks. The walls were double, as in Baghdad, but built in a horseshoe shape joined by one straight side. The inner wall consisted of a core of mud bricks which was protected by an outer layer of kiln-burned bricks. The Baghdad Gate in Raqqah demonstrates what ornamental brickwork really means, and it was here perhaps that the later Persians may have come to study this technique.

Internal strife and the increasing unruliness of the Turks caused the caliph (al-Mu'tasim) to leave Baghdad in 836 and establish a new capital at Samarra, higher up the Tigris, leaving the former city in a state of eclipse resulting from military operations. At Samarra there arose a city worthy only of a lofty culture, with a carefully designed layout of streets and canalization systems for water and drainage, with mosques, palaces, dwelling houses, and workshops. The presence of workshops has proved of the greatest importance, since the material discovered on these sites has afforded us a glimpse into the development of arts and crafts.

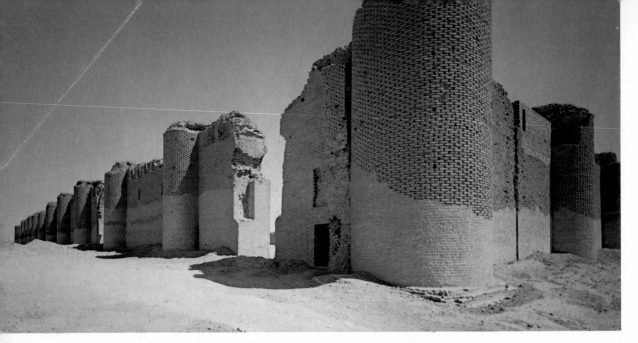

Outer wall of the Great Mosque in Samarra, Iraq. Begun by al-Mutawakkil in 847

ARCHITECTURE

Nothing remains today of the mud-brick mosque of Baghdad. It was built according to the old principle, with an open inner court and colonnades of wooden pillars surrounding it, and increased its size on the side of the *qiblah* wall to form the proper place of prayer. Harun ar-Rashid had this mosque demolished so that it could be rebuilt with better material and in somewhat larger dimensions. About the year 875, when the mosque proved too small for the needs of the faithful, a second mosque was built lengthwise against the *qiblah* wall—not a reflection of the first mosque, which would not have corresponded to the correct direction of prayer, but nearly enough of similar proportions, so that viewed from outside a sort of unity was suggested.

The Great Mosque of Samarra is decidedly one of the most striking constructions in the entire history of Islamic architecture. In plan, it forms an immense rectangle of about 784 by 512 feet, making it the largest in the world. The outer walls, built of light-red bricks to a thickness of about eight feet, have proved able to withstand the ravages of time. The roof of the sanctuary and the porticoes of the interior court were supported by 464 columns (of which only vestiges remain). Eighty-nine feet away from the mosque stands the minaret, which the Arabs called al-Malwiyah, meaning "the spiral." This remarkable monument, which from a distance recalls the *ziggurats* of pre-Islamic Mesopotamia, reaches a height of 164 feet.

Shortly after Caliph al-Mutawakkil had completed the Great Mosque, he decided to build a new city to the north of Samarra, which he named Ja'fariyah. Within a year (in 861) the city was ready, complete with streets, houses, a palace, and a mosque, known as the Mosque of Abu Dulaf. This mosque was only slightly smaller than that of Samarra; in this case, the mud-brick outer walls have largely disappeared, but the interior is comparatively well preserved. The minaret is a miniature copy of the Malwiyah in Samarra, and reaches no higher than fifty-two feet.

Minaret of the Great Mosque in Samarra ▶

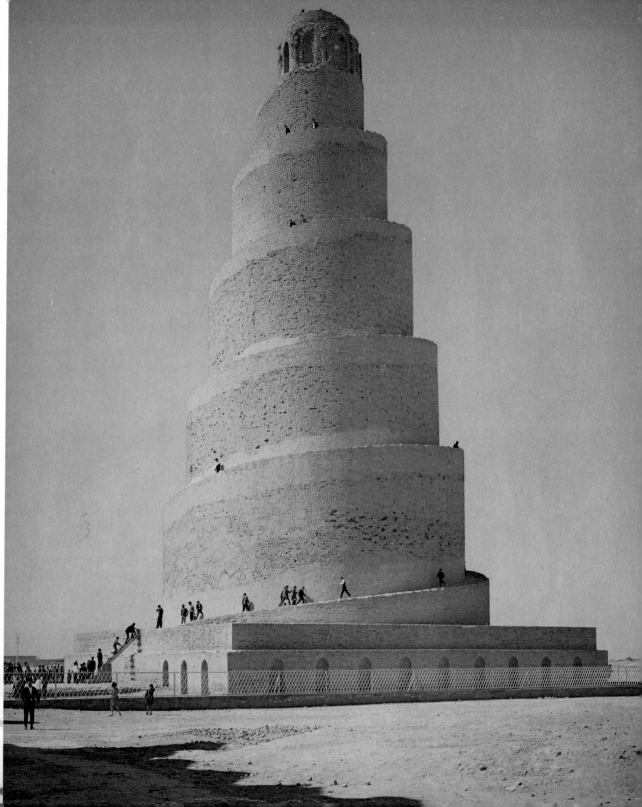

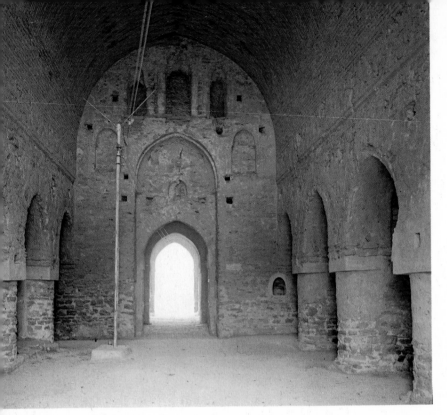

Interior of the palace of Ukhaidir.
Built c. 780

We can form a picture of al-Mansur's palace in Baghdad only from the accounts of the Arab chroniclers. Known as the Palace of the Golden Gate, it is famous for incorporating, for the first time in Islam, the *iwan*, a high vaulted hall open at one end, such as had already been in vogue among the Parthians.

As for al-Mutawakkil, it is said that he took such delight in building that he erected no fewer than eighteen palaces. One of the most celebrated is the palace of Balkuwara near Samarra, which was built for his son, al-Mu'tazz, between 854 and 859. Its walls enclosed a terrain more than four thousand feet square, and a special feature of this palace was the T-shaped throne room. Every comfort and amenity had been thought of, moreover: the courtiers' houses each had its own inner courtyard; on the banks of the Tigris lay a great walled garden with open-air basins and a game preserve; nor was a polo ground forgotten, for already this game had become one of the courtiers' favorite relaxations. The residence of the caliph in Samarra is equally impressive for the grandeur and comprehensiveness of its design.

The houses of Samarra might be compared to bungalow-type dwellings of the present day—except that they were very different in size, sometimes containing as many as fifty rooms. Speaking of size, it is interesting to note that the city itself stretched over a length of some twenty miles, and that in the 'Abbasid period the population was estimated at one million. All the houses had baths and a good water supply. Moreover, many could allow themselves the luxury of a ventilated underground living room, to give shelter from the fierce heat of the sun.

About a hundred and twenty miles to the south of Baghdad, in the midst of the desert not far from Karbala yet still utterly isolated, lies the mysterious desert fortress of Ukhaidir, which means "the green."

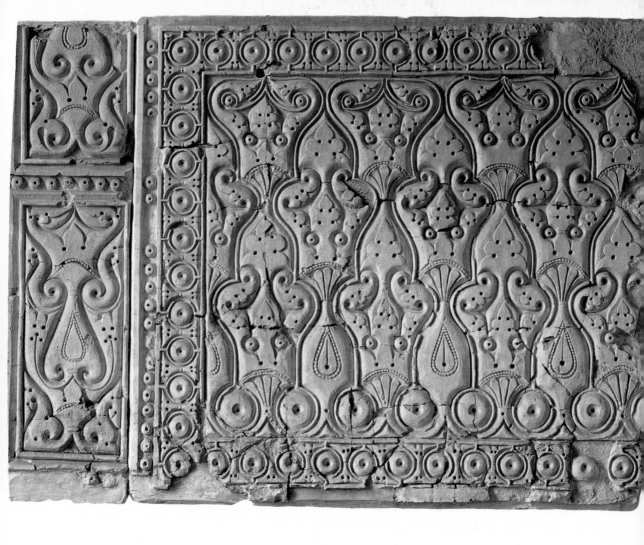

Two panels, typical examples of the beveled carving technique of this period. Stucco. Ninth century. From a private house in Samarra. Staatliche Museen, Berlin

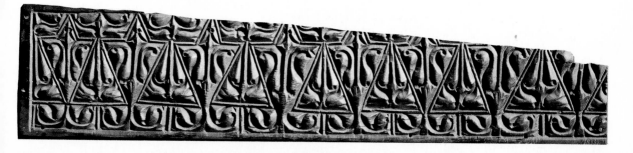

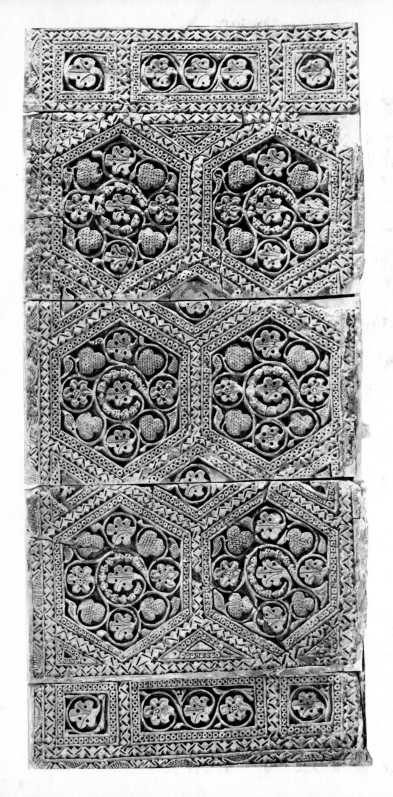

Panel, typical of the first style, of molded
decoration with five-lobed vine scrolls.
Stucco. Ninth century. From Samarra.
Staatliche Museen, Berlin

Plate, painted in brown with geometric patterns and rudiments of floral decoration. c. 860. From Mesopotamia. Victoria & Albert Museum, London

The reason for this poetic name is not clear, for the palace is situated in a very arid region within the desert. It is an exceptionally impressive fortification in which progressive ideas of military architecture were put into effect. It is ascribed to 'Isa ibn Musa, a former governor of Kufah, who, after falling into disfavor, retired embittered to his estates.

'Isa had, in fact, been pretender to the throne. The first 'Abbasid caliph, on having his brother al-Mansur recognized as caliph, had nominated 'Isa ibn Musa (who was their nephew) as the latter's successor. At first, relations between al-Mansur and 'Isa had been excellent, hence his appointment as governor of Kufah. The situation gradually deteriorated, since al-Mansur wanted to advance his own son while 'Isa attempted to preserve the right of succession for *his* son. By means of the most infamous tricks, al-Mansur tried to get rid of 'Isa, but he did not succeed in killing him. Finally, determined to come to an agreement, al-Mansur summoned 'Isa and his son to the palace. It was a trap, for the son was seized and, in his father's presence, was half strangled by the chamberlain. 'Isa could not allow the threatened murder to take place and, to save his son's life, he agreed to sign a contract renouncing his rights. For this he received a huge sum of money and was accorded the right to succeed al-Mansur's son, should he outlive him. Al-Mansur died soon afterward and his son, al-Mahdi, succeeded him according to the agreement. Three years after his accession, however, he proclaimed his son Harun ar-Rashid as his heir, and moreover deprived 'Isa of his governorship of Kufah. With such a history as background, we can imagine the state of mind of the builder and occupant of Ukhaidir after this unsavory affair.

Plate, with luster-painting of
the so-called Samarra type.
Diameter 8⅝". Ninth century.
The Louvre, Paris

Plate, with painted slip decoration of bird and
script. Ninth–tenth century. From Samarkand.
Haags Gemeentemuseum, The Hague

Dish. Glazed relief ware, diameter 8½″. Ninth–tenth century. From Hirah. British Museum, London. The Kufic inscription is of a distich by Muhammad ibn Bashir: "Despair not though the seeking is long. May you see deliverance when your patience is at an end"

ARCHITECTURAL ORNAMENTATION

With the use of burned brick as building material came the introduction of stucco decoration. The stucco technique had already been long known and frequently applied in the Sassanian period, so the 'Abbasids had sufficient examples on hand. Plasterwork decoration during the 'Abbasid period comprised three different styles, distinguished partly by their motifs and partly by their technique. The first style, in which the surfaces were closely covered with vine leaves and grape clusters molded in fairly deep relief, is already to be found in Mshatta, while its origin must be sought in pre-Christian art. The second style derives in some measure from the first. In it, naturalism is completely set aside in favor of highly conventionalized plant motifs, with the scroll-like stems omitted. The surface is divided into variously shaped compartments, smaller than in the previous style, so that the first impression is of geometric decoration. The detailed ornament within these compartments proves, however, to consist of stylized palmettes and open-flower motifs. Once again, it is the contrast of light and shadow given by the fairly deep undercutting

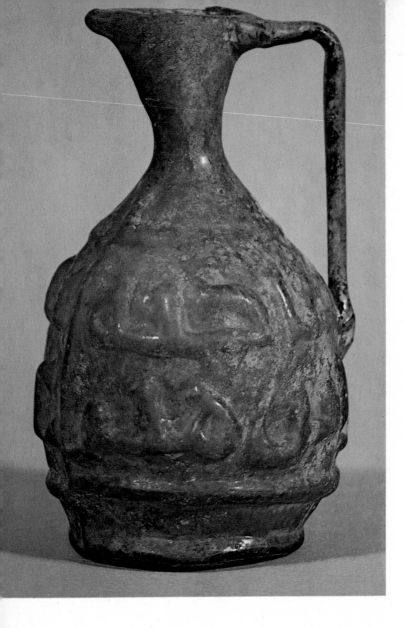

Two 'Abbasid coins. Center: gold, dated A.H. 117 (A.D. 735); right and left: silver (obverse and reverse), A.D. 908–32. Both Cabinet des Médailles, Bibliothèque Nationale, Paris ▶

Jug, with glazed impression-relief decoration. Ninth–tenth century. From Baghdad. The Louvre, Paris

that gives emphasis to the design. In the third style, a different technique is employed, which appears to have been an invention of the 'Abbasids not derived from any earlier example. The designs are made in a very low relief with slanted edges, usually referred to as "beveled carving" or *Schrägschnitt*, as the German archaeologist Herzfeld called it. Here, the relief is so shallow that the pattern no longer depends on *chiaroscuro*. The decorative scheme is somewhat simplified, while the motifs remain largely the same. This style probably evolved from the stucco technique itself. Since large wall surfaces were to be covered, "negative" models of the desired decoration were carved in wood, and from these a "positive" impression was made in the stucco. This method is only practicable in low relief.

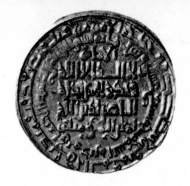

In the decorative patterns of houses and palaces in Samarra, we are confronted for the first time in Islamic art with the phenomenon of the continuity of motifs. In one mysterious manner or another, certain themes find their way through the ages in the same region, irrespective of the branch of art or craft in which they make their appearance. Although naturally the context in which each design is employed at a particular period varies greatly, we see how decorative motifs made in roughly the same region in the eighth century B.C. are in accordance with some of the designs from Samarra. The stucco ornamentation of Samarra, for example, evokes memories of the "animal style" of Central Asian origin which was introduced into Assyria by the Scythians about 700 B.C. The question arises as to whether this is a case of coincidence or the persistence of indigenous traditions. With regard to pottery, even more striking examples can be given, the "primal motifs" of which lie still deeper in the past: we shall have more to say on this subject later. The new style of decoration in stucco is also to be found in architectural sculpture and in wood carving.

When discussing the earliest forms of Islamic architecture, we mentioned the importance of the town of Kufah in Mesopotamia, after which the oldest types of mosque were named. The oldest script also takes its name from this city. Kufic script, with its square and angular characters, was especially suitable for carving texts in stone, which is presumably why the earlier script has been called lapidary Kufic. No fine examples of Kufic script have come down to us from the earliest days of Islam, but in the ninth century men began to bestow more attention on this art, and even to insert the diacritical marks, which led to the so-called rounded Kufic manuscript character. This was a calligraphy more appropriate to writing out copies of the Koran than to chiseling inscriptions in stone, and on that account does not belong to the realm of architectural decoration.

As for wall paintings, the 'Abbasids had a different conception of this art from that of the Umayyads. Instead of the more elaborate compositions of their predecessors, the 'Abbasid artists concentrated more on distinct scenes in which figural themes were included.

Typical of Samarra are the so-called "portrait steles," of which a number of fragments were found in a palace. These are a kind of cylindrical clay jar, about thirty-four inches tall, closed at the top and tapering to a point at the base so that they might be pressed into the soft ground and made to stand upright. The

function of these unique objects is not altogether clear, but, leaving aside the decorative and pictorial element, they are also interesting from the potters' standpoint. At the time when the 'Abbasid Caliphate was in its glory, potters were of great importance.

CERAMICS

It is difficult to describe in a few words the causes of the vehement development of Islamic ceramic art: its evolution in the Near East proceeded with the same swiftness and overwhelming conviction as Islam itself expanded as a religion. Naturally, potters had been busy making wares for everyday use ever since the invention of pottery in Mesolithic times, but they had still not reached the height of luxury and elegance. Apart from the products of their own workplaces, the market abounded in Chinese porcelain and Byzantine and other pottery. The Chinese in particular provided the potters of Persia, Egypt, and Iraq with good models to imitate. Out of the local kilns came plates, bowls, jugs, and jars, together with an enormous quantity of tiles, which were used in architectural designs. Supported by an age-old tradition and inspired by particular Eastern examples, the 'Abbasid potters evolved a ceramic style that for richness of forms and technical refinement has never been excelled in later periods.

Undoubtedly Baghdad would have had its share in this immense output, but the destruction of this city was so drastically carried out that scarcely even fragments remained. The cradle of Islamic ceramics is Samarra, an abbreviation of *Surra man ra'a* (pleased is he who sees it). The name is in stark contrast to the desolate condition in which this once so flourishing metropolis finds itself today. Between 838 and 883, when for almost half a century Samarra was capital of the 'Abbasid Caliphate, the city established a worldwide reputation in ceramic art. The Chinese porcelain that had entered the country in the time of Harun ar-Rashid (786–809) by way of ambassadorial gifts had stimulated direct imitation, not so much of form and decoration as of the technical perfection of Chinese stoneware. The lack of good pipeclay made the actual manufacture of stoneware impossible. In their attempts to imitate porcelain, the potters covered their products with a tin glaze, the somewhat translucent ivory color of which gave quite a close resemblance from a distance. Experiments in search of still better results led to the discovery of a special process, the so-called luster technique. Objects treated by this process have a lustrous metallic sheen which may vary between golden yellow and brown, sometimes even tending toward red or green. The effect was achieved by painting a thin layer of silver-and-copper alloy over a clay object which had already been fired, and then refiring it in a muffled kiln at a low temperature. The great success of this technique is evident from the way it spread to every corner of the Islamic world, for specimens have been found in Syria, Egypt, Spain, and Persia.

As well as these glazing techniques, which also included a typical lead glaze, the potters of that time made use of other processes. The mastery that the 'Abbasid artists had demonstrated in stuccowork evidently had its influence on the potters, too. In Hirah in Mesopotamia we encounter a center which produced pottery with decorations in relief, and examples made in a variant of this technique are found at Susa in Persia. In the Hirah workshops, the decoration was molded and the product was further enhanced by a glaze, usually green or yellow. In the second technique, the decoration was applied in the form of a thin paste, and usually this so-called barbotine ware was unglazed.

The choice of decorative motifs is similar to that found in other branches of art. We find lettering variously employed for inscriptions and adornment, together with plant motifs stylized into geometric figures, including the many versions of the schematized split leaf and continuous stem known as the arabesque. Portrayals of men and animals are also found on objects of everyday use, but are entirely absent in the tile decorations of sacred buildings.

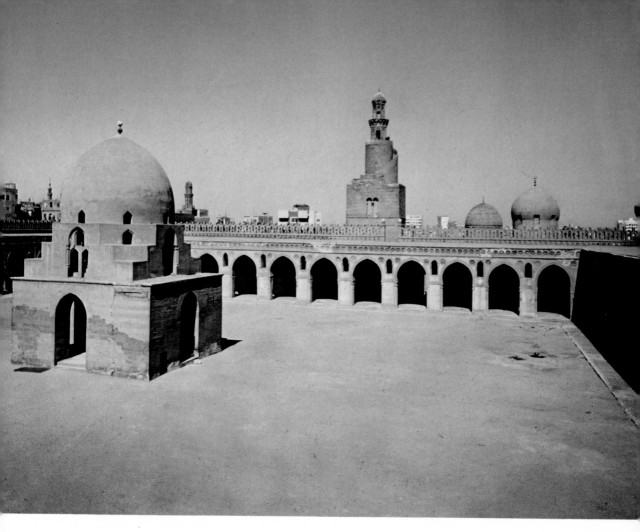

Courtyard of the mosque of Ibn Tulun, Cairo. 877–79

Sassanian influence can still be observed, especially in the products of other crafts, and in metalwork in particular.

OTHER CRAFTS

The religious prohibition on using objects made of precious metals like gold and silver forced the crafts-man into an awkward position. He found himself obliged to forge noble forms in base metals or alloys such as bronze. The true masters in this field were to be found in Persia and the provinces of Khurasan

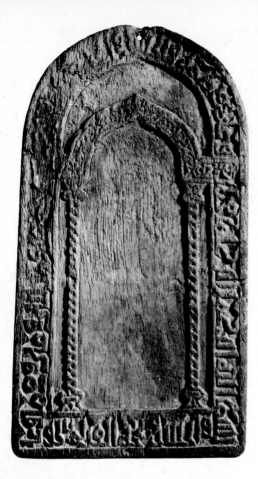

Small *mihrab*, or prayer niche. Wood. Tulunid period, ninth–tenth century. From Egypt. The Louvre, Paris

Page from a Koran written in Kufic script, the oldest form of Islamic calligraphy. The rectangular shape lent itself both to carving in stone and writing on parchment. Ninth century. From Syria or Iraq. The Metropolitan Museum of Art, New York City ▶

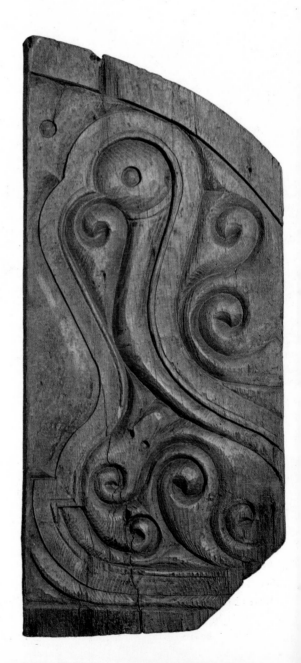

Carved panel, treated in a style resembling the ▶ "beveled carving" of Samarra. Wood. Tulunid period, ninth–tenth century. From Egypt. The Louvre, Paris

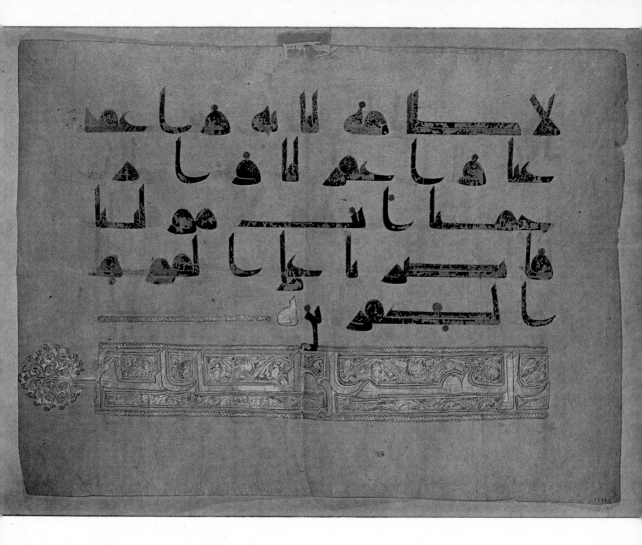

and West Turkestan, where they had been active since the Sassanian period. They managed to hold their monopoly until the tenth century, when first Egypt and later Mesopotamia succeeded in producing masterpieces of their own distinctive type. The few examples from the 'Abbasid period, which are now almost all in Russian collections, consist mainly of aquamaniles (water vessels) and incense burners.

In Samarra, fragments of glass engraved with animal motifs have been found. Probably the goblets, vases, bottles, or other objects to which they belonged had been made in Egypt or Persia. Glass decorated with burls and threads was more likely to have been a product of Syria and Iraq.

Woven fabrics formed an important part in the caliphs' luxurious mode of life. The royal textile factories must already have been in existence in Umayyad times, and numerous fragments have come down to us from the 'Abbasid period. The textiles which left the royal factories were inscribed with the names and titles of the reigning caliph, and were used as gifts to reward foreign princes and court dignitaries.

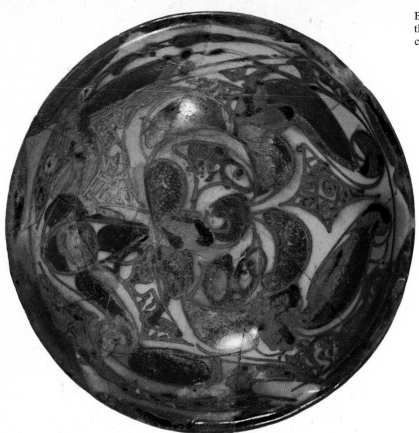

Bowl painted in luster technique, of the so-called Samarra type. Ninth century. The Louvre, Paris

NEW DYNASTIES AND OLD INFLUENCES

THE TULUNIDS

As we have seen, the power of the 'Abbasids dwindled, and various caliphs of other lines, emirs, governors, and usurpers dispensed the law in the four quarters of the immense Islamic Empire.

Already, during the time when the 'Abbasid rule was in full bloom, Ibn Tulun had set up a virtually independent kingdom in Egypt, where he had been appointed governor, and had even made an attempt to dominate Syria, although this proved unsuccessful. He certainly succeeded in building in Cairo a mosque of exceptional beauty, a work completed in 879 and probably begun three years earlier. Ahmad ibn Tulun, who had been brought up at the court of Samarra, had obviously feasted his eyes on the beauties of that city, and so it is not surprising that he should have taken the mosque of Samarra as a model. In a number of details, especially those concerning architectural ornament, the mosque of Ibn Tulun resembles that of Samarra. The minaret, which was destroyed by a great fire in the tenth century and restored in the thirteenth so as to rise from its base in three stories of diminishing size with a cylindrical portion at the top, originally may well have been a faithful copy of the Malwiyah (spiral) minaret in Samarra.

The Tulunid craftsmen distinguished themselves in wood carving, as may be seen both on the doors of

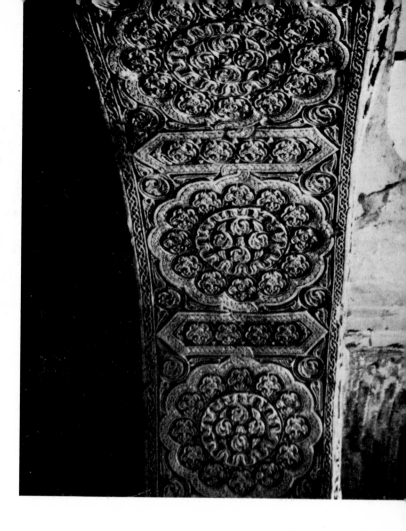

Inside of one of the arches enclosing the court of the mosque at Nayin, Iran. c. 960

mosques and in the decorative panels inside houses. The panels were carved in a manner resembling the beveled style so splendidly employed in the stuccos of Samarra. According to tradition, the Tulunid ruler Khumarawaih had numerous wood sculptures of himself and his courtiers set up in his palace, but unfortunately none of these has survived. In the case of pottery, too, we have nothing more than a quantity of lusterware fragments, found in Fustat, which show us that the 'Abbasid style also persisted there.

THE BUWAIHIDS

Toward the end of the ninth century, when the 'Abbasid caliph Mu'tamid had again chosen Baghdad as capital of the empire and was attempting to consolidate his power, the Buwaihids were stirring on the Persian frontiers. These were a people who had originally lived along the southern shore of the Caspian Sea, and had extended their dominion into West and even South Iran. In 945, they advanced on Baghdad. To win their favor and support, the caliph conferred on them positions of honor and power, and they did

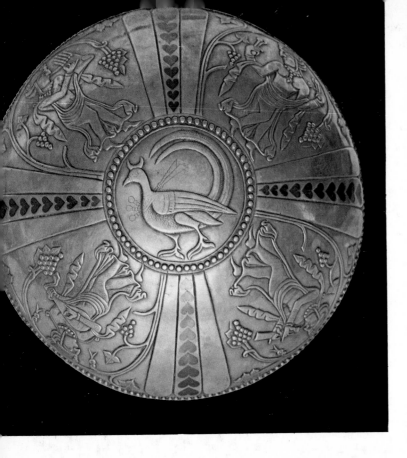

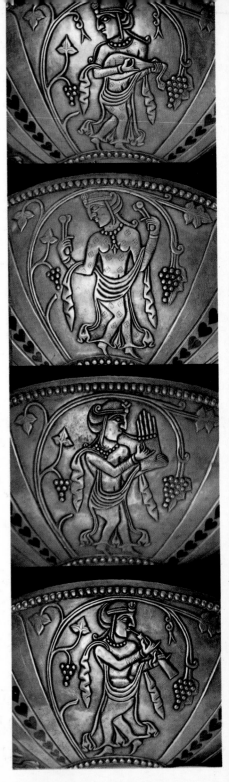

Basin of Buwaihid workmanship, though both material and motifs recall Sassanian products. Silver. Tenth century. Teheran Museum. Right: details

not molest him. After having expelled the Turks, they became the virtual rulers of the country, reducing the caliph to a kind of vassal. After rather more than a century they had exhausted their role, and were in turn driven out by the Seljuks.

ARCHITECTURE

Among the most celebrated architectural works of the Buwaihids is the mosque in Nayin, in Iran. With the passing of time this mosque has lost something of its original form, but stucco decorations from the tenth century are still to be seen. These are closely related to the tradition of the Samarra stuccos.

ARTS AND CRAFTS

The Buwaihids occupy an outstanding place in the field of metalwork. When discussing the 'Abbasid craftsmen, we mentioned that workmanship in precious metals was taboo in Islamic art. We also stated that the best workers in bronze had vied with those of Khurasan and West Turkestan. The Buwaihids apparently were prepared to override both the wish of the Prophet and the reputation of the finest metalworkers in Persia. During their hegemony, a large number of silver bowls and plates was made, as well as several gold jugs and a quantity of gold medallions bearing the head of their princes. Formerly it was supposed that the silverware should be ascribed to the Sassanians, as at first glance these dishes strongly

Woven fragment, with elephants and Kufic border inscription: *"Glory and prosperity to Qa'id Abu'l-Mansur Bakht-tegin, may Allah perpetuate his happiness."* Silk, height 20$^1/_8$". Tenth century. From Khurasan. Formerly in the church of St. Josse-sur-Mer, Pas-de-Calais. The Louvre, Paris

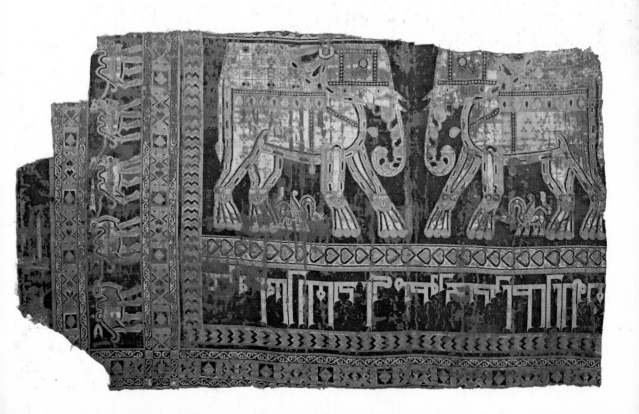

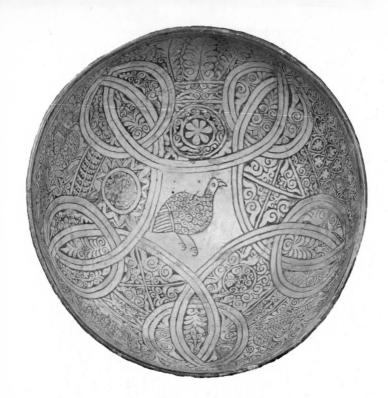

Bowl, with *sgraffito* decoration. Eleventh century. From the Garrus district. The Metropolitan Museum of Art, New York City. Gift of Fahim Kouchakji, 1964. The design may represent the tyrant Dahhak, a figure from Firdausi's *Shah-nameh* (Book of Kings), in which case it would be the earliest portrayal of a scene from Persia's greatest epic

Plate of the so-called *Gabri* type, with *sgraffito* decoration. Diameter 13″. Ninth-tenth century. From Persia. Kofler-Truniger Collection, Lucerne

call to mind the products of Sassanian craftsmen. Closer examination, however, reveals too many stylistic differences, and the Buwaihids are now acknowledged as the makers.

CERAMICS

The Buwaihids produced some impressive types of pottery, and it is probably to them that we owe the so-called *Gabri* ware. In this type, the design was deeply engraved, resulting in a decoration in low relief which was covered with glazes in various colors. Here, too, the decorative elements are sometimes strongly reminiscent of the Sassanians, but we also find contemporary and indigenous themes. In certain cases, the iconography has proved to be of the greatest importance, and some modern historians of Islam have suggested that the designs on Buwaihid plates may include illustrations of the Persians' greatest epic, Firdausi's *Shah-nameh* (page 55). If this hypothesis is correct, then these earliest illustrations show the immediate popularity of the poet of the "Book of Kings" in his own day. Later, when we consider Persian painting, this subject will be discussed more thoroughly.

Besides this elaborate *Gabri* type of pottery, we also find a simpler style, sometimes with a thinly engraved design in the technique known as *sgraffito*, and sometimes with only a painted decoration. This second type, which is somewhat more rustic in character, is associated with the villages of Amul and Sari, near the southern shores of the Caspian Sea. The *Gabri* style of pottery had a very wide distribution, and

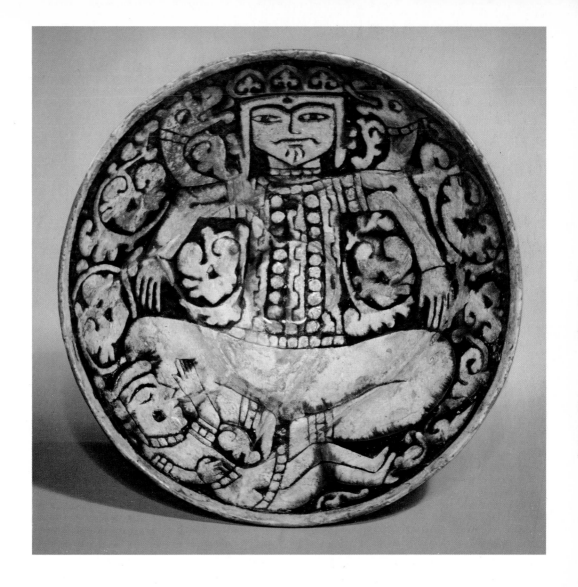

sites where it has been found include Garrus and Aghkand, roughly halfway between Teheran and Samarra and a little to the north.

TEXTILES

Textiles, and silk fabrics in particular, were greatly in vogue among the Buwaihids. In the factories at Rayy, the more or less fixed color schemes were of brown, black, and blue designs worked on a creamy white background, or this was sometimes reversed so that a light pattern stood out against a dark ground. Among the designs, we find the familiar hunting scenes, and also many stylized animals, while gradually the calligraphic element was also being brought into decoration.

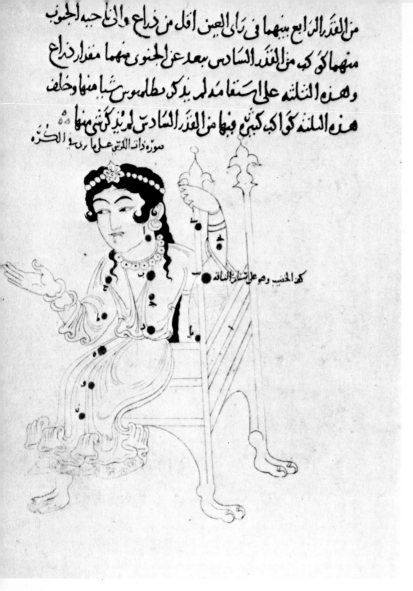

من القدر الرابع منهما في راس الصين افل من ذراع وان احيد الجنوب
منهما كو كب من القدر السادس بعد عن الجنوب منهما مقدار ذراع
وهذه الثلثه على استقامة مدلم بذكر بطلموس شا منها وخلف
هذه الثلثه كواكب كبير فيها من القدر السادس لريد كثير منها

مورة ذات الكرسى ما راى ه الكرة

كه الحقيب وهو على نساق الساقه

Cassiopeia. Miniature, height 10¼".
Leaf from a copy of 'Abd ar-Rahman
as-Sufi's book on the *Constellations.*
Dated A.H. 400 (A.D. 1009). Bodleian
Library, Oxford. Ms. Marsh 144, fol.
100. This work is one of the oldest
illustrated books of Islamic literature
that has come down to us. The author
based his work on the *Mathematiké
Syntaxis* of Ptolemy, furnishing it with
a commentary based on his own ob-
servations.

THE SAMANIDS

The Samanids came of a different stock and from a different region from the Buwaihids, originating in Khurasan and Transoxiana, otherwise East Iran and West Turkestan. As early as the ninth century, the Tahirids (820–73) of Khurasan had withdrawn their allegiance from the caliph of Baghdad and had set up their own dynasty. They were followed by the Saffarids, and then by the Samanids, whose dynasty lasted up to the memorable date of 999, by which time most of northern Persia was under their control. Their rulers chose Bukhara as the capital, and later resided in Samarkand and Nishapur.

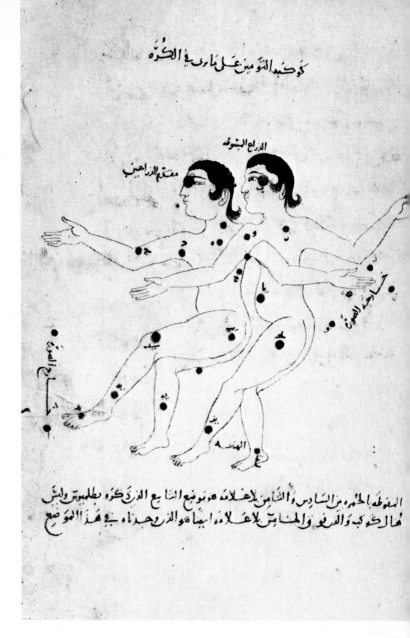

Gemini. Miniature, height 10¹/₄″. From the description of the signs of the Zodiac in as-Sufi's book on the *Constellations.* Bodleian Library, Oxford. Ms. Marsh 144, fol. 210

كوكب التوءمين على مارّ في الكرة

الذراع البسوط

مقبض الذراعين

المنكب الصعير

الهنا

الفوطه الحمرة من السادس والثامن لاعلامه هو موضع النابع الذرع كوه بطلبيتر والش
هما الكوكب والذرع والحامس لاعلامش لاعلا به ايهاهو والذرع وحده في هذا الموضع

ARCHITECTURE

Funerary monuments had been a rare feature in 'Abbasid art. An exceptional case was the mausoleum of al-Muntasir in Samarra, the so-called Qubbat as-Sulaibiyyah, erected at the request of the caliph's Greek mother, who herself had been a Christian, and reminiscent in its plan of a Syro-Palestinian martyrium. The tomb of Isma'il the Samanid in Bukhara was, however, specially designed for its purpose, and it became a kind of prototype, or rather archetype, for later developments in the building of mausoleums. The architect made great play with decorative brickwork, and the outer walls give from a distance the impression of beautifully interwoven basketwork. Both in the interior and exterior, abstract patterns of ornamental brickwork are imaginatively employed, their effect being enhanced by the play of light and

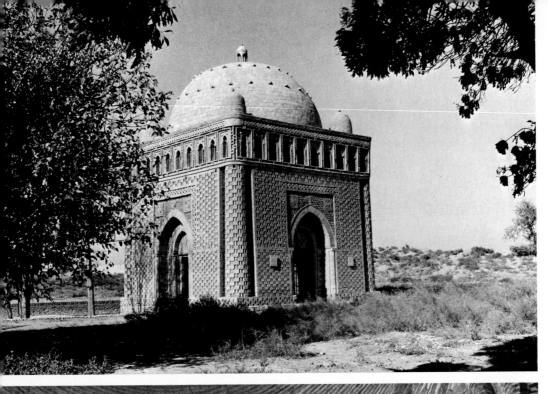

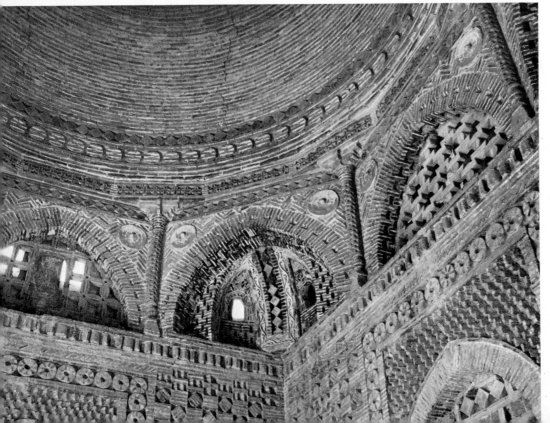

shade. The cube-shaped building, which is pierced on each side by a doorway with a pointed arch, brings
to mind the Sassanian fire temples. The central dome, together with the four small cupolas at the corners,
is a splendid example of vaulted construction by means of squinches (small arches built obliquely across
the internal angles of a square structure in order to carry a circular dome).

Among the architectonic fragments found in Nishapur were stucco panels molded into stylized flowers
and abstract motifs which show a direct relationship with those of Samarra in the so-called second style.
Little has been preserved of the wall paintings, unfortunately—too little to enable us to reconstruct the
great compositions of which the few surviving fragments formed a part. A single portrait that has survived
bears witness to the Turkish influences from which these works stemmed. As in Samarra, the Turkish
mercenaries indirectly brought their influence to bear outside their own military sphere. The portrait of a
woman, now in the Metropolitan Museum of Art, New York, is a forerunner of the Seljuk portrait heads,
of which the same museum possesses an example in stucco from the twelfth–thirteenth century. The ethnic
type reminds one of the Uighur paintings from Khocho in Chinese Turkestan.

Bowl, painted in slip technique with decoration exclusively in Kufic script.
Diameter 9½″. Tenth century. Samarkand type. Teheran Museum

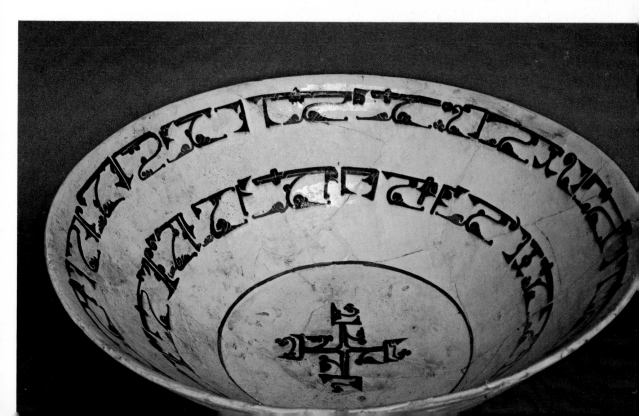

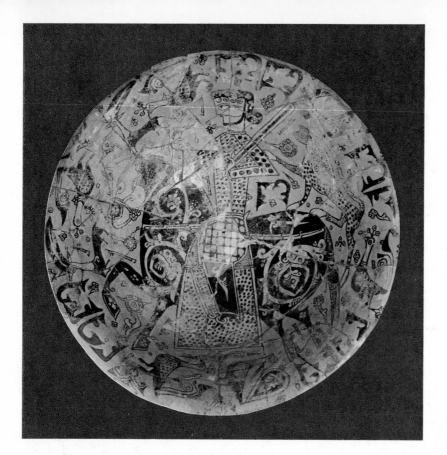

Bowl, with design of basically Sassanian character showing a mounted prince hunting, a pouncing leopard behind him, and various forms of wild life around him. Polychrome on white ground, diameter 11 3/4″. From Nishapur. Teheran Museum

CERAMICS

The Samanid potters of Nishapur and Samarkand produced very distinctive wares that once more confirmed the high reputation of the Persians in this field. Theirs is the great merit of having rediscovered the slip technique, which for centuries had been virtually forgotten, and introducing it into the Islamic world. Slip is merely a layer of thinned clay, colorless or colored, spread over the body of the pot to make it smooth. In the same way that, on a larger scale, walls are first made ready for the painting of a fresco, so is slip a ground preparation for ceramic painting. Its advantage was that the decorator need no longer be afraid that his paint would run when the glaze was poured over it. The craftsmen of Nishapur painted in bold colors—yellow, green, black, and purple—in a vigorous and angular style that is further characterized by an unsystematic filling of the surface. The motifs were mainly sitting or standing figures, riders, or animal groups.

In all the attempts that the Islamic potters had made, or were to make in the following centuries, to imitate or emulate the Chinese, the Muslim artists again and again had to take second place, both in technical performance and in the "character" of the product. For the Chinese, a good piece of porcelain or pottery was almost a cult object, something that brought him closer to grasping such conceptions as beauty and perfection. Rivalry apart, the Samanids produced a type that would surely have found favor

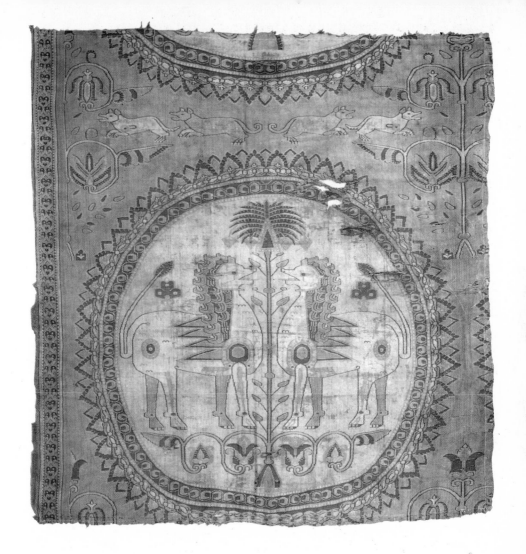

in the eyes of the Chinese. In Samarkand we find a most happy union of ceramics and calligraphy. The potters of Samarkand mainly restricted themselves to simple, severe forms such as plates and conical bowls of various sizes. Round the rim, on a pure white ground, the calligrapher painted a benediction in beautifully rhythmic Kufic characters, generally in black. The vessel—a true work of art—was then completed by a pure, brilliant glaze. Slightly varying designs, to which a palmette in a single color might be added if any noncalligraphic element were included in the composition, were also made in Nishapur. The text was also occasionally written in a different type of Kufic script, or it might be allowed to run obliquely across the object; but most successful of all were the simple plates and bowls with a border of script round the edge.

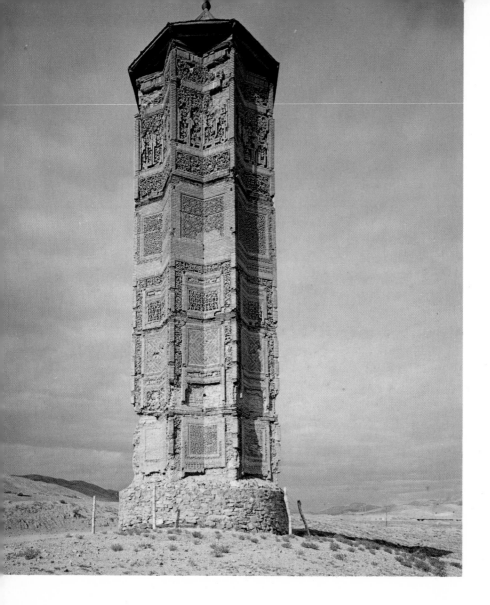

Minaret of Mas'ud III. c. 1114–15. Ghazni, Afghanistan

Specimen of "floriated Kufic," taken from a marble *mihrab* from Ghazni. Second half of eleventh century (far left)

السلطان الأعظم علاء الدولة ظهير الإسلام

Specimen of "interlaced Kufic," taken from the minaret of Mas'ud III in Ghazni

THE GHAZNAVIDS

Toward the very end of the tenth century, a new Turkish dynasty was founded by Sabuktagin in Ghazni, in present-day Afghanistan. In consequence, part of India, too, came under Islamic control, with the regions of the Punjab, Hindustan, and Gujarat. The distance from Baghdad was not great enough to allow any lessening of 'Abbasid influences. It is true that the mausoleum of Isma'il the Samanid in Bukhara formed a first rung on the ladder to free development which the Ghaznavids were to mount a step further, but the links with the western provinces of the empire were still unbreakable. Only one of the Muses managed to exert her authority on Sultan Mahmud, and this was Calliope, patroness of eloquence and epic poetry. The great Persian poet Firdausi (935–1020) had come to Ghazni with the intention of entering Mahmud's service, which, after much difficulty, he succeeded in doing, thus gaining official recognition for poetry and literature among the fine arts. Their influence is closely connected with later developments in painting.

ARCHITECTURE

The mosque of Mahmud was spoken of in lyrical terms as his "celestial bride," and is said to have been built of stone and marble, a substance that is "softer than a young girl's hand and smoother than a mirror."

The artistic use of brickwork in the minaret of Mas'ud III, built in Ghazni in 1114–15, elicits great admiration. This prism-shaped tower is divided by a linear framework into various symmetrical compartments containing geometric openwork decorations in brick. At the top, it terminates in a wide band of Kufic inscriptions against a background of arabesques. This variant of script is called "interlaced Kufic" because of the style of the characters. Two further types of script developed, probably influenced by the Ghaznavids' interest in poetry. First there is the so-called "foliated Kufic," and then the flowing *Naskhi*, which is more or less a derivative of the former.

An example of palace architecture is afforded by the complex of Lashkari Bazar, an ancient royal residence dating from the beginning of the eleventh century and built entirely after the manner of Samarra. In Lashkari Bazar we encounter the same kind of *iwans* and the same T-shaped hall as the throne room in Samarra. Many other similar details could be mentioned, the wall paintings probably being the most interesting in this connection. The reliefs of the earlier Assyrian kings were of an intimidating character, and the same may be said of the row of sixty dignitaries painted on the wall beside the throne in Lashkari Bazar. They wear the typical kaftans, held together by girdles with little bundles of chains, like chatelaines, from which hang personal necessities.

THE EMIRATE OF CORDOVA (THE UMAYYADS IN SPAIN)

During the merciless struggle for power between 747 and 750 in which the Umayyads finally had to yield before the might of the 'Abbasids, one of the sons of the last Umayyad caliph managed to escape. If one is to believe the epic tales of this era, the escape might be called a miracle. The partisans of 'Abbas, still in the fanatical intoxication of their victorious battles, did everything in their power to exterminate as many Umayyads as possible. Finally, one of the generals is said to have invited the last eighty survivors of the illustrious Umayyad house to a peace celebration. At the height of the festivities he had his unsuspecting guests put to death, covered up the corpses, and carried on with the banquet. One man

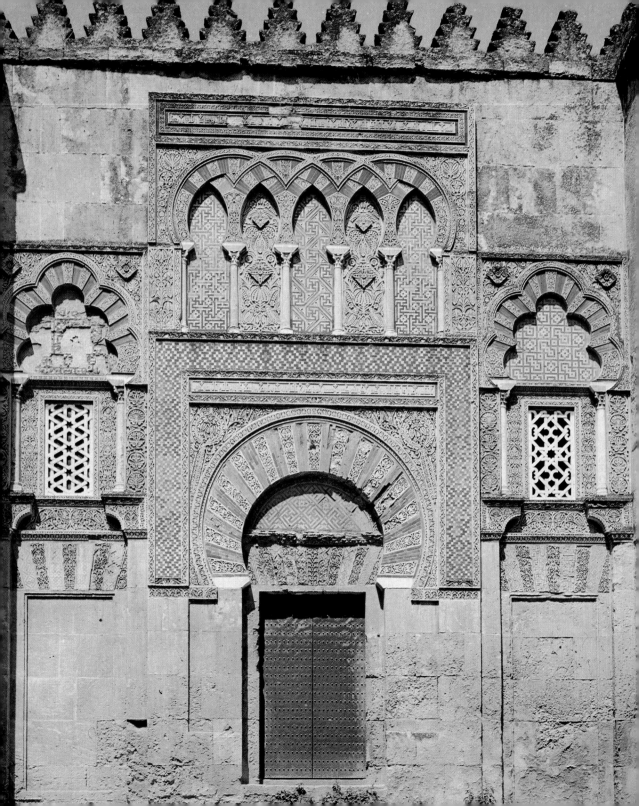

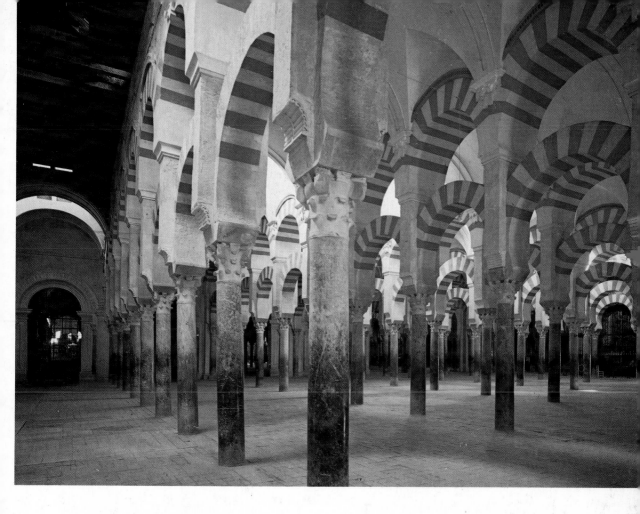

Portal of the Great Mosque in Cordova.
Built by Caliph al-Hakam II, 961–66

Interior of the Great Mosque in Cordova. Begun
by 'Abd ar-Rahman I and enlarged by al-Hakam II

escaped, and he fled to Spain, where, after many hardships, he succeeded in founding a new Umayyad dynasty in 756.

When, after a long journey through North Africa, he finally arrived in Spain, he was by no means welcomed there with open arms, for there had been no thought of establishing a new Arab dynasty. In their triumphant advance, the Arabs had recruited soldiers left and right, and Spain had been largely conquered by Berbers under the leadership of an Arab general. The Berbers, who were no particular friends of the Arabs, therefore had some difficulty in reconciling themselves to the new, self-appointed ruler. 'Abd ar-Rahman I was therefore not proclaimed caliph, but received the title of emir. The title of caliph was claimed by one of his successors, 'Abd ar-Rahman III, in 929. The residence of the new Umayyad line was established in Cordova, a city that was to prove a worthy center of Islamic art and culture.

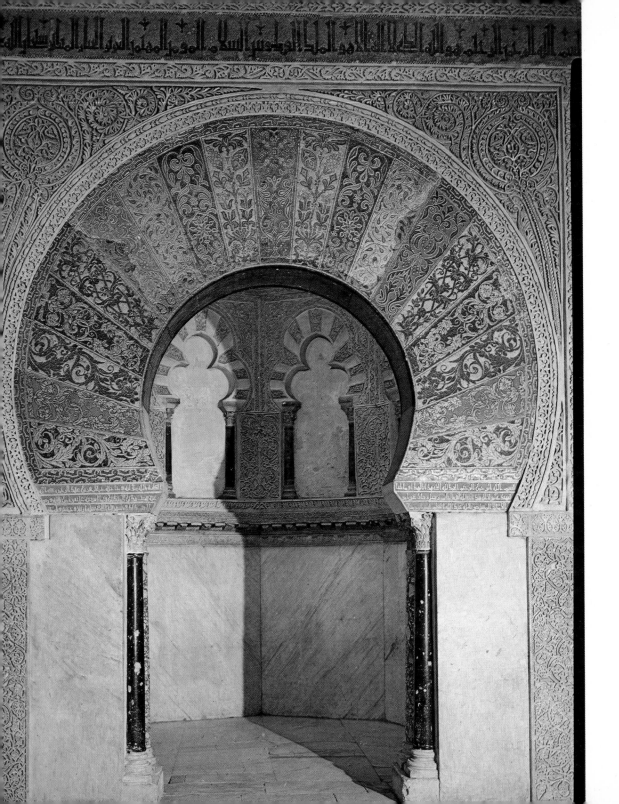

Arch before the *mihrab* in the Great Mosque in Cordova

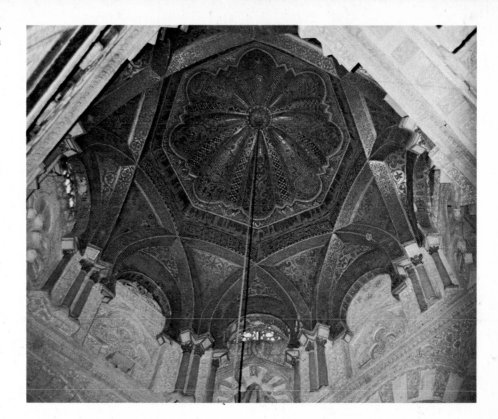

Central dome of the Great Mosque in Cordova. Completed under Caliph al-Hakam II, 965–70

ARCHITECTURE

The Great Mosque of Cordova was begun by 'Abd ar-Rahman I in 785–86. Constructed according to traditional design, it was a rectangular enclosure with an inner courtyard and a sanctuary of eleven aisles. For some reason, the mosque is set exactly north and south, so that the *qiblah* is not oriented on Mecca. In later years, various portions were added to the building. 'Abd ar-Rahman II enlarged the sanctuary lengthwise by the addition of eight columns to each of the original ten rows, so that the *qiblah* wall was moved a considerable distance. Al-Hakam II further extended the mosque toward the south by the addition of twelve more columns to the rows. Al-Hakam spared neither expense nor trouble in the decoration, and—as his predecessor al-Walid had done in Damascus—brought in Byzantine artists from Constantinople for the work. The domes, the frames of the arcades, and the *mihrab* are elaborately ornamented with gold and mosaic. Under the administration of al-Mansur, who was vizier from 976 to the end of the Umayyad Caliphate in 1009, the whole mosque was extended in width, so that it became the third largest in the Islamic world, being exceeded in size only by the two mosques of Samarra.

What Samarra signified for the 'Abbasids, the palace complex of Madinat az-Zahra (now called Córdoba la Vieja), five miles from Cordova, must have meant for the Umayyads. 'Abd ar-Rahman III founded this city on the sloping banks of the Wadi al-Kabir (long valley), which today we know as the Guadalquivir. The walled city was built on three terraces, with the palace standing on the uppermost, gardens and vineyards on the middle one, and the dwelling houses (and also a mosque) on the lowest.

The Spanish Umayyads lived in princely luxury, and numerous fortifications and citadels were built during their rule to defend their prosperity. The oldest of these is the Conventual of Merida, erected by 'Abd ar-Rahman II in 835 near the Guadiana River. This square fortress with rectangular towers at the corners was built of blocks of stone.

ARCHITECTURAL ORNAMENTATION

In contrast to the majority of his colleagues in the Near East, the Spanish architect had stone and marble at his disposal, yet, evidently guided by Eastern influences, especially those of Persia, he made great use of ornamental brickwork. The Umayyads proved themselves unequaled masters in the building of arches, as may be seen from the tiers of double and hexafoil arches in the mosque in Cordova. The capitals are based on the Roman pattern. The decoration, in marble and stucco, is based on classical naturalistic motifs and is most skillfully executed. Finally, we find a purely 'Abbasid element in the floriated Kufic script that occurs both in mosaic and in stone carving in the Great Mosque of Cordova.

Fragments of stucco decoration from the palace
of 'Abd ar-Rahman III at Madinat az-Zahra. 936

Panel, delicately carved with plant motifs,
roughly comparable with the first style of
'Abbasid stucco ornaments in Samarra. Marble.
c. 970. From the side of the *mihrab* in the
Great Mosque of Cordova

ARTS AND CRAFTS

History provides us with many examples of cases in which one man has proved capable of giving an
unexpected direction to the established pattern. During the reign of 'Abd ar-Rahman II (822–50), a fugitive
from Baghdad, the singer Ziryab, arrived and asked him for asylum. At the emir's court, Ziryab obtained
not only protection but also a high position and an immense amount of money. This man, who was truly
a great musical artist, founded, among other things, a conservatoire in Cordova; but his activities extended
far beyond this sphere. He succeeded in introducing the good taste and customs of the court in Baghdad,
founded an institute of beauty, inaugurated a calendar of fashion, and became not only an arbiter on what
should be worn but even on what should be eaten. Ziryab in his day evidently exalted the idolatry of
luxury to a high degree, and may well have been responsible for the 'Abbasid tendencies in Umayyad arts
and crafts.

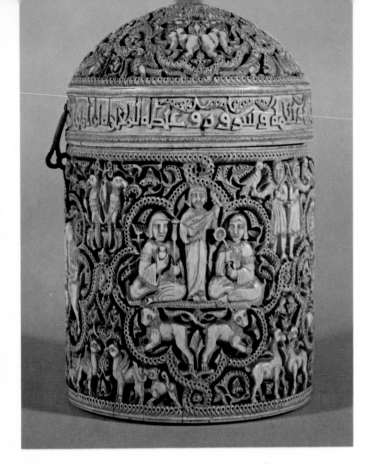

Casket, inscribed with the name of al-Mughiza. Ivory. Dated 968. From Cordova. The Louvre. Paris

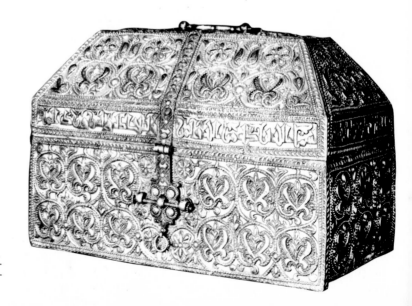

Box, with the name of Hisham II. Jeweled silver. Dated 976. Gerona Cathedral

With regard to pottery, for example, a very large amount of imported ware from Mesopotamia was found in Cordova, only a small quantity of pots, and these of a nature used for everyday purposes, having been supplied by the local kilns. Ivory carving was a thriving craft in Cordova, and is the only one in which the Spanish Umayyads really excelled. Among the most common products were cylindrical and rectangular caskets, carved with an exuberant decoration of palmettes, leaves, animals, and birds, often with a border of Kufic lettering. The 'Abbasid influence is to be found in other craft products also, but out of these elements the western Umayyads created a distinctive style which continued to have its effect in Europe even after that dynasty had expired.

THE FATIMIDS

About the year 909, in the province of Constantine in present-day Algeria, a demagogue proclaimed to every Berber who was willing to listen that only lineal descendants of 'Ali, who had married Muhammad's daughter Fatimah, could legitimately be caliphs. Little difficulty was involved in finding someone who fulfilled the stipulated requirements. With the new caliph in command, the new dynasty of the Fatimids at once proceeded to eliminate the Aghlabids, the reigning dynasty in Tunisia, or Ifriqiyah, as the old Roman province was known at that time. Al-Mahdiyyah, on the Mediterranean coast, was the first capital of the new regime, which for the first sixty years had to struggle to maintain its position under difficult circumstances. In 969, the Fatimids saw their way clear. They drove the Ikhshidids out of Egypt and officially established a new caliphate in rivalry to that of Baghdad. The city of Cairo was founded near the old Fustat, and was to remain their capital until their power came to an end in 1171. In the two centuries of their domination, they may not always have had very able rulers, but as far as art is concerned the Fatimid period proved one of the most superb eras in Egyptian history.

As Berbers by origin, the Fatimids were familiar with the course of events in Spain, and had come to Cairo with certain artistic predilections indirectly influenced by the style of the Spanish Umayyads, probably unaware of how much the latter in their turn had been affected by the art of the 'Abbasids.

ARCHITECTURE

The earliest of the Fatimid mosques in Cairo, that of al-Azhar (970–72), has remained largely unaltered. There have indeed been certain structural changes and additions, such as the main gate in the twelfth century, but the sanctuary has been preserved in its original form. The pointed arches of the facade and the two domes in front of the *mihrab* recall the Sidi 'Uqbah Mosque in Qairawan. The second great monument of the Fatimid period in Cairo is the mosque of al-Hakim, which was built between 990 and 1013 in imitation of Ibn Tulun's mosque. The inner court is surrounded by open colonnades, with five aisles in a slightly raised transept on the *qiblah* side, and a small brick dome over the *mihrab*. On either side of the great main gate, at the corners of the huge quadrangle, stand two tall minarets, one round and one rectangular, with an octagonal upper portion.

A third mosque which we should mention is that of al-Aqmar, which was completed in 1125. Its most striking architectural feature is the facade, although, owing to modern urban development, this is now unfortunately hidden behind a row of houses. The entrance gateway, with its rectangular doorpost, is surmounted by an intersected dome, boldly decorated with projecting ribs, first running in horizontal lines and then radiating upward from a decorative medallion. The walls enclosing this entrance on either side are built up in three superimposed rows containing niches, the central row having a stalactite decoration

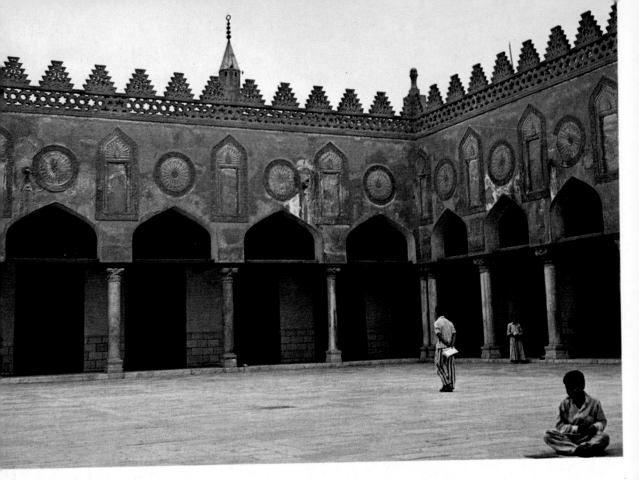

Inner court of the al-Azhar Mosque, Cairo. Founded 970

and the top and bottom rows being ornamented with shell motifs. The Fatimids probably elaborated this style, which was completely new to Egypt, from the example of their first mosque in the old capital of al-Mahdiyyah in Tunisia.

The Fatimids were active builders, for, as well as several other mosques such as the as-Salih Tala'i' and the burial mosque of al-Guyushi, there are still other mausoleums such as the Sab'a Banat (the seven maidens), the tomb of the brothers of Yusuf (Joseph), the Ikhwat, the tomb of Ga'fari, the tomb of Sayida Ruqayyah, etc.

Obviously, the architects had also to devote a good deal of attention to military and secular constructions. We are reminded of the former by the Bab al-Futuh, one of the magnificent gates with guardian towers built to protect the old walled city. These fortifications after the Byzantine model were erected at the time when the Seljuks captured Jerusalem. It was not then realized that, a few years later, protection of this sort might be needed against the Crusaders, although, according to the Muslims, they were not particularly alarmed on this account: in their eyes, the Crusades were mere skirmishes in which from time to time they were obliged to intervene. One of their savants expressed this feeling even more forthrightly, saying that, for Islam, the Crusades signified no more than a tick on a camel's back that clings for a little while and then drops off, almost unnoticed by the camel.

As for the Fatimid palaces in Cairo, we have to rely on what information the historians can give us, for not even ruins now remain to give us any tangible evidence. Two great palaces once stood in the city, flanking a large public square; one of them was completed in 973 and the other at the turn of the tenth–eleventh centuries. Elsewhere in the Fatimid dominions, in Algeria and Tunisia among other places, there are some important details of Fatimid secular architecture, but the most interesting examples are to be found in Sicily, where one can see the Fatimid style mirrored in the palaces of the Norman kings.

ARCHITECTURAL ORNAMENTATION

Fatimid buildings are striking in their choice and application of decorative elements, which differ somewhat from the ideas current at that time on spatial arrangement and sobriety of decor. Without being altogether original, the Fatimids made full use of motifs derived from elsewhere, achieving revolutionary results. In this respect, a very good comparison is afforded between the facade of the al-Hakim Mosque in Cairo and the roughly contemporary buildings in Madinat az-Zahra near Cordova. In the stucco decoration of the interiors, we can also see how many elements of Moorish, 'Abbasid, and Tulunid origin have been brought together, which later were to grow into a more individual style. The decorative effect is greatly enhanced by a refined use of "interlaced Kufic" script against a background of arabesques.

Inner court of the al-Aqmar Mosque, Cairo. Completed 1125

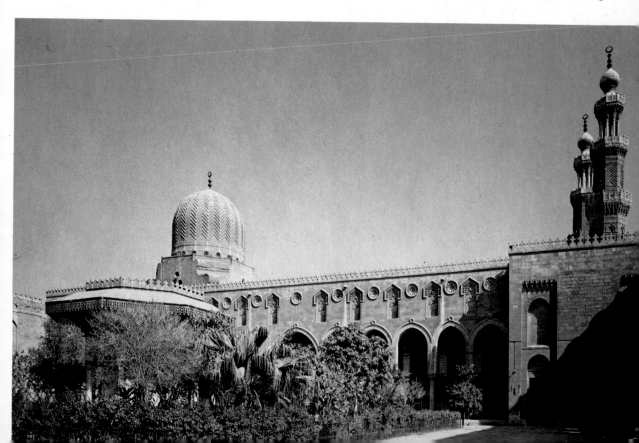

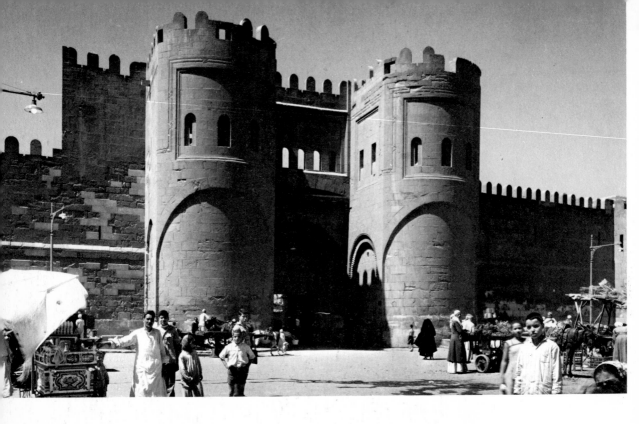

The use of wood carving in the "beveled" style harks back to the Tulunids. Wood carving seems to have been very popular with the Fatimids, for in addition to doors, cupboards, and the indispensable *minbars*, they also introduced the transportable *mihrab*, carved entirely in wood. Fatimid wood carving at its most glorious is found in the stalactite ceiling of the Palatine Chapel in Palermo. Here, every thought of simplicity was forgotten in order to give an exuberant contrast with the Christian mosaics that cover the walls. In the nave of the Palatine Chapel, the stalactite vault changes into a coffered ceiling divided into eight-pointed stars with painted and gilded surfaces. The themes of these paintings are similar to those found in sculpture: texts in fine lettering, arabesques, animal motifs, and scrolls, not forgetting human figures. In one of these paintings, the founder of the chapel, the Norman king Roger II, is believed to be depicted, sitting with crossed legs.

CERAMICS

In the potteries of Fustat, which had been very active in the time of the Tulunids, the wheels turned even faster in the Fatimid period. The decline of production in Baghdad gave the Fatimids an opportunity of monopolizing pottery making, which they had never neglected, although in quality they did not surpass their predecessors. The luster technique which had been so popular in Baghdad was also applied in Cairo, but the luster, in many shades of brown, was fired upon an underlying tin glaze which was somewhat more coarse and gray. The Egyptian luster painters sometimes signed their work, as is known from some of the numerous bases of bowls and jugs excavated in Fustat. It is not out of the question that some of the master potters at the former court of Samarra went, after its downfall, to seek their fortune in Egypt.

◄ The Bab al-Futuh, Cairo. Last quarter of eleventh century

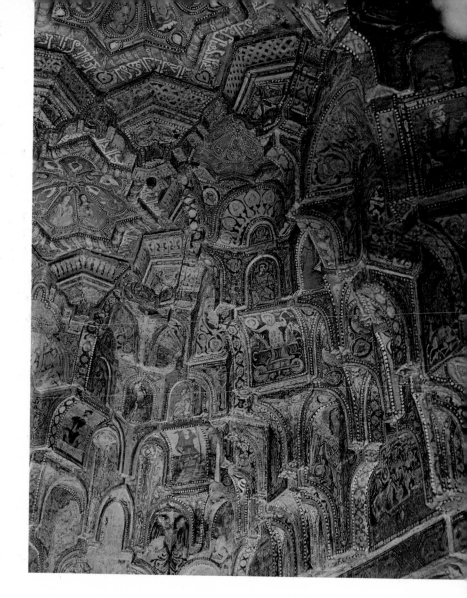

Ceiling of the Palatine Chapel. Wood, with stalactite ornament, painted on every facet. c. 1140. Palermo

The great number of pottery fragments that were found, and are still being found, in Fustat show that lusterware was greatly in demand. The decoration was adapted to the cosmopolitan atmosphere where Byzantines, Crusaders, and Arabs came into contact with one another, while China still remained a source of inspiration in this field. Among the most productive craftsmen was the potter Sa'd, whose work was famous over a wide area and even had its imitators.

Other techniques than luster painting were also practiced in the Fatimid period. Decorations incised in relief and covered with a layer of glaze, after the Persian manner, were fashionable. This *sgraffito* technique outlived the Fatimid dynasty and remained in use until the fourteenth century; it was enthusiastically received in Europe, particularly in Italy, where it won a place for itself alongside majolica.

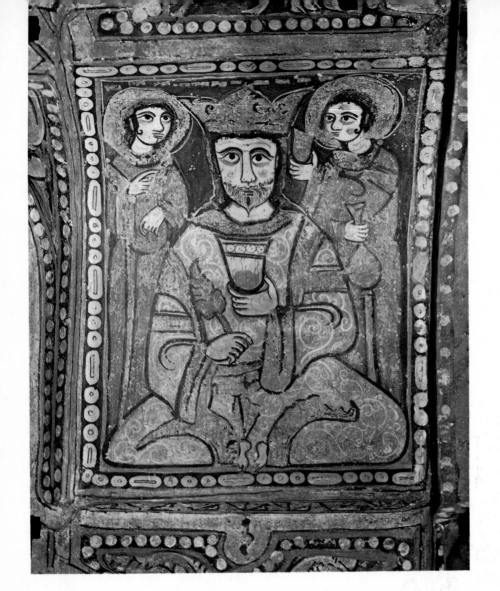

Detail of the ceiling in the Palatine Chapel, Palermo, presumably portraying its founder, the Norman king Roger II

Finally, Egypt was an important producer of unglazed earthenware. In this technique, in which relief decorations were frequently employed, the potter expressed his artistry in the forms he created. Among them we find waterjugs with perforated filters, lamps, dies, and a remarkable kind of small, egg-shaped bottle which is often called a "hand grenade." No evidence for this interesting hypothesis has ever been furnished, since burned-out fragments which would indicate a burst grenade have never been found. The function of these bottles is more likely to have been that of storing some costly or volatile substance. Examples of the same type of flask have even been found in painted glass.

GLASS

Another branch of applied art in which the Fatimids excelled was glass making, including high relief decorations in cut glass and in carved rock crystal. Evidently the demand for decorative glass became so

A so-called Hedwig's glass. Cut glass with engraved decoration. Fatimid work, twelfth century. Probably from Egypt. Rijksmuseum, Amsterdam

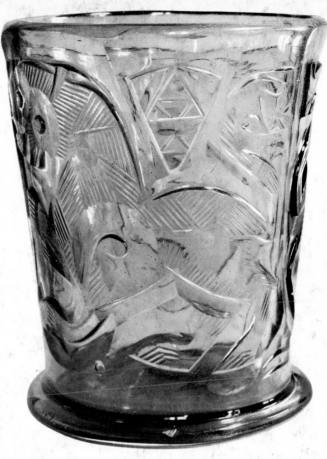

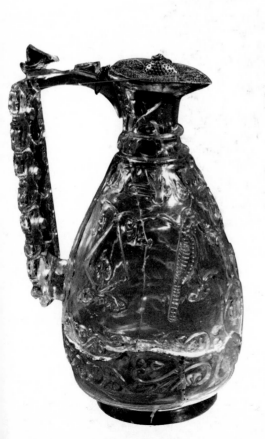

Ewer. Carved rock crystal. Eleventh century. From Egypt. Formerly in the Treasury of St.-Denis. The Louvre, Paris

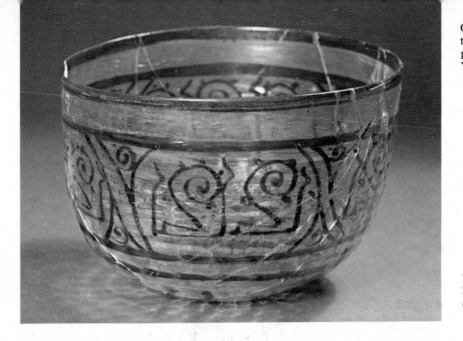

great that a new technique was developed to approximate the effect of cut and ground glass. This was the so-called impression technique, in which the newly blown bottles, dishes, bowls, and goblets were impressed with a sort of stamp which left a relief decoration on the outer wall of the object. It is hardly necessary to say that this simple mode of decoration could not stand comparison with the ornaments cut or carved either in rock crystal or in a thick mass of glass. Among the principal motifs were scrolls, animals, and especially birds. Of the thousands of objects of this kind which once filled the treasuries of the rich Fatimid caliphs, comparatively few good examples have found their way into the museums and other collections of the world. A large group of these has been given the name of "Hedwig's glasses," since it

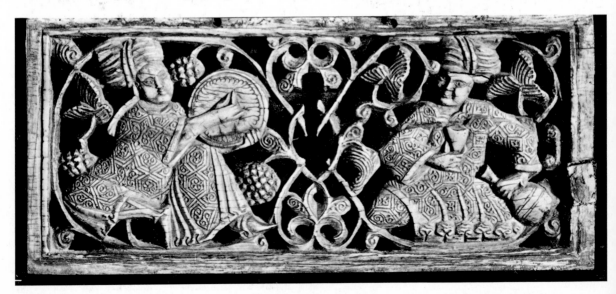

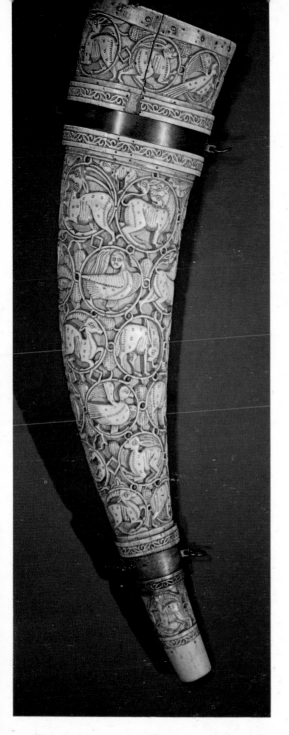

was in such a glass as this that Saint Hedwig of Silesia is reputed to have changed water into wine. Eventually, the glassblowers became expert in making versions of goblets, bottles, and lamps in excessively thin and delicate glass—objects which evidently were more for show than for daily use.

Door panel. Carved wood. Eleventh century. From Egypt. Museum of Islamic Art, Cairo

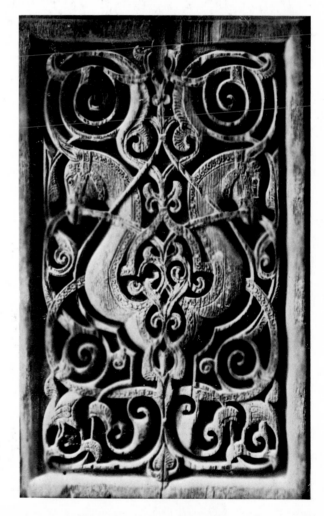

Openwork panel from a small box or casket. Ivory. Eleventh century. From Egypt. Museo Nazionale, Florence

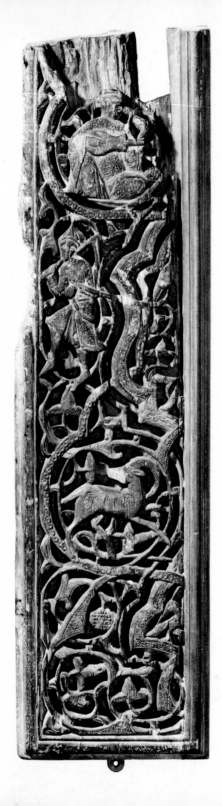

Carved panel. Wood. Tenth century. From a former palace of the Fatimids in Cairo. The Louvre, Paris

Griffin, with engraved motifs and script decoration. Bronze, height c. 40″. Eleventh–twelfth century. From Egypt. Campo Santo, Pisa

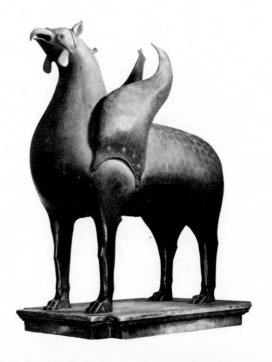

Aquamanile in the form of a peacock, inscribed on the breast: "Opus Salomonis erat" and "Made by 'Abd al-Malik, the Christian." Bronze. Fatimid, eleventh century. Probably made in Sicily. The Louvre, Paris

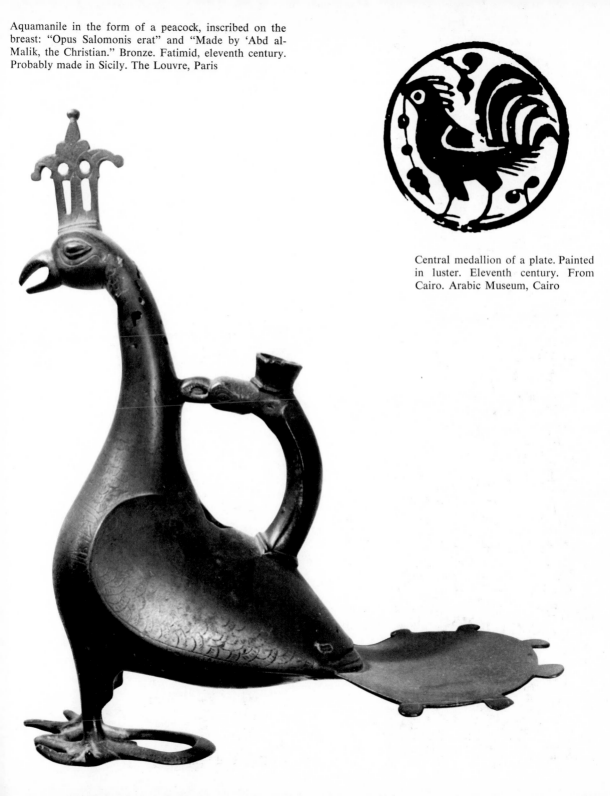

Central medallion of a plate. Painted in luster. Eleventh century. From Cairo. Arabic Museum, Cairo

IVORY

The Fatimids' skill in wood carving, so clearly demonstrated in the decoration of mosques, palaces, and houses, would lead one to expect that ivory carving would have stood in similar high esteem. However, although plenty of Fatimid ivory has been found, for the most part it is attributable to South Italian, rather than Egyptian, workmanship.

Among the most striking objects is the oliphant, which played such an important role in early European literature. These great horns were made both in Egypt and in southern Italy and Sicily, and from the end of the eleventh century gradually found their way into the Christian countries. Originally they were ornamented only at the broad end, but soon a decoration covering the whole surface came to be preferred. The motifs mainly consisted of animal and human figures enclosed in medallions of twining tendrils or geometric patterns. Sometimes the figures playfully step out of their particular framework into the next medallion.

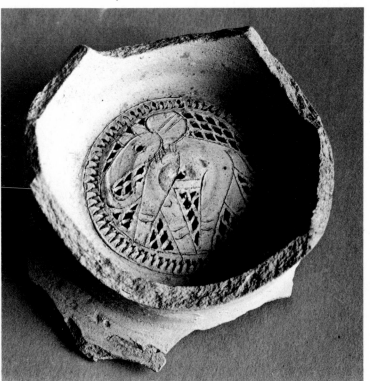

▲
Stamps for marking bread. Pottery. Eleventh–twelfth century. From Egypt. Staatliche Museen, Berlin

◀ Filter from the neck of a bottle. Eleventh century. From Cairo. Haags Gemeente-museum, The Hague

Bowl, with luster painting of a Coptic priest swinging a censer, signed by the potter Sa'd. Diameter 8³/₄". Beginning of twelfth century. From Egypt. Victoria & Albert Museum, London

Jar. Earthenware with luster decoration, height 12⁵/₈". Beginning of twelfth century. From Egypt. Victoria & Albert Museum, London

As well as these objects, the ivory carvers also made numerous pyxes and rectangular caskets. The decorations included hunting scenes, animals in combat, and occasionally genre scenes, which were carved on the flat sides of the casket. We also find plaques of openwork carving mounted on a ground of smoothly polished ivory. At a later stage, carving was omitted altogether in favor of painting the polished surfaces.

METALWORK

Let us first consider a base metal, or rather an alloy of metals, bronze. The Fatimids' use of bronze for decorative objects initiated new features in Islamic craftsmanship. Early Egyptian bronzework had been smoothly cast, but the Fatimids employed a light engraving technique, in which we once more find animal medallions together with benedictions and quotations from the Koran. The repertoire of forms known in ceramic ornament is augmented in bronze, and we find aquamaniles and incense burners cast in the shape of fabulous beasts, as well as dishes, candlesticks, and door knockers which, in one manner or another, usually included an animal in the design. The most famous example of Fatimid bronze casting is probably the griffin, more than three feet in height, preserved in the Campo Santo in Pisa. This combines the best qualities of the Fatimid bronzes, which, however, were not of the highest aesthetic distinction. The purpose of this splendid beast is not quite clear, since it is too big for an ordinary incense burner, yet it does not appear to be a complete aquamanile.

As in the court of previous caliphs, the treasuries of the Fatimids were doubtless filled with objects of precious metals and gems; but in the centuries that followed, countless ornaments were to be assigned to the melting pot. A number of enameled plaques are all that has survived from this glorious period.

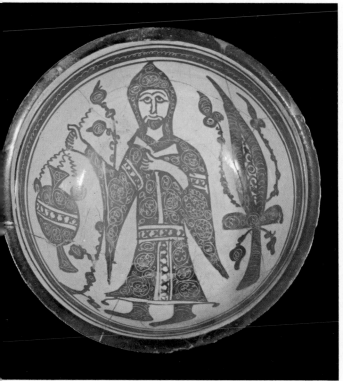

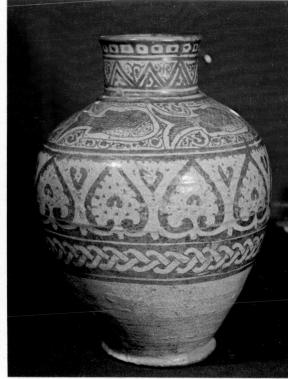

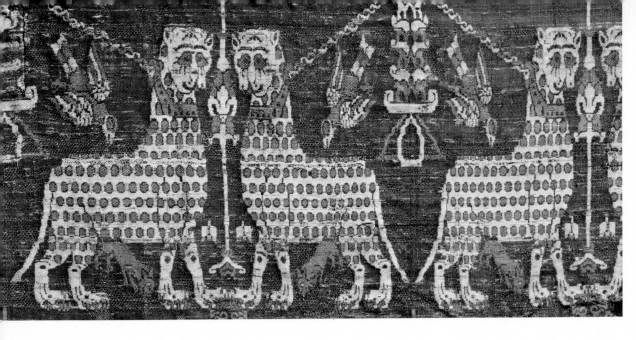

Woven fragment with repeat pattern of lionesses attacked by birds. Silk. Eleventh century. From Egypt. The Louvre, Paris

Fragment of a "Tiraz" border. Silk embroidered on linen. Twelfth century. From Egypt. Kunstgewerbemuseum, Berlin

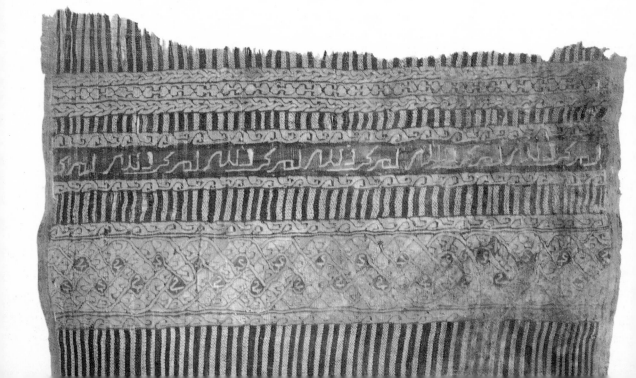

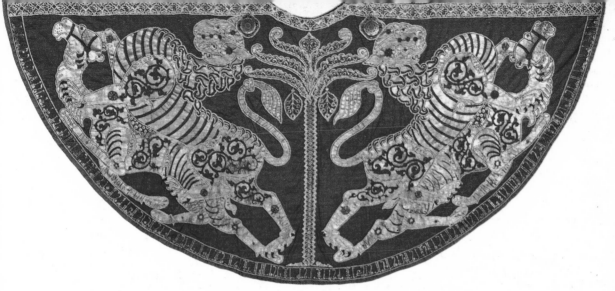

Coronation mantle of the Holy Roman Emperors. Embroidered with gold and colored silks on red twill. 1133. Hofburg Treasury, Vienna

TEXTILES

Under this heading are included many techniques which flourished during the Fatimid dynasty. The textile industry has a complex history from its genesis in Pharaonic times to the Fatimid period, where we find a great quantity of Coptic material, not all of it Christian, together with purely Islamic products. In other branches of arts and crafts we have seen to what extent the previous 'Abbasid domination had exerted its influence on the Fatimids. Here again, we are confronted with this influence, and can observe a certain continuity in the organization and administration of the weaving mills. It was still the rule that robes of honor might only be worn by native or foreign princes or, in exceptional cases, by high dignitaries, as a reward of the caliph or the governor acting in his name. Obviously the intendant of the state factories was therefore an important and highly regarded personage, having all the factories in the land under his control, and standing at the head of a personnel which numbered thousands. He was in charge of the production of everything from simple linen shirts to heavily embroidered robes of state. All the fabrics that left the state factories were marked with a signature stamp showing their provenance. Garments were adorned with bands of silk, elegantly woven or embroidered with Kufic inscriptions. Thus the "Tiraz" textiles (the fabrics of the court factory), by means of the dates and titles which were often inscribed on their silk borders, were fairly easy to distinguish from the local production, where Coptic and Byzantine influences put up the fiercest competition. The Tiraz textiles excelled in quality, and were so highly esteemed that they found their way into the treasuries of many Western European cathedrals and castles, where a number of specimens are still to be found today. In Sicily they specialized in lacemaking, gold and silver lace, silk bands, and complicated embroidery being used to embellish princely garments. As specimens of the various techniques, we might mention the so-called Shroud of the Christ of Cadouin in Périgord, inscribed with the name of al-Must'ali (1094–1101), or the still more famous "Veil of St. Anne," now in the cathedral of Apt in Vaucluse. The coronation mantle of the Holy Roman Emperors, preserved in the treasury in Vienna, may serve as the most representative example of embroidery. The date and inscription show that this mantle was made for King Roger II in Palermo in A.H. 528 (A.D. 1134).

Another decorative technique, which had been in use since ancient times but which experienced a certain revival in the Fatimid period, was the process of resist-dyeing. Certain parts of the cloths were covered with a fluid-resistant material such as wax and then completely immersed in a dye. In this way a pattern was obtained, either positive in the dye color or negative by its absence. In modern times this technique is still to be found in Indonesia, where it goes by the name of *batik*.

THE SELJUKS

When discussing the Buwaihids, we stated that their dominant position in Iran was taken over by a new line. The Turkoman nomads who, under the name of Seljuks, had invaded Persia from Bukhara, were not long in founding a kingdom there. These Seljuks were the people who barred the way to Fatimid political expansion eastward. As, in principle, their predecessors had done, the Seljuks supported the 'Abbasid caliph, and in 1055 one of their leaders even received the title of sultan from the caliph's own hands. The 'Abbasid acceptance caused religious dissension, but did not result in any deep rift in the cultural field; on the contrary, Fatimids and Seljuks stood so close to one another in certain branches of art that in many cases it is difficult to decide the source of particular objects. The Turks no longer played the minor and unappreciated role they had held on their arrival at the 'Abbasid court. Theirs was the last great empire before the Mongol invasions. In 1078, the Seljuks wrested Anatolia from the Byzantines and established a flourishing kingdom there, independent of Iran. Just at the time when the armies of Jenghiz Khan were devastating Persia, the cultural life of the Seljuks in Anatolia reached its zenith. For a long time before this, unity had ceased to reign among the Seljuk rulers of Iran. On the death of Sultan Sanjar in 1157, the central power was split up. The members of the dominant family quarreled among themselves for control of Iran, while Iraq and Syria were placed under the rule of Atabegs, or Regents. So there came into existence various more or less independent dynasties which left their own impression on art. In the second half of the twelfth century, Salah ad-Din Ayyub (known to the West as Saladin) was sent to Egypt as representative of Nur ad-Din Mahmud ibn Zangi, Atabeg of Syria, to put an end to the Fatimid rule, and he quickly succeeded in breathing new life into that culturally dormant region.

To sum up, we can divide the age of Seljuk supremacy into three important streams: a) The Seljuks in Persia, between 1050 and 1250; b) The Western Seljuks, or the Seljuks of Rum, as they called themselves, who flourished in Asia Minor between the end of the eleventh and the beginning of the fourteenth century; c) The Ayyubids, who between 1171 and 1250 gave fresh inspiration to the old Fatimid Empire. We shall consider the art of each of these streams in turn.

THE SELJUKS IN PERSIA

ARCHITECTURE

Great changes involving earlier building traditions can first be observed in sacred architecture. In the new design of the mosque, we find ideas which hark back not only to the old Arabian model but which reach still further back to the Sassanian palaces. The courtyard is bounded by four great *iwans*, of which the one before the place of prayer is larger than the others. These *iwans* are flanked by walls containing two superimposed rows of small *iwans*. This conception of the mosque, however, must be considered in conjunction with a new type of building, the so-called madrasah, which we might compare with a seminary or theological college. The great vizier Nizam al-Mulk founded a number of these madrasahs in Nishapur, in Tus, and in Baghdad, and it was in building such schools that the old architectural forms which we

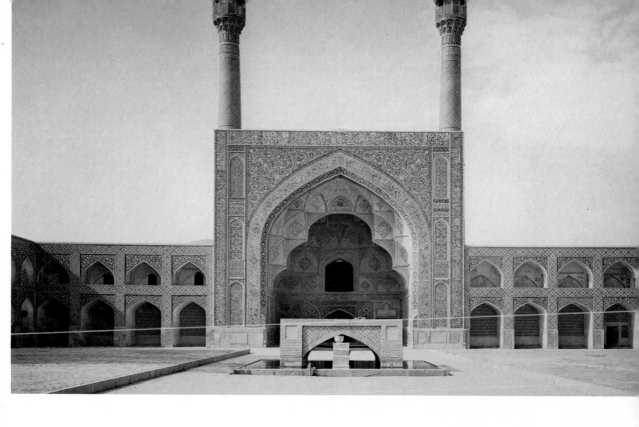

The great *iwan* in the south side of the courtyard
of the Masjid-i Jami' in Isfahan. Begun 1088–89,
tilework later

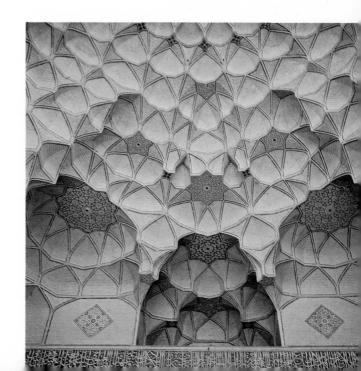

Detail of the stalactite vault of the *iwan* above

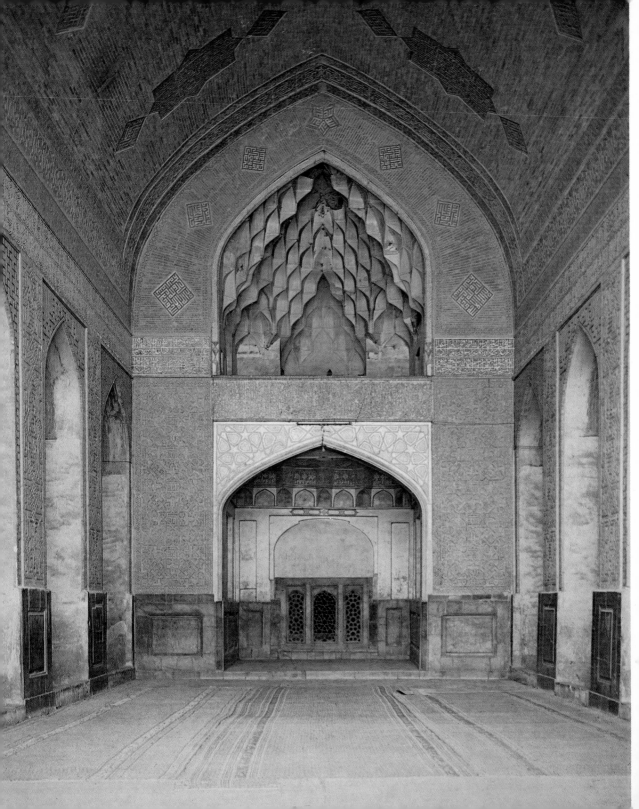

◀ Interior of the Masjid-i Jami',
Isfahan

So-called Mausoleum of Sitta
Zubaida, wife of the illustrious
Harun ar-Rashid. Thirteenth
century. Baghdad. There is
some doubt as to the authenti-
city of this tomb, since the
village of Kazimain, near
Baghdad, also claims to be the
last resting-place of this queen

find later in the new type of mosque were first adopted and applied. Very nearly the only essential differ-
ence lay in the fact that, in the madrasah, the *iwans* gave access to the students' cells, while, in the
mosque, they ended in blind niches, behind which were the colonnades.

Of the mosques, the lovely Masjid-i Jami' in Isfahan is the most important. Malik Shah began the
building of this mosque in 1089, on the site of a Kufah-type mosque of the tenth century. The vizier
Nizam al-Mulk, who died in 1092, was responsible for the monumental domed chambers and the great
iwan with the tall minarets which can still be seen today. We find other examples of *iwan* mosques in
Gulpayagan, in Zaware, and in Ardistan, the first two having been constructed at the beginning of the
twelfth century and the last in the second half of that century.

New features are also to be observed in the construction of burial monuments, among which the first
distinction to be made is between those having a tower and those with a dome. Most of the domed tombs
have a circular or polygonal plan, only a few being rectangular, such as that attributed to the famous
theologian Ghazali, who died in Tus in 1111, and that of Sultan Sanjar in Merv, which was erected in
1157. These are true domed tombs, being covered with a dome built with a drum on the outside and
pendentives on the inside in accordance with basic architectural principles.

The mausoleums with a multiangular plan, however, are crowned with a conical roof or a small conical
tower on a flat roof, so that they have a certain outward resemblance to the tomb towers. The tomb
towers conceal, as it were, the dome construction, for the interior is covered by an inner dome which,
on the outside, is hidden by a conical roof.

In some cases these tomb towers (known as *gunbads* or *türbes*) have two stories, a fact that may be
connected with the burial ritual, which the nomads of Central Asia used to carry out in two stages. Of the

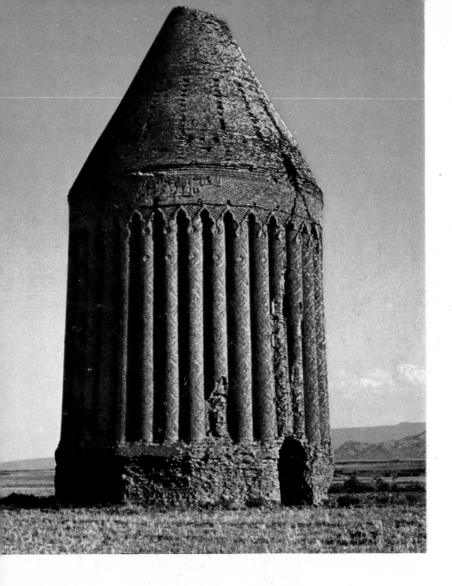

burial of Attila, the notorious king of the Huns, it is said that his body was first laid out in a tent of costly Chinese silk, around which his followers gathered to perform the ceremonial lamentations, singing and reciting his heroic deeds. Not until these duties had been carried out in full was the dead king interred, in a combination of three coffins, one of iron, one of silver, and the innermost of gold. Customs of this kind have given rise to the hypothesis that the upper story of the Seljuk tomb tower corresponds to the funeral tent, and the lower one to the sarcophagus, the actual tomb. The outward appearance of the tomb towers sometimes gives added strength to this argument; the magnificent *gunbad* in Radkan in East Persia, for example, strongly calls to mind the prototype of the tent of the nomads of Central Asia.

As for secular architecture, little has come down to us, either of military constructions (although the citadels of Damascus and Aleppo do recall memories of the Seljuks) or of the palaces which once stood in Nishapur and Merv.

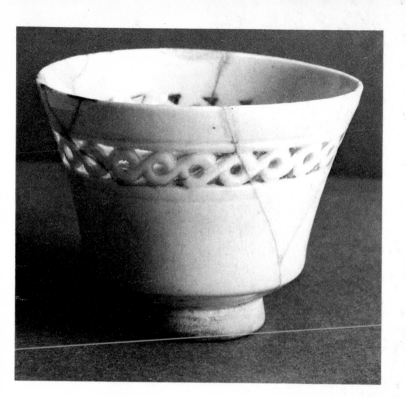

Small bowl. White porcelain imitating the Chinese *ying-ching* style. First half of twelfth century. From Persia. Haags Gemeentemuseum, The Hague

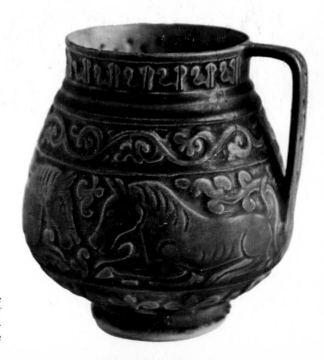

Jug, with two recumbent horses on the obverse; on the reverse, two running lions. Earthenware, with relief decoration under blue glaze, height 5¹/₂″. Twelfth century. From Persia. Haags Gemeentemuseum, The Hague

Dish, depicting dancers and hyenas. *Lakabi* (painted) ware, with relief decoration under polychrome glazes, diameter 16¹/₈″. Twelfth century. From Persia. National Gallery of Victoria, Melbourne. This was a luxury ware necessitating great care in the manufacture to ensure that the colored glazes did not run into one another and it was thus restricted in quantity

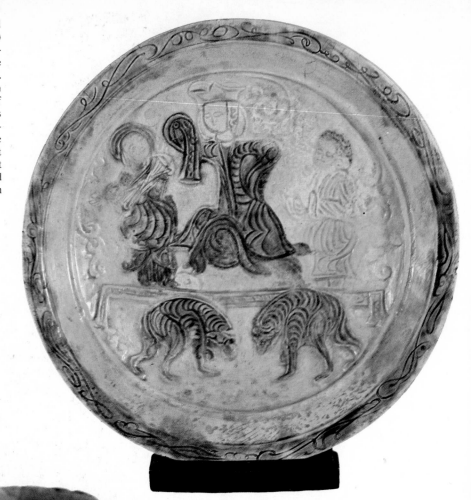

Bowl. Earthenware, painted in colors and gold and fixed by various firings, in the so-called *mina'i* (enamel) technique. Twelfth–thirteenth century. From Persia. Teheran Museum

Small jug, with figures in silhouette painting. Twelfth century. From Persia. Haags Gemeentemuseum, The Hague

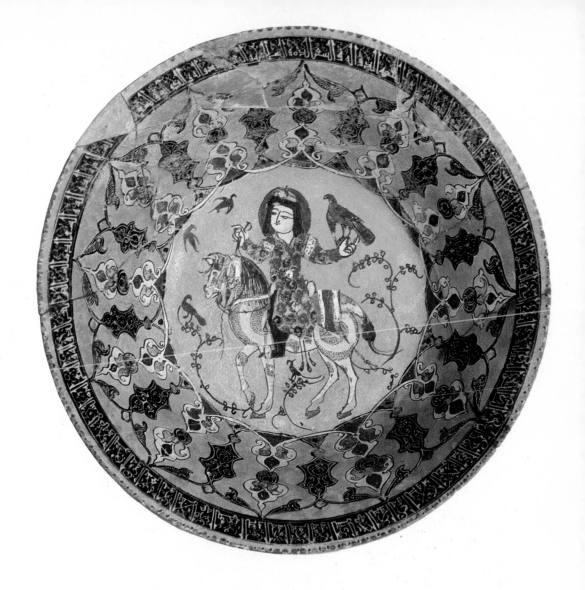

ARCHITECTURAL ORNAMENTATION

As we have seen, the *iwan* played a dominant role in Seljuk architecture. At first, fairly plain lines and pointed arches were favored, but soon a more voluptuous "baroque" style was desired, resulting in arched roofs with stalactite ornamentation. We find this more exuberant style echoed in other decorative techniques. Whole allegorical scenes were sometimes represented in stucco, but of these little has been preserved. Portraits of princes and courtiers have been found in Rayy, albeit fragmentary, which convey an impression of the decorative ideas of the time.

A new element of architectural ornament is found in the Seljuks' use of glazed bricks and tiles, both for interior and exterior decoration. The great production center was the city of Kashan, from where decorative tiles, known as *Kashani*, were distributed far and wide through the Near East. The tiles were often made in the luster technique, which gave an iridescent effect in the light of the sun, especially when they

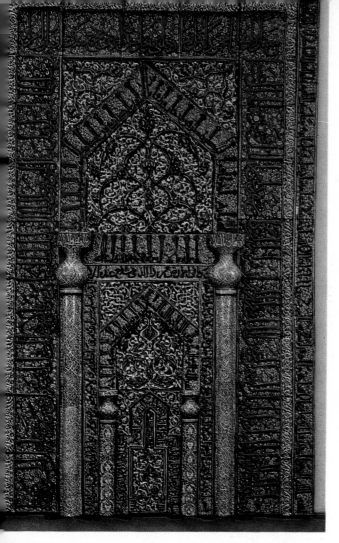

adorned the outside of a building. The color range of the early period consisted of black, brown, and dark- and light-blue. A complete *mihrab* in luster tiles from the Maydan Mosque of Kashan (1226) has been preserved, and is now in the State Museums in East Berlin.

CERAMICS

Pottery belongs, and always has belonged, to the most important products of the minor arts. Ever since its invention, it has provided useful and indispensable objects which enable us to follow closely the course of history, and which reflect the character of a people or a civilization. Obviously the insights that it gives will be more vivid on one occasion rather than another, according to material circumstances. In the case of the Persian Seljuks, however, we have an unparalleled example of numerous factors involved in ceramic art, and we are given an impression of the period which goes far beyond the wares themselves. Apart from the striking beauty of certain forms, it is the decoration in particular which can sometimes lead us to

Incense burner in the form of a stylized animal. Bronze, height 14″. Twelfth century. From Persia. Cleveland Museum of Art

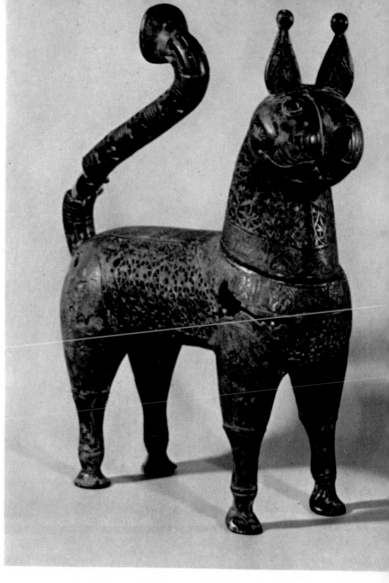

realms which have nothing to do with the object itself. By means of decorative script we are introduced to literature; in epic and lyric writing we learn something of commerce and history; we discover the imitation of motifs and techniques of other peoples; and finally we are presented with a choice of objects made in at least five different main techniques.

Architectural ornament has familiarized us with Kufic script in its several rectangular variations, such as the monumental and the floriated Kufic. Under the Seljuks, we find a new script of graceful and cursive lines, which is known as *Naskhi*. Before long the inspiration of this script was seen in new forms of calligraphy which appeared, either as pure decoration or as actual words of benediction, on bowls, jugs, and dishes. First they employed the *sgraffito* technique, which we know from the workshops of Rayy, Aghkand, Amul, and Yasukhand. Its coarse character gives little cause for satisfaction, but the Seljuk potters went on to assimilate foreign influences and to enlarge their decorative range with that of the

stuccoworkers and the tapestry weavers. Chinese stoneware and porcelain, which had been imported into the Near East since the days of the T'ang dynasty (618–906), had already exerted some influence on Islamic artists. During the Sung dynasty, when in China the poets praised the potter's mastery of his art, the Seljuks succumbed to the enchantment and imitated the white *ying-ching* porcelain. Compared with the delicate, sometimes almost translucent, material produced by the Chinese, the Persians' was a much cruder imitation, and yet is characterized by a certain delicacy of its own. In fact, Islamic pottery possesses a quality which is of a more intrinsic value than that of the Chinese, which attracts the eye mainly through its outward appearance. The difference is to be found in a religious conception: the Muslim made his product to the best of his ability, with the knowledge that perfection is reserved for Allah alone; the Chinese attempted to give his work, by outward perfection, as much inner meaning as possible for the emperor. As well as imitating the material, the potters at first also adopted motifs from the *ying-ching* and *ting* designs. Sometimes they strove after an openwork effect by making patterns of holes in the wall of the vessel, but, when this was immersed, glaze remained clinging to the holes, resulting in a pattern that was transparent but not open. From white, they proceeded to monochrome engraved decorations, using cobalt blue, turquoise, and a reddish color. The old and well-tried method of appliqué, in which a previously molded ornament was laid on the wall of the vessel, was also employed, particularly for decorative tiles.

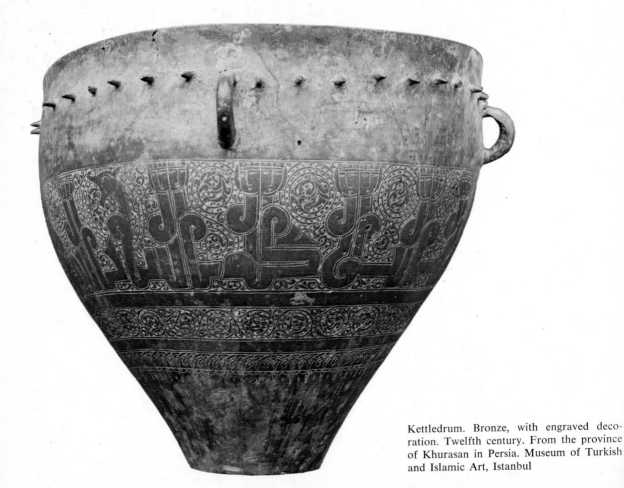

Kettledrum. Bronze, with engraved decoration. Twelfth century. From the province of Khurasan in Persia. Museum of Turkish and Islamic Art, Istanbul

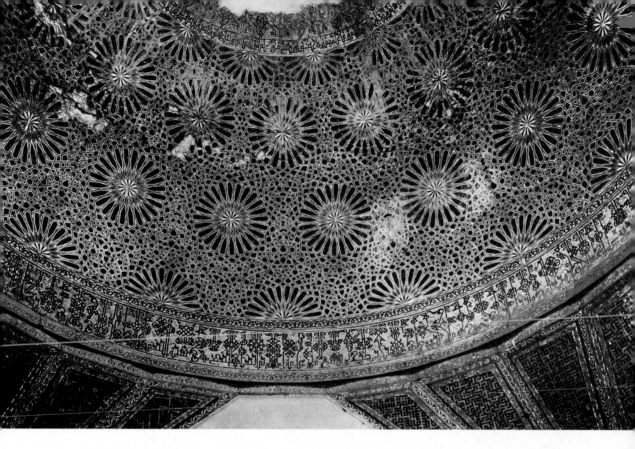

Detail of the dome of the Büyük Karatay Madrasah, Konya, with tile mosaics in deep-blue colors with gold. 1252

The great center of production, supplying the whole of North Persia with pottery and also exporting it further afield, was Rayy, now a city of ruins not far from Teheran. Immediately next in importance was Kashan. Both centers excelled in the difficult manufacture of *lakabi* ware. *Lakabi* means "painted," and this ware is in fact an offspring of the two types we have just mentioned: the engraved or carved white, and the monochrome pottery. The figures—men or animals or both together—were carved in the soft earthenware and then the areas in relief were painted in various colors as desired, in blue, yellow, green, and aubergine. A cloisonné technique prevented the colors running into one another. A final technique in this group of engraved or carved pottery is the silhouette type, in which knife and brush were used in making the decoration, so that the black-painted figures stood clearly defined under the glaze.

Given the Seljuks' sensibility to light and color, it is not surprising that the luster technique, which we have met already in the Fatimid workshops, found a ready acceptance in Persia and flourished once more in the cities of Rayy and Kashan. The lusterware that Rayy first produced still showed elements of Fatimid influence, but Kashan, which began production somewhat later, set up a completely independent school. We have already mentioned the extent to which Kashan tiles were used in Seljuk architectural ornament. On the other hand, it was Rayy that took first place in the production of lusterware, both in quality and quantity. The decorations on vessels and tiles included complete poems and illustrations—among them

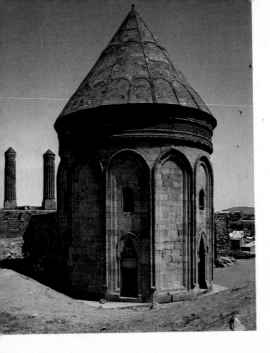

Türbe at Erzurum, with the Çifte Minare (twin minarets) in the background. Thirteenth century

The Çifte Minare and the Madrasah of Khwand Hatun, daughter of 'Ala' ud-Din Keyqubad II, who built this madrasah for her in 1253 at Erzurum

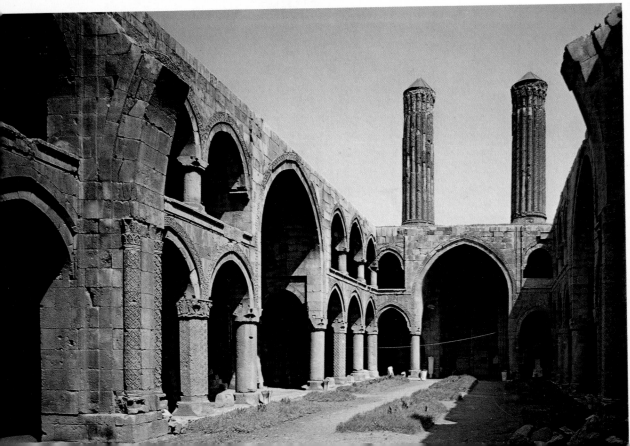

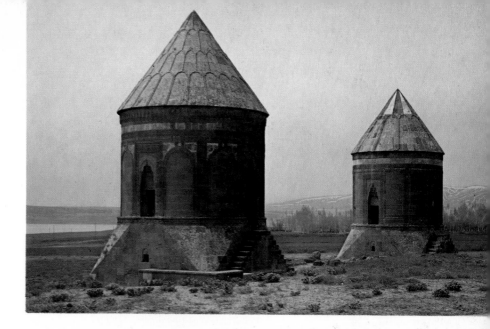

Gunbads, or tomb towers, on the shores of Lake Van; in the foreground that of Bughatay Agha, dated 1281

scenes from the *Ruba'iyyat* of 'Umar Khayyam or the poems of Nizami, such as portrayals of Prince Khusrau and his beloved Shirin, all rendered with the completeness of illustrative paintings. This style continued into the fourteenth century.

The store of techniques was by no means exhausted with this. Since painted scenes were so popular, the potters advanced further in the manipulation of colors and design, producing veritable miniatures in the *min'ai*, or enamel, technique. The palette was extended to seven colors. The vessels were painted in purple or green, under or on the wet glaze, and then fired. Black outlines were added and details filled in with the other colors, a second glaze was applied, and the colors fixed by a second firing. Literary subjects were also favored in this technique, and we even find episodes from Firdausi's great epic poem, the *Shah-nameh*, or Book of Kings, long before they are depicted in miniature paintings. Such a situation, in which the potters' painted scenes from this account of the heroic deeds of the legendary Persian kings antedate copies of the book, may well have come about because the Mongols, in the destructive fury of their invasion, probably burned all the manuscripts.

One of the most logical consequences of these difficult and complicated techniques such as *min'ai* and luster was simply to paint under a glaze. In Rayy, the potters limited themselves mainly to black figures under a turquoise glaze, in a style which at first sight can scarcely be distinguished from the silhouette ware. In Kashan, they used blue and black under a turquoise glaze, producing a much more delicate effect than in Rayy. In this style, the designers especially delighted in filling the surface with arabesques and continuous plant motifs. After the Mongol invasion of Persia in 1220 came a deterioration of quality in the output of the great potteries, but we shall deal with that period separately.

METALWORK

As in the heyday of the 'Abbasid and Fatimid courts, gold- and silverwork in the time of the Seljuks was mainly in the form of tableware, such as knives, dishes, and bowls, although a few ornaments have also

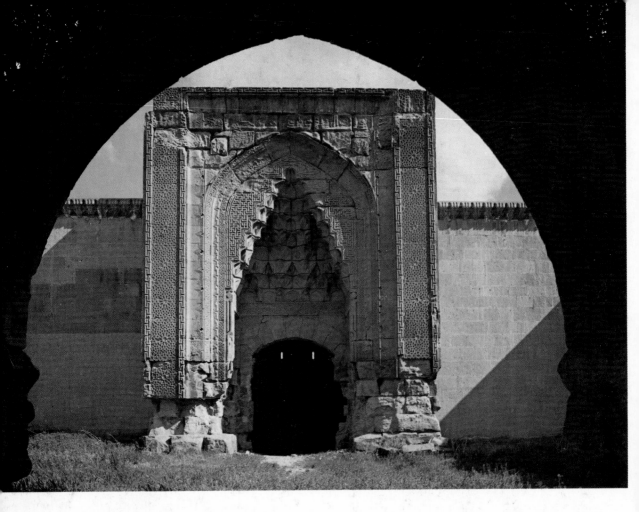

Portal of the Sultan Han, near
Kayseri. Thirteenth century

Detail of the portal of the Sultan
Han, near Kayseri

been found. The most spectacular examples of metalwork, however, are found in bronze. These fall into
two main groups: those with an engraved decoration and those with a gold or silver inlay. Eastern Persia
seems to have been the cradle of both techniques. From the province of Khurasan came numerous incense
burners, and, as a new feature, mirrors with decorations of the planets and the Zodiac—a favorite subject
of the Buwaihids, as we have seen. There were also the well-known animal forms, mostly lions. As these
also served as incense burners, they were provided with openwork decorations. The inlay technique is,
in fact, an elaboration of the engraved design. In order to enhance the engraving, it was earlier the custom
to hammer thin strips of copper, which soon came to be replaced by silver and gold, into the grooves.
Finally, a finishing touch was added with the burin, so that a colorful and particularly beautiful result
was achieved. Among various objects not previously encountered are pen boxes. Both Kufic and *Naskhi*
script were used as decoration, together with motifs which we have met in the ordinary engraving
technique.

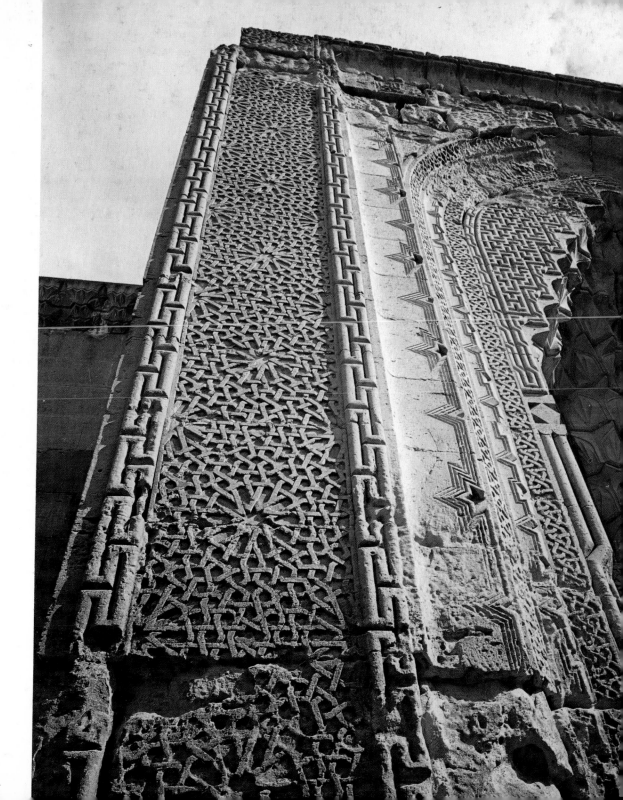

Part of a door. Wood, with decoration in Kufic script in the lower panel and *Naskhi* script in the borders. Twelfth century. Museum of Turkish and Islamic Art, Istanbul

Fragments of glazed and painted cross and star tiles. First half of thirteenth century. From Qubadabad. Karatay Madrasah Museum, Konya

Dish. Bronze with enamel inlay; in the border, the name of the Ortokid prince Süleyman ibn Da'ud (1114–44). Possibly made in Mosul for the Ortokid regent of the Seljuks of that district. Ferdinandeum, Innsbruck

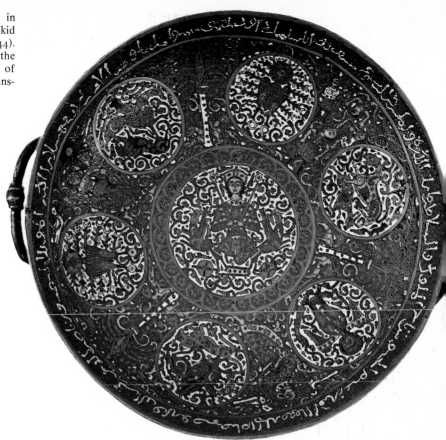

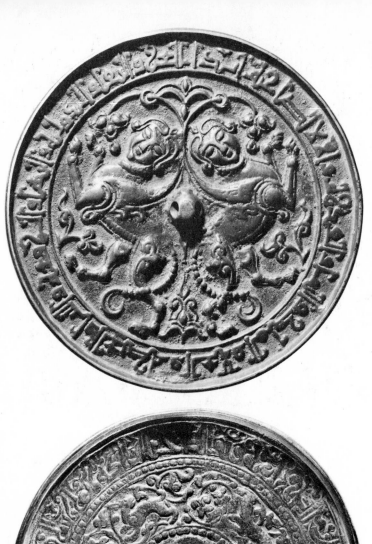

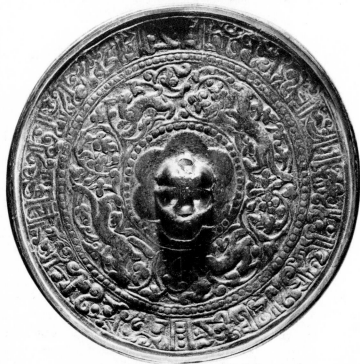

Obverse and reverse of a bronze weight. Seljuk period, twelfth century. From Asia Minor. The Louvre, Paris

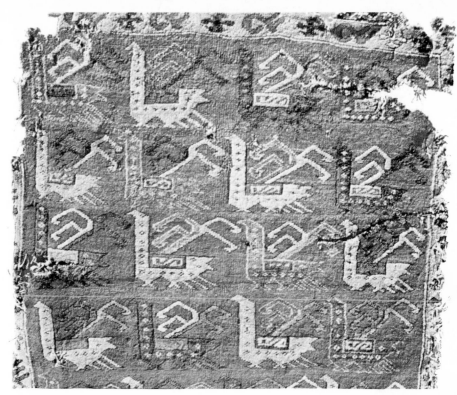

Fragment of carpet with pattern of stylized birds. Wool, width of detail 40″. Thirteenth century. From the 'Ala' ud-Din Mosque at Konya. Ethnographical Museum, Konya

THE WESTERN SELJUKS

Alp Arslan, son of Toghrul Beg, the conqueror of Baghdad, defeated the massive Byzantine forces of the emperor Diogenes Romanus at the battle of Manzikert in 1071, and thus laid the foundation for a new, independent dynasty of Seljuks in Turkey. The new rulers brought with them a period of cultural and economic prosperity for the region they had occupied. In general, their art owed much to the traditions of the Persian Seljuks, but this is not true of the architecture of the Seljuks of Rum, as they were called. The great *iwan* constructions which had been such a feature of architecture in Persia found little acceptance in Anatolia, especially as far as mosque buildings were concerned. The architects of the region evidently saw no reasons for changing the old principles, and continued to adhere to the old Kufah type and the transept mosque.

Characteristic of the former is the 'Ala' ud-Din Mosque in Konya, while the mosque of Diyarbakir may be taken as an example of the latter. Most of the mosques had no court and consisted of a hall of prayer with side aisles, and one or more domed constructions along the *qiblah* wall. The 'Ala' ud-Din Mosque in Nighde has three domed chambers along the *qiblah* wall, each connected with one of the aisles of the hall of prayer. One of the exceptions, in which the building has been inspired by the plan of the madrasahs, is found in Malatya, where the Ulu Cami, or Great Mosque, has a single great *iwan*.

The madrasahs can also be divided into two types: one with an open forecourt according to the Iranian system, and the other with an enclosed domed chamber. The latter is a typically Turkish variant of madrasah style, and is by far the more common type in Asia Minor. One of the most beautiful of the first group is the Çifte Minare Madrasah in Erzurum. Two features of this dignified building are particularly striking: its handsome entrance portal, and the fact that the long principal *iwan* is connected with a *türbe*, the Seljuks of Rum having instituted the custom that the founder of a madrasah should henceforth be buried nearby.

The entrance portals were built in a completely new style which was frequently employed in both sacred and secular Turkish architecture. Rectangular in plan, these impressive entrances were crowned with stalactite niches, and their pointed arches were framed with ornate carvings and further surrounded by a variety of pillars, sometimes set one above the other, and occasionally both above and beside one another. The tops of these columns varied from simple cuboids to elaborate stalactite capitals. The Karatay Madrasah in Konya has a marble portal spendidly adorned on the inside with faience mosaics; in its structure, this building is the prototype of the madrasah in which the inner court is covered by a dome, which is so specifically Anatolian in conception.

BURIAL MONUMENTS

Türbes, or tomb monuments, were as important among the Seljuks of Asia Minor as in Persia, and we have already seen that they were built at some madrasahs. Again, in these structures, a certain native style developed, this time stemming from Armenian influences. The rectangular plan is replaced by the octagonal, and the cylindrical form is also in favor. The customary covering of tiles has been changed, and instead large stone slabs are used after the Armenian manner, blind niches being formed by a series of round-headed or ogee arches. As in Persia, these *türbes* have two stories, but here the decoration is more finely executed.

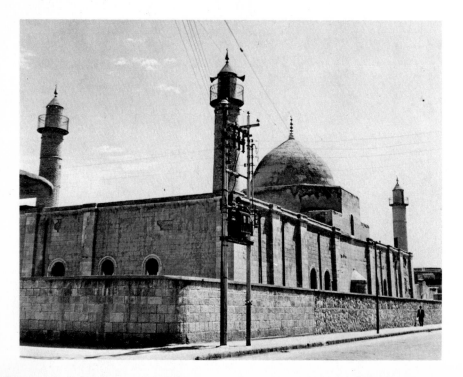

Mosque of Nur ad-Din, Mosul. Built in two periods: first in 1148, then 1170–72

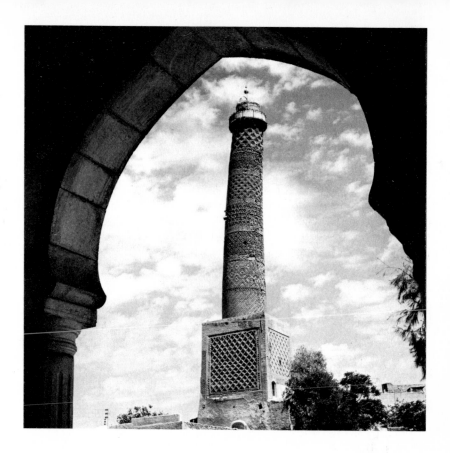

Minaret of the old mosque An-Nuri. Thirteenth century. Mosul

SECULAR ARCHITECTURE

One of the most famous creations of Turkish architecture is the kiosk, a word whose meaning has been debased in our Western idiom through a confusion of ideas, so that now we think of it as nothing more than a roofed stall where we can buy papers or candy. Originally it was a pavilion of a palace, which in the heyday of the Seljuks of Rum must have been the equivalent of the *temples d'amour* of the luxury-loving French kings of a later age. We know of three great Seljuk palaces, in Konya, Diyarbakir, and Qubadabad, though hardly anything has survived of the three. The kiosk of the palace of 'Ala' ud-Din in Konya remained standing until the beginning of the present century. Evidence from recent excavations points to the exceptional splendor of these buildings, not only in their decoration but in their whole construction. As well as throne rooms, domed chambers, and *iwans*, there was a multitude of living rooms—those in the palace of Diyarbakir alone numbering fifty.

Finally, we come to those unique Seljuk buildings, the *caravanserays* or *hans*, which occurred in simple form in Persia, but which in Anatolia were often palatial in size and magnificence. Erected at keypoints along the more essential trade routes, they served as resting-places for important travelers. In plan, they stand midway between the madrasah and the early Christian cathedral, having a great hall with side aisles, spanned by flat or vaulted ceilings supported on slender arches. One of the largest and finest is the Sultan Han, just beyond Konya.

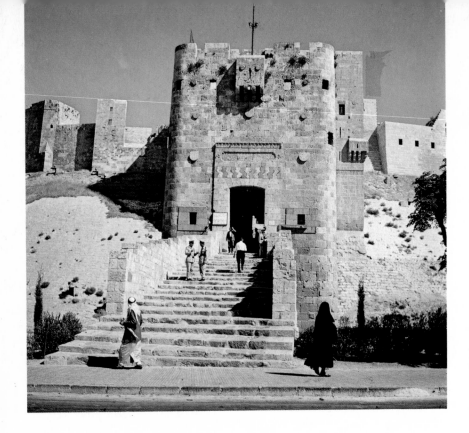

Detail of the Talisman Gate in Baghdad, built in 1221; destroyed by an explosion in 1917

Entrance gate to the citadel of Aleppo, built in 1170 by Nur ad-Din and restored and enlarged by Salah ad-Din

ARCHITECTURAL ORNAMENTATION

In speaking of the entrance portals and the *türbes* we have already mentioned various ornamental features, such as the columns, capitals, and blind niches. In the smaller details of stone decoration, we again encounter geometric patterns, with palmettes and rosettes, knots and cords, fluting and linear patterns, together with friezes of decorative script. In the palaces, entire walls were taken up with decorations in stone and stucco; in Konya, for example, animal friezes, battle scenes, and detached sculptures were found. For various reasons, wood was in particular favor, as for example the mosques with wooden pillars, which were not made of this material merely for economic or traditional reasons. Undoubtedly, a delight in fine ornamentation played a part in the choice. This is also indicated by the numerous objects connected with the mosque—wooden *mihrabs*, pulpits, cupboards, doors, cenotaphs, and Koran stands—which were made in this period. The designs include openwork patterns and similar themes to those we find in stone and stucco sculpture. A favorite and characteristic pattern in wood carving was in the shape of stars and rosettes, which we also find in ceramic decoration.

Brick was used in some buildings, the brickwork being strikingly arranged in intricate geometric patterns and bearing inscriptions; but at the beginning of the thirteenth century, mosaic tilework came to be preferred for interior ornament. For exterior decoration, a combination of unglazed bricks and glazed tiles was sometimes employed. The motifs were prefabricated in mortar panels with clay and lime, and then set in their place on the building. Among the most successful examples of this style is the Mu'mina Khatun in Nakhchuvan.

ARTS AND CRAFTS

CERAMICS

Our information on this subject is less complete than in the case of Persian ceramics, partly because the sites where archaeological research has been carried out have not yielded sufficient material, and partly because a great deal more research needs to be done before we can arrive at a thorough survey of Turkish pottery. We have already mentioned the tile decorations which were a feature of mosques and madrasahs here, as in Persia. It is worthwhile returning to this subject, since the Mongol invasion of Persia in the first quarter of the thirteenth century had its repercussions on the ceramic art of the Western Seljuks. Assuming that the tile decoration of the 'Ala' ud-Din Mosque had been made about 1220 by a Persian, there is still the question as to whether Turkish workmen could have arrived at such skill in the craft at short notice.

After the invasion of Persia, a number of potters probably fled to Anatolia and made a fresh start there, fitting in where they could and at first working on architectural decoration. Later, having convincingly demonstrated their taste and expertise to their new employers, they could allow their talents to unfold, so that here and there we find the celebrated Persian techniques in application. In the kiosk of Konya, for example, various forms of *mina'i* tiles have been found. In the palace of Qubadabad, star and cross tiles were found, in luster and underglaze painting. The luster technique resembles that of Rayy, while the underglaze painting recalls types from Raqqah in northern Iraq. Various finds of celadon fragments of Chinese provenance suggest a fairly regular import of wares from the East. This is borne out by Turkish imitations of this ware. Finally, the local potters made the *sgraffito* wares that were so common throughout the Near East. When the dynasty of the Seljuks of Rum came to an end, the ceramic industry also collapsed. A century passed before the Ottomans restored this art to high esteem in the fifteenth century.

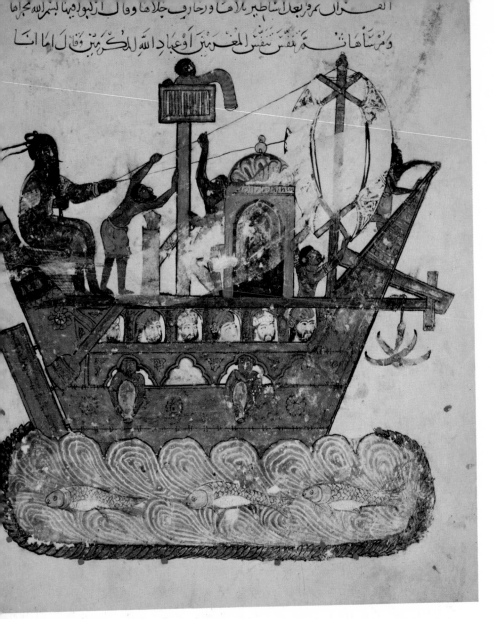

Leaf from the *Maqamat*
(Assemblies) of al-Ha-
riri, showing a passen-
ger boat on the Tigris.
Manuscript, by Yahya
ibn Mahmud al-Wasiti.
Baghdad School, 1237.
Bibliothèque Nationale,
Paris

METALWORK

According to the chronicler Ibn Bibi, the Seljuk princes must have been well supplied with vessels of silver
and gold; but unfortunately nothing has survived. The Seljuks were very skillful in bronzework and
especially in the technique of enamel, judging by the only undamaged piece that has come down from this
period: an enameled goblet, now in the Ferdinandeum in Innsbruck. As well as this superb example, the
Western Seljuks have left us numerous bronze mirrors and weights.

The perishable nature of the material explains why so few carpets of the Seljuk period have been preserved. They can be counted on the fingers of one hand, and were discovered in the 'Ala' ud-Din Mosque in Konya. There are also a number of fragments from the Eshrefoghlu Mosque in Beyshehir. The fame of these carpets, although they were not as finely knotted as later examples, was already spread in the thirteenth century by various famous persons. Marco Polo extolled the carpets as "the best and loveliest in the

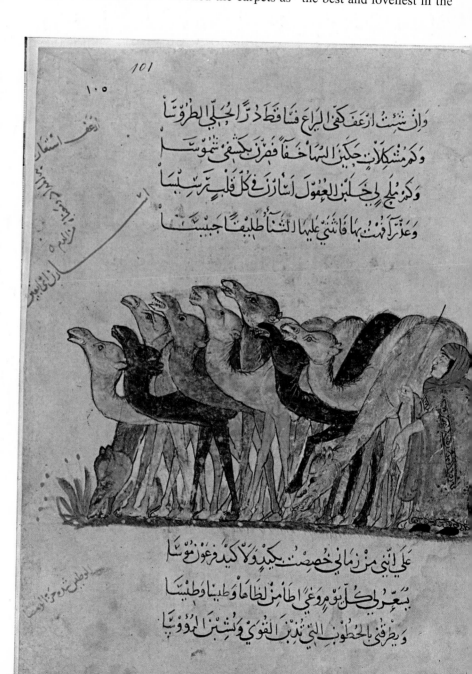

Leaf from the *Maqamat* (Assemblies) of al-Hariri, showing a camel driver. Manuscript, by Yahya ibn Mahmud al-Wasiti. Baghdad School, 1237. Bibliothèque Nationale, Paris

<div dir="rtl">

لتعلم ان بعض الحيلة مهلكة للحيال لكن تزايدك على امر ان انت عدرت
عليه كان فيه هلال الاسود من عران ثقال به تفضل وتكون فيه
ثلاثك قال الغراب و ماذاك قال تطلق مصر في ... ايد لعلل ان ط
</div>

Leaf from a manuscript of the *Antidotes*, originally a work of Galen which was translated into Arabic under the title of *Kitab ad-Diryaq*. Northern Iraq, 1199. Bibliothèque Nationale, Paris

Illustration from a manuscript of *Kalilah wa Dimnah* (Fables of Bidpa'i). Baghdad School, c. 1300. Bibliothèque Nationale, Paris

world," and the Hispano-Arab traveler Ibn Sa'id wrote: "In Aksaray are made the Turkoman carpets which are sent forth to all countries." A striking feature of these carpets is the contrast between the central field and the borders, which usually contain Kufic inscriptions. The geometric decoration of the central field, with its rectangles and diamond shapes, forms the basis of later motifs in Ottoman carpets. In their turn, the Seljuk carpets derive from the felt carpets and tent hangings of Turfan. Perhaps the most delightful effect is given by superimposed shades of blue, green, and red.

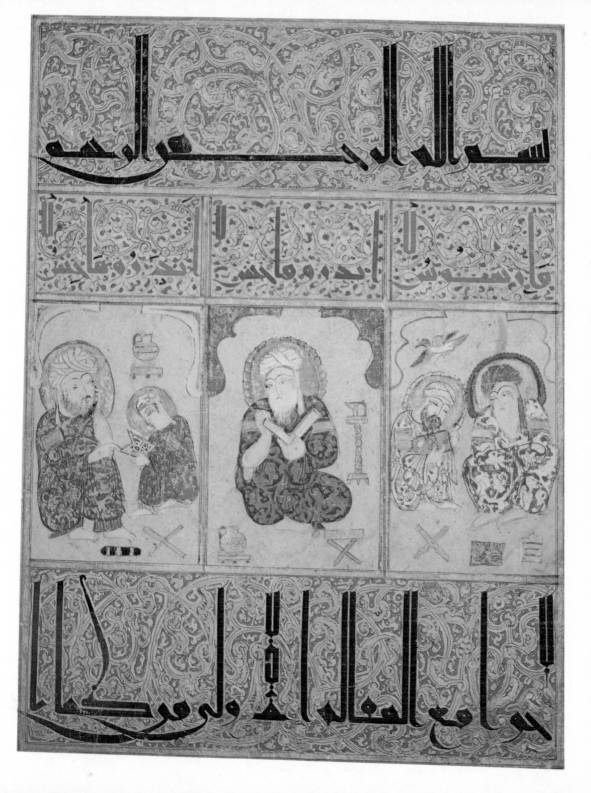

THE AYYUBIDS AND CERTAIN LOCAL DYNASTIES OF ATABEGS

When the empire of the Persian Seljuks split up in 1157, Iraq and Syria came under the government of Atabegs, or Regents. These, together with various members of the Seljuk ruling class who had remained in Iran, consolidated Seljuk authority. The Atabegs enjoyed a large measure of independence and, as it were, founded dynasties of their own within the established regime. Thus, we find the dynasty of the Zangids in Damascus, under whose government the cities of Mosul and Aleppo grew to great prosperity. In the north of Syria und in Anatolia we find the Ortokids, with their center in Diyarbakir (which has already been mentioned in connection with the Seljuks of Rum). Later, we find the dynasty of the Ayyubids, founded by Salah ad-Din after he had been sent to Egypt in 1171 as the ambassador of Nur ad-Din. This dynasty carried out a swift and effective policy of political expansion and quickly managed to reverse the roles so that Iraq and Syria became subject to Egypt. Even Jerusalem was recaptured from the Christians in 1187, which led the West to embark on further Crusades. Salah ad-Din restored the damaged city and in particular devoted much attention to the Dome of the Rock. The 'Amr Mosque in Fustat was completely reconstructed and many new buildings were erected during his reign, which lasted until 1193.

A small table. Pottery, width 11¾″. Twelfth–thirteenth century. From Raqqah, Syria. British Museum, London

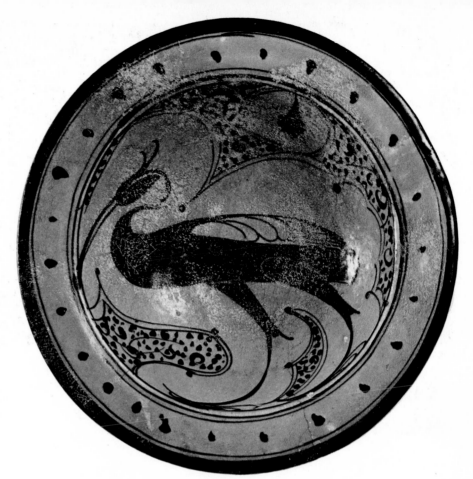

Plate. Earthenware with underglaze painting, diameter 10½″. End of twelfth century. From Raqqah, Syria. Freer Gallery of Art, Washington, D. C.

ARCHITECTURE

Certain buildings which belong to this section have already been mentioned under the Persian Seljuks, in connection with the influence of the vizier Nizam al-Mulk on architectural works in Baghdad. In Mesopotamia, the new wave of Persian ideas was slow to make itself felt, and at first work continued on the old pattern. The Great Mosque of Nur ad-Din in Mosul was supported by octagonal pillars, and this form is also found in minarets, for example, in the Suq al-Ghazl in Baghdad. In Syria, too, they clung to the old tradition and favored the open mosque. Not until the thirteenth century do we find the first example of the dome-covered inner court, in the mosque of Rukn in Damascus. The Great Mosque of Aleppo, which had been founded in the time of the Zangids, was completed by Salah ad-Din after he had come to power. Salah ad-Din was a great lover of art, and his patronage greatly benefited the mosque, as may be seen from the immense hall of prayer with its beautiful polychrome *mihrab* and the lavish use of marble.

In the design of madrasahs, the classic scheme was followed. They were built with great enthusiasm—in Baghdad alone, more than thirty were erected in the course of a century. In the thirteenth century, just before the Mongol invasion, al-Mustansir, the last but one of the caliphs, ordered the building of the largest madrasah in Baghdad, which was designed to house a teacher and some seventy-five students of widely different Muslim sects in surroundings of considerable comfort. Its supplementary buildings included, among other things, a bathhouse, a library, a kitchen, and also a hospital.

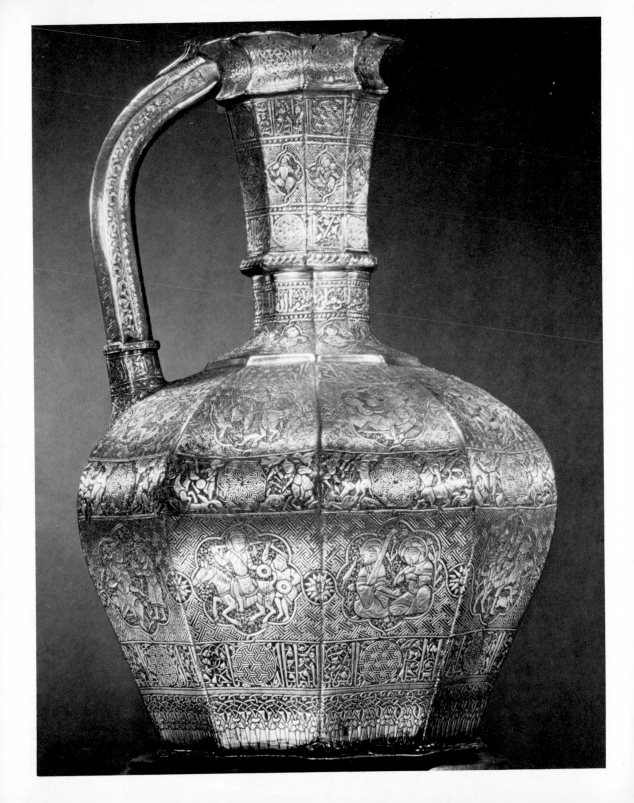

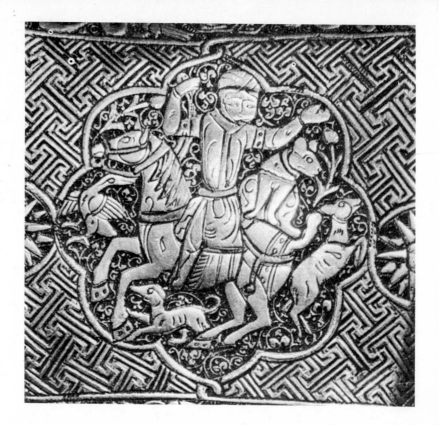

Detail of ewer on the facing page

In Syria, the great patron of architecture was Nur ad-Din, and the madrasah in Damascus, founded in 1172, was named the Nuriyah for him. It became his burial place. The madrasahs in Hamah and Aleppo were built in the style of the Nuriyah. Salah ad-Din also admired this model and introduced it into Egypt, where it was later followed by Sultan Qalawun and Sultan Hasan. Like the Mustansiriyah in Baghdad, Sultan Hasan's madrasah was intended for the study of the four doctrines, those of the Malikite, Hanafite, Shafi'ite, and Hanbalite Schools. We shall look more closely into the subject later when discussing the Mamluk mausoleums, since the buildings of Qalawun and Hasan properly belong to that period.

The type of funeral monument with a rectangular base crowned by a conical top is frequently encountered in Mesopotamia, Iraq, Syria, and Egypt. An octagonal variant is found in the presumed tomb of Sitta Zubaidah, the wife of Harun ar-Rashid. In Mosul there is an example of a tomb with a cuboid base crowned by a tent-shaped roof. In Egypt, the tomb of Imam ash-Shafi'i is of particular importance, not so much for its traditional form as seen from the outside, but for the solution of certain architectural problems in the interior.

MILITARY ARCHITECTURE

One of the most imposing military constructions in the whole Islamic world is undoubtedly the citadel of Aleppo, with which once more the name of Nur ad-Din is associated. The Muslims had fortified various important positions along the western frontiers of their territory, as a defence against possible inroads by the Byzantines or the Crusaders. Nur ad-Din therefore surrounded the city of Damascus with

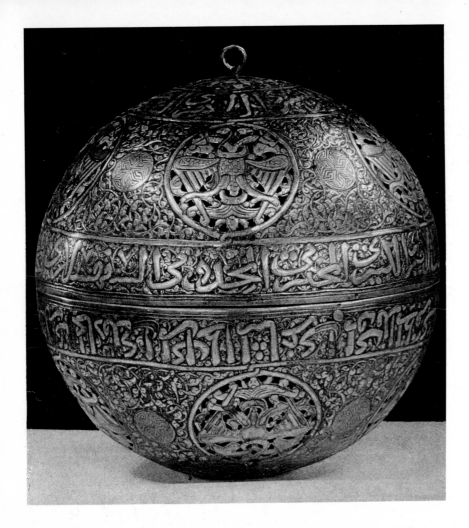

Astrolabe. Copper and silver inlay, height 15 1/2". Made by 'Abd al-Karim in 1236. From Cairo. British Museum, London

A pome or hand-warmer. Openwork copper with silver inlay, inscribed with the name Badi' ad-Din Baisari, diameter 7 1/4". 1264–79. From Syria, British Museum, London

walls and built a citadel. Salah ad-Din followed this example in Cairo and at various places in Syria. The citadel in Cairo, begun by Salah ad-Din and completed by his brother al-'Adil, has much in common with that of Aleppo, e.g., the gates with their great round towers, containing numerous guardrooms and living quarters on several stories.

SECULAR ARCHITECTURE

Here also we find some impressive gateways, though fewer than elsewhere, in imitation of the many examples found in the buildings of the Turkish Atabegs. In Baghdad, two gates are still standing which once formed part of a Seljuk palace.

In the Qara Seraglio in Mosul—the only part that remains of the old Zangid palace, other than a few ruins—we can still, with the help of a little imagination, form an impression of the stately splendor in which the Atabegs—in this case, Badr ad-Din Lu'lu'—lived at the beginning of the thirteenth century. We find only occasional examples of the *hans* or *caravanserays*, the only one worthy of note being the so-called Al Khan. This has a rectangular plan with round towers at the corners, the interior being covered

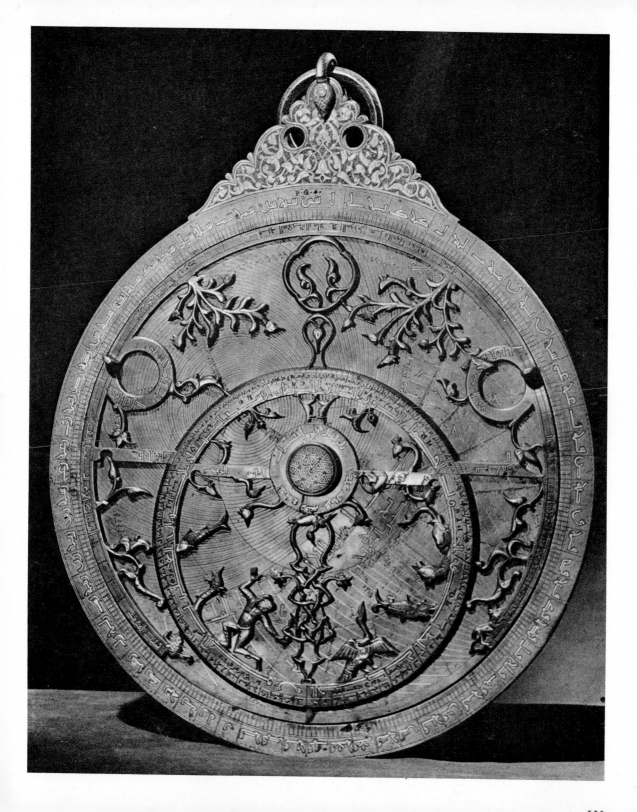

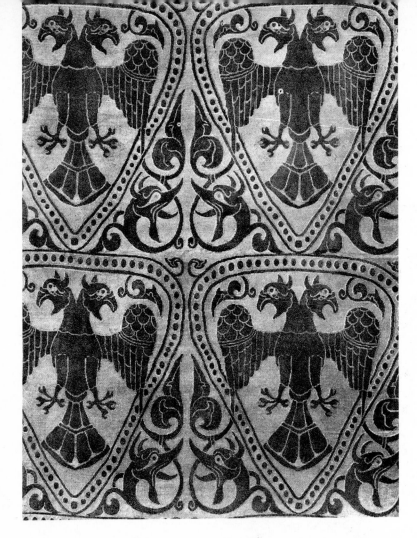

Textile fragment with double-eagle motif. Silk. 1220. From Baghdad. Siegburg Museum

Goblet. Glass, with enamel decoration, height 10³/₈″. c. 1280. From Syria. The Metropolitan Museum of Art, New York City

by a vaulted ceiling. Of the palaces in Egypt, and Cairo in particular, nothing is left today. Reports written at the time of the Napoleonic expeditions speak of the remains of various palaces, among them that of Hakim ad-Din on Rawdah Island. The principal hall had a domed roof supported on four groups of three columns. A *caravanseray* was also found in Egypt; there is nothing of this kind left in Syria.

ARCHITECTURAL ORNAMENTATION

Broadly speaking, the decorative techniques of the regions now under discussion do not differ from those of Persia or Turkey. In the Talisman Gate in Baghdad (1221) we see the same technique of stone relief as elsewhere, the only difference being in the motifs, which appear to have been inspired by Chinese examples. In the Qara Seraglio of Badr ad-Din Lu'lu's palace in Mosul, there are, in addition to the customary script, flower, and leaf decorations, a series of half-sculptures and human representations that have a Buddhist quality about them.

Wood carving, which had been one of the most favored arts under the Fatimids, was continued, particularly in Egypt through the enlightened patronage of Salah ad-Din. Mosques and madrasahs are noted for the

richness of their furnishings. Wood was always prized as a medium for carving, as is evident in the *iwan* of the Qal'ah in Baghdad, where, by means of a coffered ceiling inset with tile decorations, a suggestion of a wooden roof is evoked. The technique of combining stucco and tile decoration perhaps reached its zenith here.

PAINTING

One of the most important forms of art of the Seljuk period was miniature painting, such as we find in the so-called Baghdad School at the beginning of the thirteenth century. The books comprised scientific treatises and *belles-lettres*, both illuminated in a simple, ingenuous, illustrative style. In matters of science, it is clear that the Greek philosophers had not failed to influence the Arabs. The works of Dioscorides and

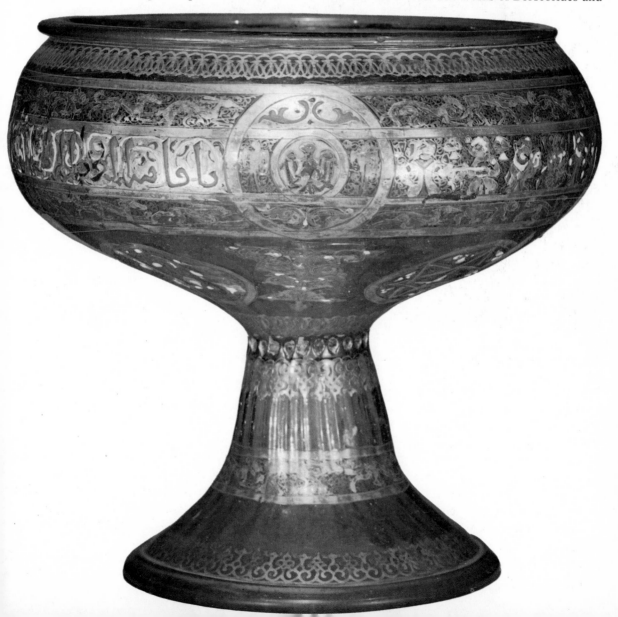

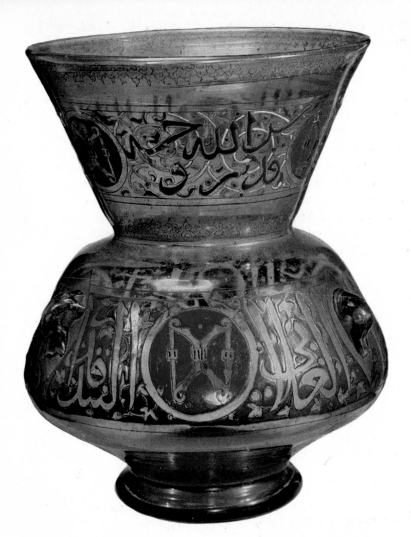

Mosque lamp. Glass, with enameled decoration, height 10⅜″. 1286. From Syria. The Metropolitan Museum of Art, New York City

Galen were translated and illustrated, thereby also paving the way for the development of miniature painting in literature. Among popular literature were the fables of the Indian philosopher Bidpa'i, which were delightfully illustrated in exuberant colors. Kalilah and Dimnah, after which the collection of fables was called, are the names of two personified jackals who experience all kinds of adventures with other animals. The Bibliothèque Nationale in Paris possesses a very fine copy, which must have been written about 1300. Bidpa'i, however, lived much earlier, before the sixth century.

Another popular book was the *Maqamat* (Assemblies) of al-Hariri, of which several copies exist, one in the Hermitage Museum in Leningrad, three in Paris, and a much damaged copy in Istanbul. In the famous Schefer Hariri in Paris, the names of two artists are given: Yahya ibn Mahmud al-Wasiti and 'Abdullah ibn al-Fadl, who illustrated the *Maqamat* between 1225 and 1235. The book tells of the travels and adventures of the quick-witted rascal Abu Zaid (a counterpart of the German Till Eulenspiegel) and his companions, and reflects the everyday atmosphere of the period, so that it has the twofold character of a dramatic presentation and a picaresque novel.

It is difficult to ascertain how miniature painting came into existence. Various scholars have made the

suggestion that it may have been derived from the elegant miniatures produced in the Manichaean monasteries. These were probably introduced by the copyists under the patronage of the Seljuk princes.

CERAMICS

Among the centers which were directly under Persian Seljuk influence were the Syrian towns of Raqqah and Rusafah. Egypt also followed the Iranian example. In general, we find in Raqqah a complete imitation of the techniques employed at Rayy, although the body of the ware is of a somewhat different texture. The technique of making the decoration by means of a mold is perhaps at its most accomplished here. This preference for relief decoration is also shown in the barbotine ware, for which Mosul was the center. Double-walled vessels were made, which were given a lively relief decoration by the barbotine method, in which the design is applied to the surface in a thin paste like sugar icing. Lusterware was also made. The blue underglaze painting and the relief patterns do not differ from Persian work. Here, too, arabesques and borders in *Naskhi* script are the most frequently recurring ornaments. Animal figures tend to be more stylized: birds and plants which have been schematized almost to abstract patterns afford some of the most pleasing designs.

METALWORK

What Baghdad signified for the art of painting, Mosul signified for bronze casting, or rather for the art of bronze inlay. The term "Mosul bronzes" embraces many lovely objects of bronze inlaid with gold and silver when these have no signature to indicate any other provenance. Fortunately, it had become a custom among the bronze casters to sign their work, so a number of names are known. The inlay work was exceptionally fine, and showed nicely balanced compositions comprising scenes of court life framed by bands with rosettes, or stylized flowers enclosed in medallions. Particularly favored scenes were those of musicians and tumblers diverting a group of courtiers, or of knights relaxing from their military duties by hunting or playing polo. As in Anatolia, we find the constellations and various fabulous beasts forming single motifs. Similar principles of design were employed at the other centers of metalwork in Aleppo, Damascus, Baghdad, and Cairo.

TEXTILES

The Atabeg and Ayyubid dominions were restricted to woven fabrics. In Egypt, they followed the Fatimid pattern, and in Iraq and Syria, they followed the Persian, or more precisely, the Buwaihid examples. The names we use for certain fabrics today still remind us of their place of origin, although the resemblance to the original is often difficult to find. Thus, we have the words "damask" from Damascus, the city which used to export brocade woven with pure silver thread, and "muslin," which was a gauzy silk material from Mosul.

Designs current among the other crafts were adapted for ornamenting the fabrics. Favorite themes included confronting animal motifs, stylized or representational, and smaller ornaments set in medallions, with borders of animal friezes or script. These are the very designs which we have already seen in the Fatimid period.

GLASS

Possibly it was the potters' many new and daring experimental techniques that spurred on the glassmakers to develop new processes on their part. Whatever the reason, from the beginning of the twelfth century, the glassmakers of Aleppo started to enamel and gild glass, with amazing results. Gold was generally used for the background, serving, as it were, as a reflector against which the designs in white, red, and blue enamel stood out in splendor. The motifs were similar to those chosen for the bronzes.

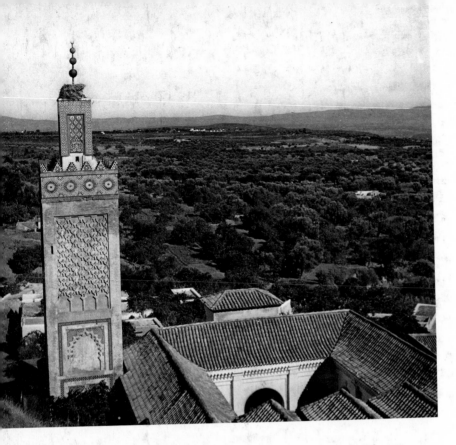

SPAIN, THE MOORS, AND THE MAGHRIB

When the caliphate of the Umayyads of Spain finally came to an end in 1009, a kind of administrative vacuum ensued in which twenty petty kings contended for the flourishing empire of the lords of Cordova. The Christians saw their opportunity and tried to make tactical use of this internal weakness to reconquer territory from the Arabs. The most influential prince of the dismembered empire, the sultan of Seville, therefore invoked the aid of the Almoravids, a race of Mauretanian Berbers. These stern and ascetic Muslims quickly averted the Christian peril, but in return required submission to their authority. Thus, Marrakesh became the center of government, and Spain an Almoravid province. The empire of this semi-nomadic people of the Sahara, related to the Tuareg of the present day, extended across Algeria and the western part of Barbary and included the southern half of Spain. In the middle of the twelfth century, they were succeeded by the Almohads, a Berber tribe from the Atlas region, who, though more moderate in character, nevertheless succeeded in bringing North Africa and Spain under their command. In the first half of the thirteenth century, however, the great empire of the Almohads collapsed, breaking up into various separate kingdoms. Spain came under the rule of the Nasrids from Granada; Tunisia was governed by the Hafsids; Algeria came largely under the rule of the Zayyanids, while a kindred group called the Merinids installed themselves in Morocco. These proved themselves the most competent and worthy successors of the Almohads and managed to restore a certain luster to the old grandeur, especially in the cities of Fez and Tlemcen.

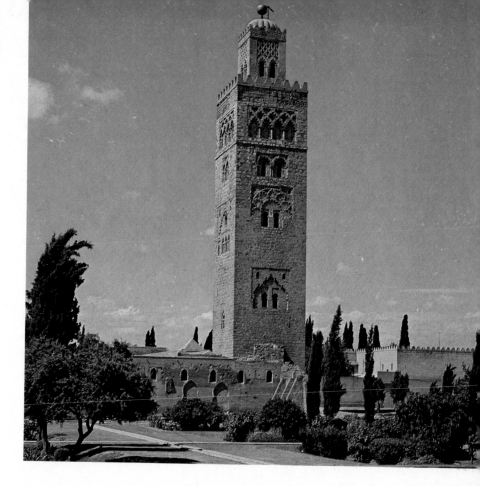

Minaret of the Qutubiyah Mosque in Marrakesh, traditionally ascribed to the Sevillian architect Guever. Twelfth century

The history of Moorish Spain ends with the fall of the last Moorish ruler, Muhammad Abu 'Abdullah (Boabdil), when Ferdinand and Isabella of Castile captured Granada in the last phase of the Christian reconquest of the peninsula. In the light of Christian influences, there is still another important period to discuss, that of Mudejar art. The Mudejars were the Moors who had submitted to Christian sovereignty without renouncing their religious beliefs. In fact, this group made its appearance as early as the end of the eleventh century, and developed more or less separately.

ARCHITECTURE

In order to find a connection between the art of Cordova and that of the new rulers, we must turn our attention to North Africa, where the austere Almoravids gave expression to their artistic feelings in more moderate forms than the exuberant Cordovans. Little remains of the original stages of the Great Mosque of Algiers (c. 1096) and of the Qarawiyyin Mosque (begun in the ninth century) in Fez, many improvements and changes having been made in the twelfth century. The Great Mosque of Tlemcen was built in 1082 and restored in 1136 by 'Ali ibn Yusuf, clearly under the inspiration of the mosque in Cordova.

Nor has much remained of Almohad mosque architecture. The ruins of the mosque at Tinmal in the Atlas have a special emotional importance, as it was there that Ibn Tumart preached the Almohad doctrine.

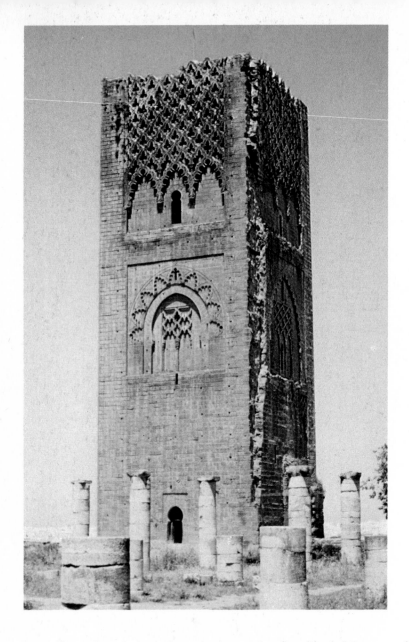

Minaret of the Hassan Mosque in Rabat. Begun by the great architect of the Almohad dynasty, Ya'qub al-Mansur (1184–98), this mosque was never completed

From the point of view of art, however, the Qutubiyah Mosque, which 'Abd al-Mu'min (1130–63) built in his capital of Marrakesh, is among the finest creations of Islamic architecture. His successor, Ya'qub al-Mansur, completed the mosque, with its seventeen aisles, in 1196. The great transverse nave is covered by five domes. Here we see one of the very few indications of Seljuk influence in the stalactite treatment of the vaults. The influence from the eastern regions of Islam, which had been so strong in the Umayyad period, became proportionately weaker as contacts with the Christians intensified.

Ya'qub al-Mansur (1184–98) was the great patron of architecture of the Almohad dynasty, and to his name can be ascribed three other mosques of interest from this period: the mosque of Hassan in Rabat,

Minaret of the Great Mosque in Seville, originally built in 1195. The upper portion was destroyed by an earthquake in 1355, and was completely altered and rebuilt by Hernan Ruiz between 1560 and 1568. A statue of *Fides* (Faith) was set at the top as a wind vane, which earned the tower the nickname of the Giralda

Ruins of Alcala de Guadaira, one of ▶
the largest fortified towns of the
Almohads. Twelfth century

The Torre del Oro, a twelve-sided
tower formerly set in the fortification
wall around Seville. Twelfth century

which was never completed, probably owing to the vastness of its design (456 x 629'); the Great Mosque
of Seville, which, like the Qutubiyah, numbered seventeen aisles; and the mosque in the Casbah at Marra-
kesh, built on the same scheme but with eleven aisles and with three domes over the transverse nave. A
distinctive feature of these early mosques is their dignified minarets, which show as great a resemblance
to one another as do the plans of the mosques themselves. According to tradition, the Giralda at Seville,
the unfinished minaret of the Hassan Mosque, and the minaret of the Qutubiyah were all the work of a
single architect, named Guever, from Seville. The upper portion of the Giralda, which today serves as the
clock tower of the cathedral, was modified in Renaissance style by Hernan Ruiz between 1560 and 1568,
but the rest is still in the Almohad fashion.

The introduction of the madrasah by Ya'qub al-Mansur is of more historical than artistic interest, since
on the whole the buildings contain no new elements of architectural importance. Two madrasahs, those
of as-Sakhrij and of al-'Attarin, form favorable exceptions, although these were built later on, under the
Merinids, at their capital of Fez.

CIVIL AND MILITARY ARCHITECTURE

One can scarcely speak of palaces in connection with the Almoravids and the Almohads, since luxury was a word excluded from their ascetic vocabulary. More in the democratic style often encountered in our own day, they named their residence *dar al-ummah*, or "house of the people." Not much more than a ruin, which once comprised at least three inner courts, remains of the "house" that stood in Marrakesh. The same is unfortunately true of the Castillejo de Murcia, which is regarded as a forerunner of the Alhambra. This castle, which originated in the eleventh–twelfth century, had a rectangular plan, with various halls leading into a patio. On the short side of the patio were two projecting, arbor-like constructions which bring to mind the Court of the Lions in the Alhambra.

The Almoravids, who were fundamentally dwellers of the plain, must have built numerous fortifications, both in the Maghrib and in Spain, to defend themselves against the people of the mountains and the Christians. Little has remained of these strongholds, because the building material was not sufficiently durable, but the citadel of Amergu in North Morocco still serves us as an example. The wall is many-sided and is interrupted by round towers. The same may be said of the Almohad fortifications. A splendid example of these is still given by the ruins of the fortress of Alcala de Guadaira, some nine miles from Seville, and moreover by the walls of Seville itself, with the famous Torre del Oro, constructed on a twelve-sided ground plan.

Among the pearls of architecture is the palace complex in Granada, built by two generations of the Nasrid dynasty, which acquired the name Alhambra, the Red, from the color of the bricks of which its outer walls are built. King Yusuf I (1333–53) and his son Muhammad V (1353–91) were the architectural patrons of this fairy-tale palace of truly Oriental splendor. Situated on a hilly terrace overlooking Granada, it is built according to the Maghrib principle of three inner courts, each connected with a functional complex. Thus, we see the Patio del Mexuar, where the sultan used to administer justice or grant his subjects audience; the Court of the Myrtles in the center of the whole complex; and the vast Hall of the Ambassadors, which occupies all of the Torre de Comares. On the eastern side we find the harem quarters and

View of the Alhambra, Granada.
Fourteenth century

The lion fountain in the Court of the
Lions in the Alhambra. Completed in 1354

the grand reception hall, the Court of the Lions, with its celebrated lion fountain. Directly accessible from here were the family tomb of the Nasrid kings, the residential annex of smaller rooms for subordinates, and the palace mosque. In addition, there were the indispensable gardens and bathing places.

Strict adherence to the particular architectural principles of former styles was abandoned, probably less by desire of the builders than of their patrons. It is as if a selection had been made from old familiar architectural forms of what would best fulfill the wish for a luxurious and commodious palace, and which would, at the same time, be a work of art. All kinds of decorative elements were brought into play with extraordinary skill and refinement, but it is in the work on a grand scale, such as the blind niches, the domed roofs with their honeycomb of stalactite vaulting, and the diverse forms of columns, that the architects of the Alhambra showed their greatest qualities. Furthermore, it seems as if the designers wished to give a place in the palace to all the decorative elements known from the past (the 'Abbasid, Fatimid, and Seljuk periods) and from contemporary styles (Mamluk and Mongol). Together with the arabesque, which plays an important part, there are palmettes, rosettes, trefoils, lancet shapes, cornucopias, twining tendrils, plants, and flowers. Nor was script decoration omitted. In addition to Kufic, which had declined in popularity with

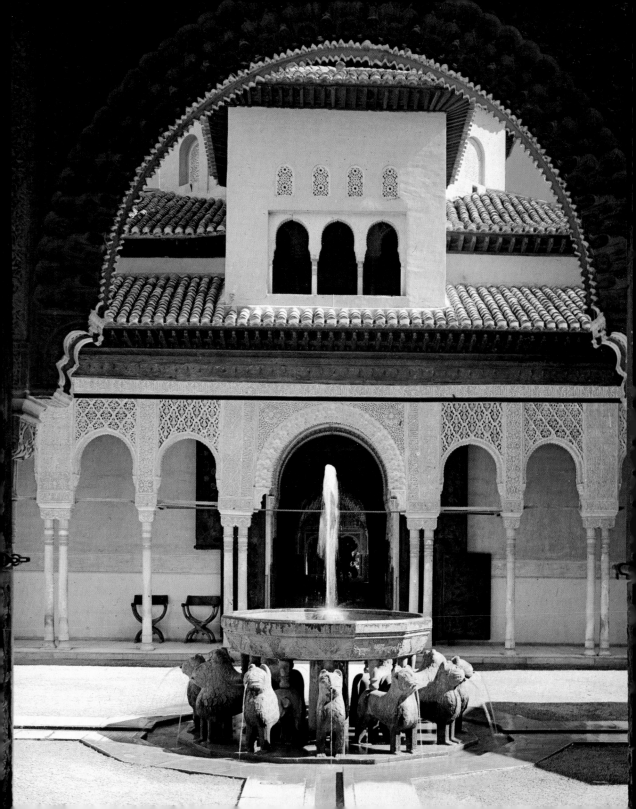

The Court of the Myrtles in the Alhambra, Granada

the passing of the Umayyads, a new flowing script, similar to *Naskhi* and known in this region as *Maghribi*, had come into existence. This was not, however, used in architecture, where *Naskhi* continued to be employed. Ceilings and wall paintings were also among the adornments of the Alhambra. Finally, it is striking how frequently the coat of arms of the Nasrids, with the almost prophylactic motto "No victor except Allah," is flaunted among the decorations.

The Mudejars particularly distinguished themselves in the minor arts, although they have also left their indelible mark upon architecture in the cities of Toledo and Seville. About 1200, the Mudejars erected a synagogue in Toledo in which the horseshoe arches and the acanthus motifs are clearly connected with the

Detail of the elaborate architectural ornamentation of the Alhambra: a capital in one of the rooms of the harem

Almohad style. That they also worked for the Christians is shown by the fact that, on the orders of Alfonso the Wise (1252–84), they built a Catholic chapel in the Great Mosque of Cordova. Here, in this San Fernando Chapel, we again find the stalactite vaulting and the plant motifs that we saw in the Alhambra.

In 1357, the treasurer of Pedro the Cruel presented the city of Toledo with a second synagogue, oblong in shape and covered with a magnificent wooden ceiling, its walls decorated with stucco panels in floral and epigraphic motifs. Pedro had begun by building a pleasure-palace after the manner of the one in Granada, thereby assuring Seville of a worthy place in the series of Islamic places of interest. The Alcazar, as the palace was called, was one of the showpieces of Mudejar architecture. Two inner courts, splendidly deco-

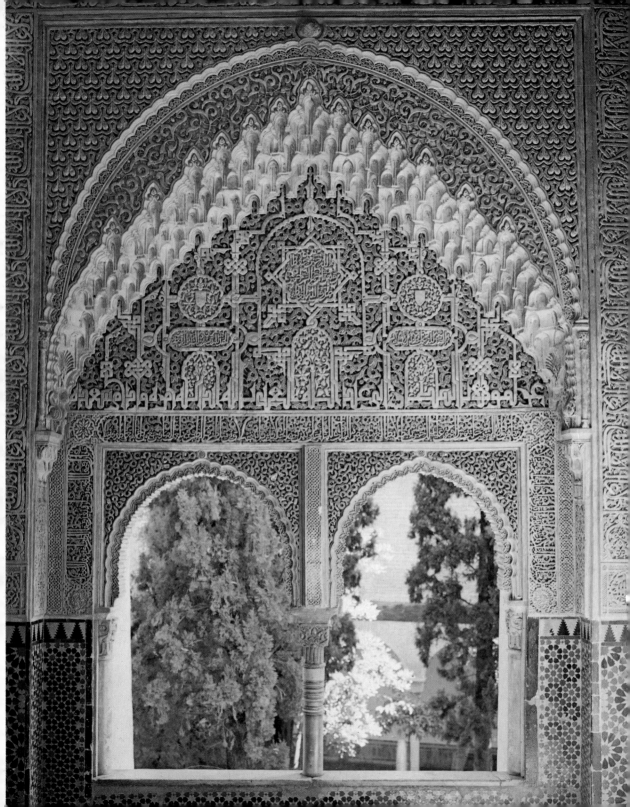

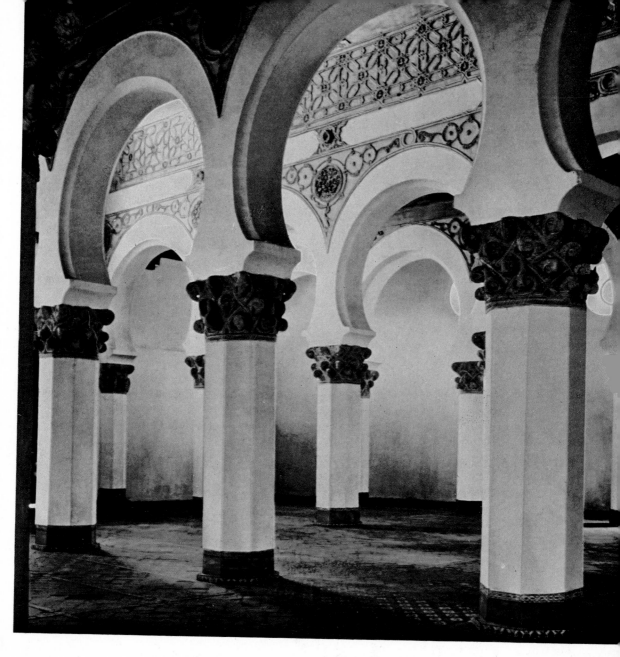

Interior of the old synagogue in Toledo. Built in the Almohad style, twelfth–thirteenth century. Now the church of Santa Maria la Blanca

rated halls, and delightful gardens recall the golden days of the great kings, a heyday that neither Seville nor the Alcazar actually knew.

The so-called Queen's Room in the Alhambra, Granada

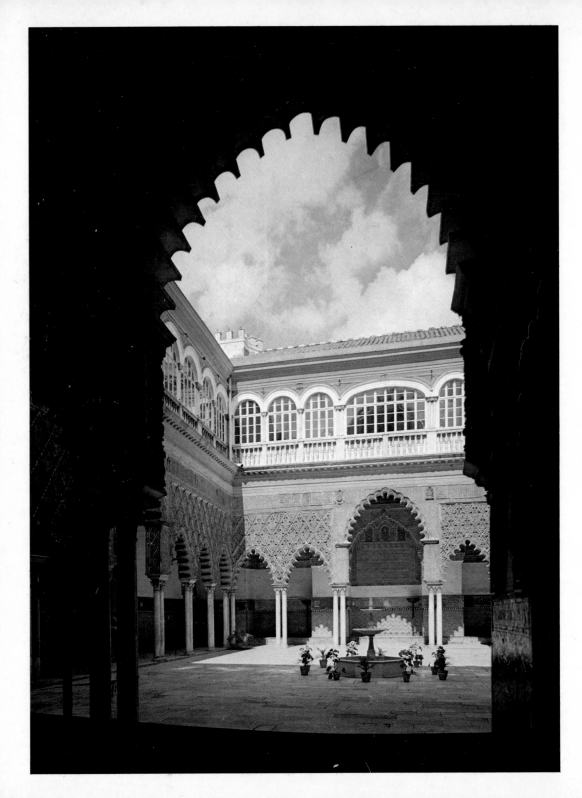

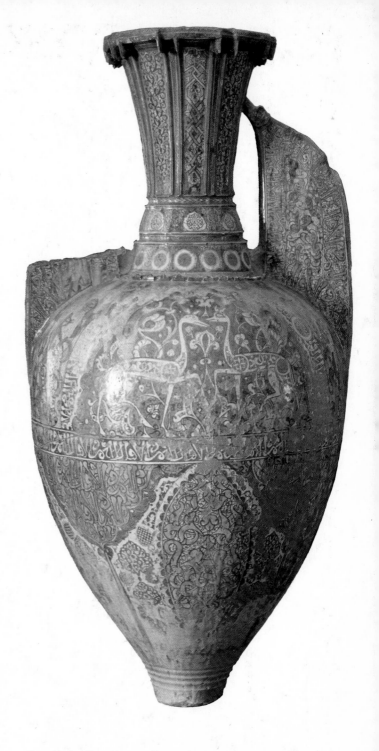

So-called Alhambra vase, a type of pottery current in Malaga
in the fourteenth century. Archaeological Museum, Granada

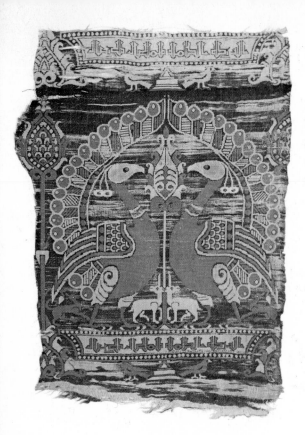

Fabric, with confronting peacocks and borders of Kufic script. Silk. Twelfth century. From Spain. Victoria & Albert Museum, London

Tile mosaic. Baked clay fashioned in the *cuerda seca,* or dry cord, technique, a kind of cloisonné process. Sixteenth century. From Andalusia. The Louvre, Paris

Small plate, with the inscription *Ave Maria*. Fifteenth century. From Manises, near Valencia. Historisch Museum, Rotterdam

ARTS AND CRAFTS

CERAMICS

Although a great deal of attractive pottery with molded relief decoration was made between the twelfth and fifteenth centuries, it has failed to excite the interest that the Hispano-Mauresque lusterwares have aroused. Their fame is well deserved, for in Malaga a school developed which in the West played the role that Rayy had done in the East. Among the most popular types were the so-called Alhambra vases, with decorations of arabesques, script, heraldic emblems, and sometimes animal figures. The luster has a yellowish-green tint against a background of cobalt blue. During the fourteenth–fifteenth century, one of the suburbs of Valencia, Paterna, developed a simple and practical ware painted in green and purple. The decorative scheme at times comprised stylized animals of a purely Islamic character, at times human figures in the Gothic style that the Mudejars had introduced. Another town near Valencia, Manises, was famous for its magnificent lusterware. Manises really came into its own in the fifteenth century, when Malaga was declining in prosperity.

The potters of Manises specialized in making complete sets of tableware in which, in addition to typically Islamic motifs like arabesques and script characters, an increasing number of "European" subjects appeared in the decoration: sailing ships, for instance, and especially the border inscription in Gothic letters of *Ave Maria Gra[tia] Plena*, which was frequently used on dishes meant for export. Plates with this text found a ready market in Europe, and even in the countries of the Near East, as the large number of examples that have been excavated in Cairo indicates. Spanish pottery had a great influence on later European ceramics, since Italy sought inspiration from Malaga ware at an early date. The Egyptians had a high regard for this work and encouraged the export of "Malaga," as they called it—from which perhaps the term "majolica" is derived.

In the twelfth century, the textile industry soared to great heights, and Arab historians refer to the existence of eight hundred weaving mills in Almeria alone. A few fragments of silk or embroidered work made between the tenth and thirteenth centuries have been preserved in various public collections. The motifs are not quite the same as those in the other artistic products. In addition to the Umayyad patterns to which designers had clung for many years, there are also sphinxes, men subduing lions, and animals in combat—themes that we already know from the works in the 'Abbasid manner made in the Seljuk period of the Ayyubids.

In the fifteenth century, the Mudejars distinguished themselves in brocade weaving, the decoration being mainly limited to heraldic emblems and geometric figures. During the time of the Nasrids, carpet factories were set up, and it was here that the earliest European carpets were made. Fragments were found at Fustat in Egypt. Designs of geometric figures and Kufic characters in red, blue, green, and brown appear against a background of gray. In the fifteenth century, carpets in the Mudejar style were made in which the surface was divided into diamond shapes, with octagonal "Turkish" motifs appearing on a blue ground. Alternatively, Spanish heraldic emblems were sometimes worked into the design.

Dish, with fantastic bird painted in pastel colors. Thirteenth–fourteenth century. From Paterna, near Valencia. Haags Gemeentemuseum, The Hague

THE MAMLUKS

Returning once more to the Seljuks, or more precisely to Salah ad-Din, the great founder of the Ayyubid dynasty, we find that, although his empire remained secure from the inroads of the Mongols, it nevertheless came to an end earlier than the other Seljuk states in Persia and Turkey. The cause must be sought in the almost classic Near Eastern situation in which the slave rises against his master and takes power into his own hands. Thus, the word Mamluk, which means slave, tells us half the story already.

What happened was that the bodyguard of Turkish slave mercenaries grew so powerful that they rebelled against the government and set up a new dynasty (the Bahri Mamluks) in Egypt (1250–1390). Later, descendants of the Circassian slaves of one of these Mamluk sultans, Qalawun, broke away in their turn, The Circassian Mamluk dynasty, which was established in 1382 under their first sultan, Barquq, lasted until the conquest of Egypt by the Ottomans in 1517. Their art greatly resembled that of their predecessors, and we notice only a gradual change in style.

ARCHITECTURE OF THE BAHRITES

The somewhat intricate quality of Mamluk architecture is derived from the influence of earlier periods. It is evident that the mosque of Zahir Baibars, built between 1266 and 1269, follows the schema of the al-Hakim Mosque, which is two hundred years older and which moreover, was designed on the lines of the mosque of Ibn Tulun. This explains the 'Abbasid or Iraqi influence. The monumental domed chamber before the *mihrab* points to Seljuk influence, the three-aisled transept into which it opens suggests the Syrian tradition, and so on.

Following the custom of the Seljuks of Rum, the Mamluk sultans erected magnificent mausoleums, usually accompanied by a mosque or madrasah or both. One of the most interesting is that of Sultan Qalawun (1279–90), which comprises a mosque, a mausoleum, and a hospital, and which was built on the ruins of an old Fatimid edifice of which the minaret still remained. This handsome minaret, which is in three stages, two rectangular and one octagonal, with a cylindrical top, has been incorporated in the facade, which also recalls the facades of Fatimid buildings with its high, pointed-arch windows. Perhaps the loveliest part of the complex is formed by the mausoleum, especially with regard to its decoration; its construction shows the effect of various influences.

Another very fine building, which we have already mentioned in connection with its relationship to the Persian Seljuk style, is the mosque and madrasah of Sultan Hasan. The characteristic four great *iwans* enclose the inner court, with the sultan's domed tomb built on to the principal *iwan*. At the four corners madrasahs have been erected on a reduced scale, so to speak, for each of the four branches of the *Sunni* sect, precisely as in the Mustansiriyah in Baghdad. The portal is placed asymmetrically in the corner of the facade, in accordance with Mamluk custom, and has a recessed stalactite ceiling of the kind we find in the buildings of the Seljuks of Rum.

Another combination of religious buildings is the *Khanaqah*, which originated in Central Asia. In this, cloisters, mosque, and tomb are united and gradually came to include a public fountain and a primary school for the reading of the Koran.

ARCHITECTURE OF THE BURJITES

Despite political tensions and the fairly short period of complete independence which they enjoyed, both the Bahrites and their successors the Burjite Mamluks suceeded in maintaining a high cultural tradition. In numbers alone, the total of their architectural achievements is astonishing, even without allowing for

Mosque of Qalawun. Built 1284–85. Cairo

The Mamluk necropolis, containing the tombs of fifteenth-century rulers for the most part, situated just outside the walls of Cairo

the numerous buildings that have vanished in the course of time. With regard to mausoleums, for example: in Cairo there are still to be found thirty-one Bahrite tombs and twenty-four built by the Burjites. Obviously there are fewer mosques, but we find ten built by the earlier dynasty and twenty-four by the Burjites, who also built thirty madrasahs, compared with twenty-eight built by their predecessors.

The most representative monument of the Burjite style is the mosque and mausoleum of Qaitbay (1463–96), which also included a madrasah. The square central court is covered; the dome is crowned by a lantern turret and stands on an octagonal base. Along the sides of the court we find two great *iwans* instead of four, the two remaining sides being distinguished by arches which lead into two halls of prayer, only one of which has a *mihrab* and *minbar*. The interior decoration is even more interesting than the exquisite exterior suggests.

ARCHITECTURAL ORNAMENTATION

Care for the harmonious decoration of the interior and exterior of official buildings had been a pronounced feature of Fatimid architecture, and the Mamluks bestowed a very great deal of attention on this matter. Quite apart from subsequent adornments, the building received a primary decoration by the use of colored stone, yellow and red, to define its various parts. Then doors, windows, portals, and niches would be introduced into the overall design, until a harmonious play of lines was achieved. The windows or blind niches were often framed in pointed or trefoil arches. The influence of contacts with the Crusaders is evident, for the multifoil and pointed arches are of unmistakably Gothic character. The trefoil arch was the one most frequently employed, since the Turkish examples had shown it to be most suitable for setting off the traditional stalactite vaulting.

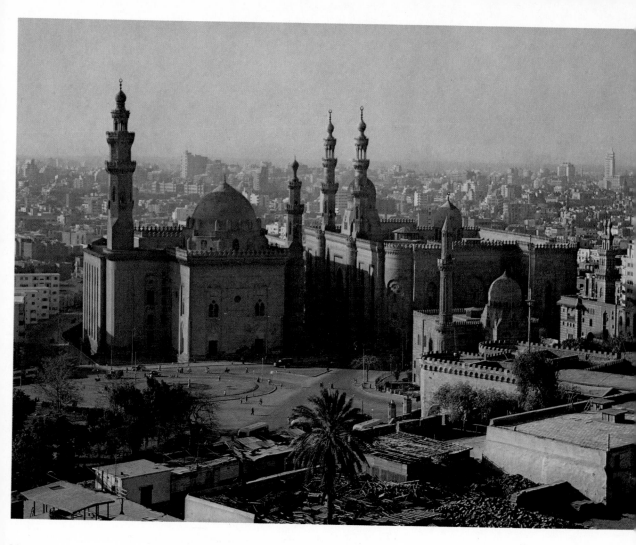

Mosque-madrasah of Sultan Hasan. Completed in 1362. The lofty mosque looks almost like a fortress and can be distinguished by its minarets, which are the highest in Cairo.

Marble was put to many uses for adorning the interior. The *mihrab* was a part of the architectural design as a whole, and if the color of the marble of which it was made was not quite right, the required color effect was achieved by the addition of other stones. For this purpose, wood and stucco were largely supplanted, but not for the ceilings and certain other places which had formerly been decorated with tiles. Painted wooden panels and gilded beams are new Mamluk features of ornamentation. The doors were given bronze fittings to match the main design in the wood. All this harmonious decoration was enhanced by the play of light falling upon it, a special, jewel-like effect being given by glass-covered stucco ornament.

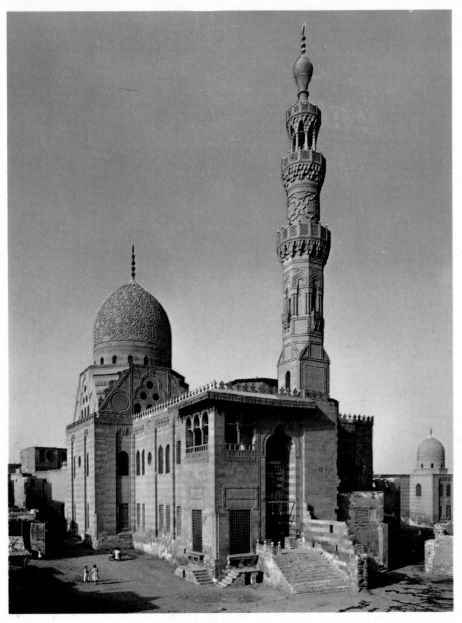

Interior of the mosque of Sultan Hasan, Cairo, showing the relative positions of *minbar* (pulpit) and *mihrab* (prayer niche)

CERAMICS

The Mamluks tended to make a fairly coarse type of pottery. Designs were scratched in the reddish clay body, which was then covered with a red, yellow, or brown glaze. The themes were mainly of horsemen hunting or in combat with wild beasts, but sometimes a creature, such as a panther or a fish, would make up the design on its own. This pottery gives some fine examples of the flowing *Naskhi* script, which here had been elaborated into a variant known as *Thuluth*, or third. Often the inscriptions were broken by heraldic emblems which remind us of important court dignitaries. From these blazons, one can sometimes quite easily recognize the functionary concerned: the two polo sticks standing for the chief umpire at the polo game, the goblet for the chief cupbearer, the sword for the swordbearer, and so forth. In addition to this pottery, there was a great deal of imported ware, as is shown by signatures on the bases of plates and bowls excavated at Fustat.

METALWORK

Inlaid bronzework was highly prized by the Mamluks. In the thirteenth century, the great masters from Mosul had set up a workshop in Cairo. In accordance with orthodox *Sunni* concepts, there was a greater preference for plant and script motifs than is found in the actual Mosul bronzes, especially in objects used in religious ceremonies. In objects of a purely private nature, we again find the familiar themes of men and animals in medallions. The forms and kinds of products were extended, and, as well as jugs, basins, dishes, and bowls, we now find plaques, typical conical candlesticks, and six-sided taborets with small cabinets which fitted on top of them. These taborets, meant for holding the Koran, formed a typical piece of mosque furniture, but later they found their way into the living room.

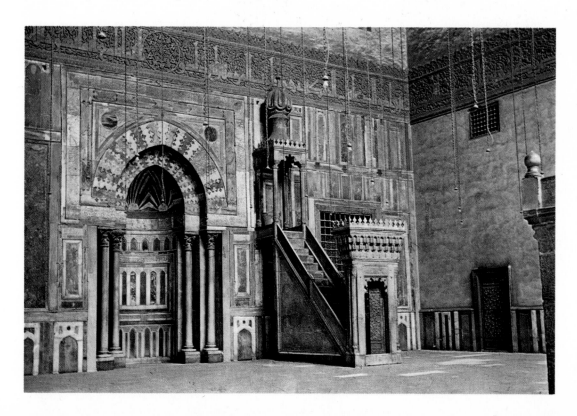

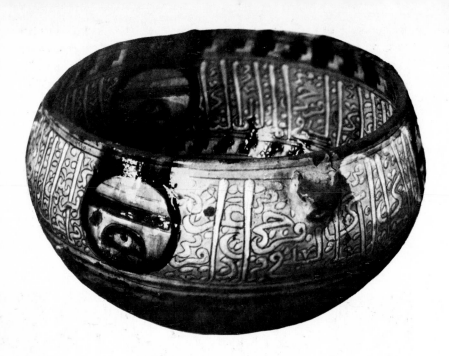

Cup, with typical Mamluk heraldic devices and script decoration. Earthenware. Fourteenth century. From Cairo. Museum of Islamic Art, Cairo

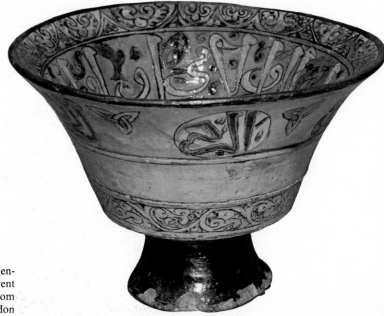

Bowl, with *sgraffito* decoration. Red earthenware, white slip, with yellow transparent glaze, height 8″. Fourteenth century. From Fustat. Victoria & Albert Museum, London

One of the most famous exceptions to the customary, nonfigural decorative scheme is the so-called Baptistery (baptismal font) of St. Louis, now in the Louvre. This work, after much doubt as to whether it should be ascribed to Syrian or Egyptian workmanship, proves to have been made in Cairo by one Ibn az-Zain between 1290 and 1310. Among the figures depicted on this inlaid copper basin, a certain Salar can be recognized; a Crusader who was taken prisoner and afterward became a protégé of various sultans, he was eventually made viceroy of Egypt.

The Syrian workshops were equally productive. With their great technical mastery and their greater freedom in figural decoration, the Syrians produced works which are often found more pleasing than the more severe Egyptian style. It is not surprising that the Venetians in the fourteenth century took to imitating the Syrian bronzes and stamped their own works "In the manner of Damascus."

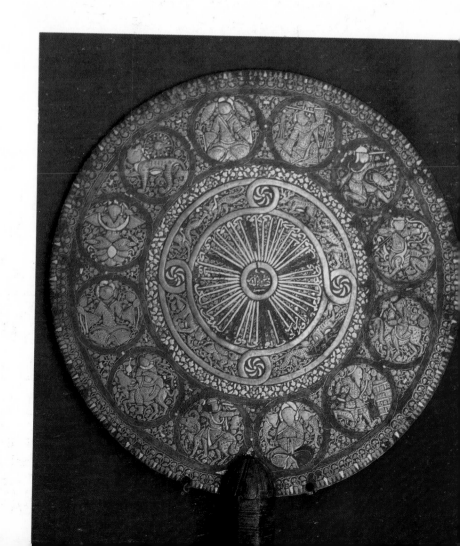

Mirror, with border of Zodiac signs and a garland of script characters in the center. Bronze with silver inlay. Made for a Mamluk governor. c. 1320. From Aleppo. Topkapı Sarayı Museum, Istanbul

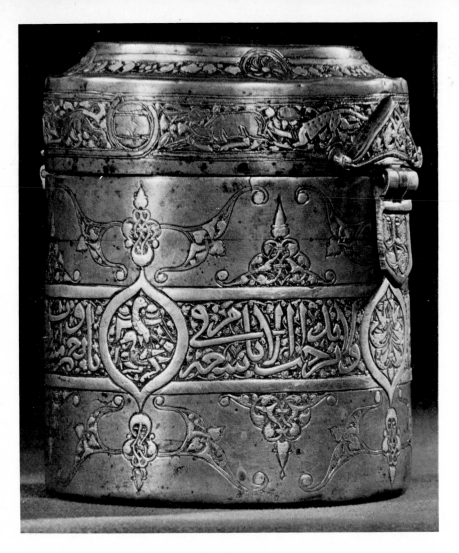

Cylindrical box with inlaid decoration. Bronze, height 3³/₄″. Beginning of fourteenth century. From Egypt. British Museum, London

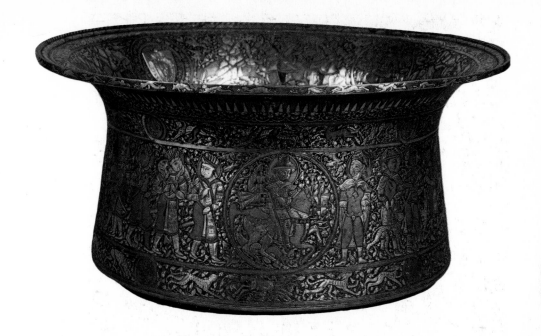

Basin; so-called Baptistery of St. Louis. Copper inlaid with silver, height 9″. Fourteenth century. The Louvre, Paris

GLASS

Glassmaking was an art which had been established in Syria for many centuries, where the cities of Tyre, Damascus, and Aleppo gave the lead. A speciality of theirs was the gilded and enameled mosque lamp, having a wide upper portion tapering down to a narrow waist and then expanding to form the large, bulging base, from which projected small ear-shaped handles. The wick lay in a separate vessel inside. Numerous lamps of this type, which had probably been presented to sultans and emirs on religious or secular occasions, were found in the mosques of Cairo. The general decorative pattern clearly matched the function, so that again we find texts from the Koran, benedictions on the founder of a building, or blessings upon the sultan. Later, heraldic emblems and plant motifs were included.

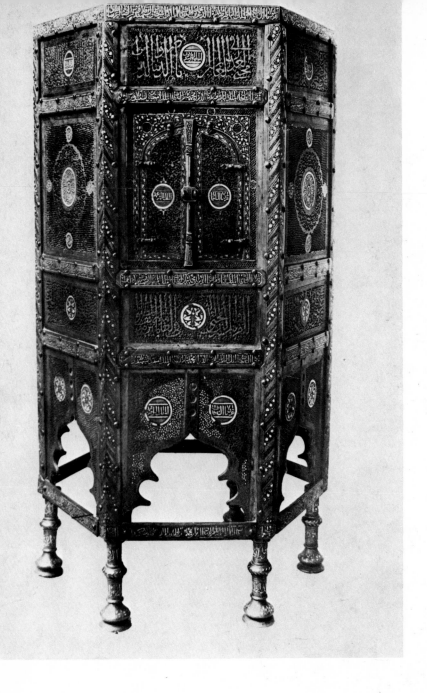

Table with cabinet for storing the Koran, a piece of furniture known as a
kursi. Bronze, inlaid with gold and silver. 1327. From Egypt. Arabic Museum,
Cairo

Goblet; so-called Chalice of Charlemagne, traditionally said to have been presented by him to the Abbey of Magdalena at Châteaudun. Glass with enamel decoration. Thirteenth century. Chartres Museum

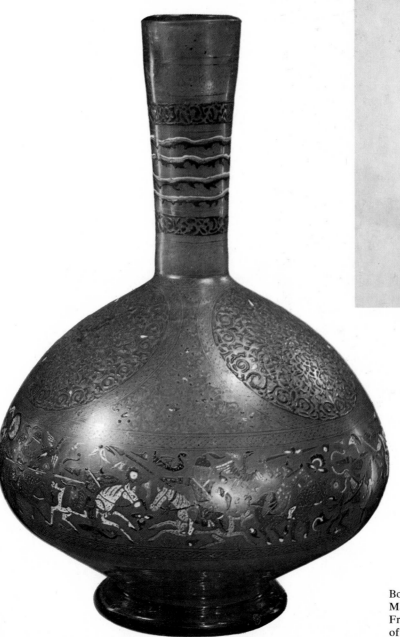

Bottle. Glass with enamel decoration. Mamluk period, fourteenth century. From Syria. The Metropolitan Museum of Art, New York City

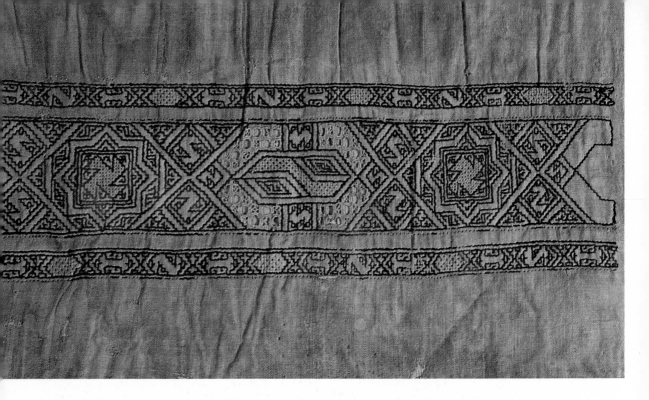

Fragment of an embroidered border. Thirteenth–fourteenth century. Probably from a village near Asyût in Central Egypt. Victoria & Albert Museum, London

TEXTILES

The royal workshops (Tiraz) had ceased to exist, but this did not mean there was any lack of woven fabrics. On the contrary, among the good things that the Mongols brought with them into Persia were great quantities of silk stuffs, which became a highly sought-after form of merchandise in Syria and Egypt. Commerce also furnished new decorative motifs as a result of indirect contacts with China. In particular, there were developments in the technique of making gold brocade at this period, of which fragments preserved in Western churches still provide tangible evidence. Linen was embroidered with silk, so that even simple garments acquired a more festive appearance. The patterns were sharp and angular, almost cubist in form, and these are the motifs that have passed into Slav and Scandinavian folk art. In addition to silk embroidery, the so-called Holbein stitch was developed at this period, while printed materials also became fashionable. The motifs were carved in wood, and with a little care a whole piece of cloth could be printed in a repeat pattern from a single block.

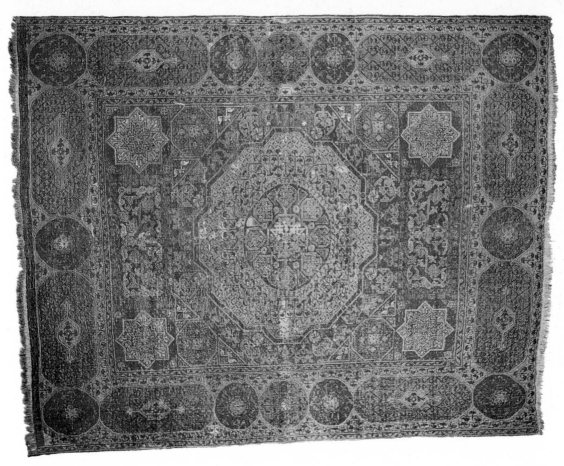

Mamluk carpet. 78 x 54″. Sixteenth century. Made, to the order of the Ottomans, in Cairo. Victoria & Albert Museum, London

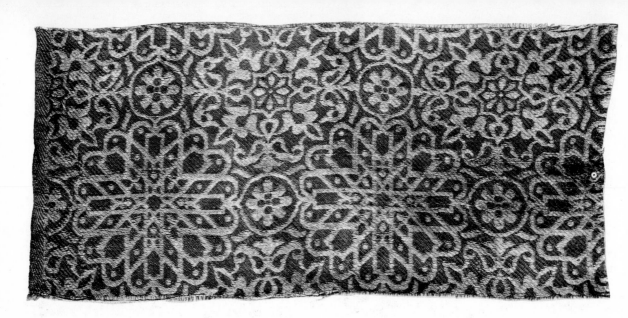

Brocade in the so-called Siculo-Arabic style. Silk, length
12¹/₄″. Sixteenth century. Rijksmuseum, Amsterdam

BOOKS AND MINIATURES

In a period of such religious awareness as this, the Koran naturally occupied an important place. The fine taste for decoration which we admire in art and architecture is also to be found in beautifully written Korans. The special style of script, the *Thuluth*, was employed, and, in addition to the magnificent flowing text, a great deal of attention was paid to the initial capitals, the marginal decorations, and above all to the title page, which was liberally embellished with gold leaf. This costly mode of decoration resulted in greater care being given to the cover, and the craft of bookbinding came into existence.

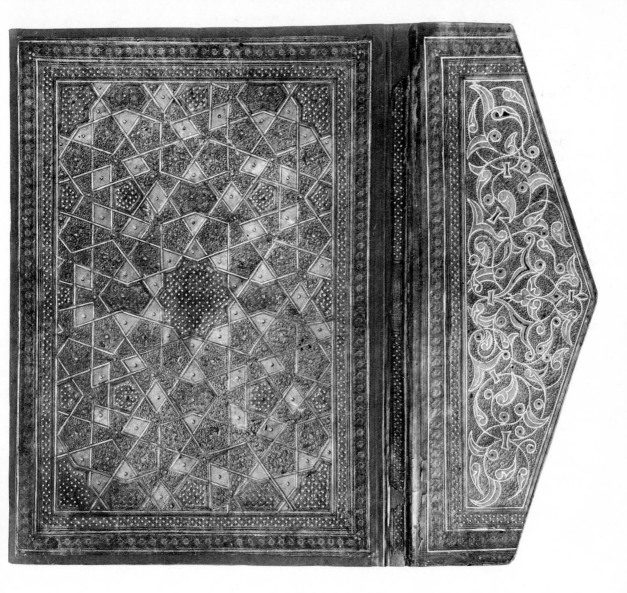

Bookbinding, with relief and gold printing. Mamluk period, thirteenth–fourteenth century. From Egypt. Staatliche Museen, Berlin

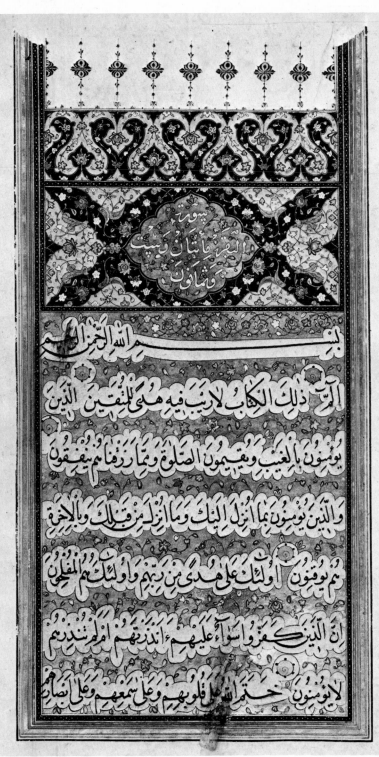

بسم الله الرحمن الرحيم

الم ذلك الكتاب لا ريب فيه هدى للمتقين الذين

يؤمنون بالغيب ويقيمون الصلوة ومما رزقناهم ينفقون

والذين يؤمنون بما انزل اليك وما انزل من قبلك وبالاخرة

هم يوقنون اولئك على هدى من ربهم واولئك هم المفلحون

ان الذين كفروا سواء عليهم ءانذرتهم ام لم تنذرهم

لا يؤمنون ختم الله على قلوبهم وعلى سمعهم وعلى ابصارهم

Leaf from the *Maqamat* of al-Hariri, showing two seated figures. Manuscript, 10½ x 7¾". 1237. From a Syrian copy of the Mamluk period. British Museum, London

Leaf from a Koran of the Circassian Mamluk sultan, al-Malik az-Zahir Barquq. Manuscript. Fourteenth century. From Cairo. Bibliothèque Nationale, Paris

Leaf from *Risalat Da'wat al-Atibba* (Banquet of the Physicians) of al-Mukhtar ibn al-Hasan ibn Butlan, showing the physician awakening to discover a banquet in his house. Manuscript, 4$\frac{1}{2}$ x 6$\frac{1}{2}$". 1273. Syrian copy of an earlier version of the Baghdad School. Biblioteca Ambrosiana, Milan

In the field of secular book illustration, we come across some interesting copies of works already known to us from the Baghdad School, such as the fables of Bidpa'i and the *Maqamat* of al-Hariri. One of the most famous of the early illustrated books was al-Jaziri's treatise on *Automata*, which must have been composed between 1180 and 1206. The original has been lost, but various copies survive—among them one in the Topkapı Sarayı Museum in Istanbul—and these undoubtedly follow it very closely. In addition, a few new works were illustrated in this period, such as *The Banquet of the Physicians,* dated 1273, and a bestiary, the *Kitab Manafi' al-Hayawan.*

In general, this school of miniature painting from Syria and Egypt is characterized by a childlike, naive style, almost exclusively decorative in intention, so that the rendering of figures suffers in consequence, although the pictures have great brilliance and charm.

Leaf from a bestiary entitled *Manafi' al-Hayawan* (On the Usefulness of Animals) of Ibn Bakhtishu', showing an ostrich sitting on eggs. Manuscript. c. 1300. From Syria. Biblioteca Ambrosiana, Milan

Sequence of three illustrations from *Kalilah wa Dimnah* (Fables of Bidpa'i), showing the adventures of the bear and the hooded crow. Manuscript. Mamluk period, second half of fourteenth century. From Syria. Bibliothèque Nationale, Paris

THE OTTOMAN TURKS

When the Mongols invaded Persia, many people endeavored to save their lives by emigrating, even if this meant leaving all their goods behind. This was the case with a small tribe from Khurasan, which settled in Anatolia about 1224. These refugees were treated well, served their Seljuk masters honorably, and managed to obtain a good position for themselves. The decline of the Seljuk dynasty in Anatolia resulted in various internal troubles, and the leader of the group of settlers, who at that time was a certain Osman, decided to put an end to the confusion by seizing power himself. His attempt was crowned with success: the Ottoman dynasty was founded in 1300, and was to continue until 1923.

The Ottomans were not content with the former dominions of the Seljuks of Rum, but quickly sought to extend their power. Orkhan, Osman's successor, conquered Bursa in 1326 and made this city his capital. The Ottomans were soon firmly established in western Asia Minor and in eastern Europe, and, although their armies suffered a defeat at the hands of Tamerlane and their sultan, Bayezid, was taken prisoner, his successor Muhammad (Mehmed I Çelebi—the "gentleman") was able to consolidate the empire once more. His successors carried on with the work of empire building. The Byzantine capital, Constantinople, fell in 1453, whereupon it became the Ottoman capital. In the sixteenth century, the Ottomans ruled from the Adriatic Sea to Mesopotamia. Subsequently, they were slowly but surely driven back inside the frontiers of modern Turkey.

ARCHITECTURE

Considering the previous history of this dynasty, it goes almost without saying that it would continue the Seljuk building tradition. The earliest Ottoman examples are to be found in the new empire's first capital, Bursa. The mosque is of the familiar type, its main aisles and halls having domed roofs, and light being allowed to enter the building through openings in the drum of the dome. Simpler constructions consisted of a single large domed hall with a front entrance portal. From this, a new type was developed by building, as it were, a duplex domed hall with subsidiary halls, again with an entrance portal at the front, as in the Nilüfer Imaret (almshouse) in Iznik. Madrasahs were of a similar design; the madrasah of Murad I in Bursa, for example, follows the scheme of the mosque in Nicaea. Further building was carried out on this madrasah in the fifteenth century. Other striking examples are the madrasahs of Mahmud Pasha and of Murad Pasha in Istanbul, which were built shortly after one another between the years 1460 and 1470.

The great monument which inevitably came to serve as an inspiration for later buildings was Hagia Sophia, originally a Byzantine cathedral built by the emperor Justinian and later converted into a mosque. The great central nave of Hagia Sophia is spanned by a dome one hundred feet in diameter, and is prolonged to the front and the rear by half-domes with the same diameter at the base. The Fatih Mosque in Istanbul, built for Mehmed II, the Conqueror, between 1463 and 1469 on the foundations of the old apostolic church of Justinian, is ascribed to the Greek architect Christodoulos. It is the first mosque to follow the design of Hagia Sophia, the arrangement of domes being almost the same, although they are of more modest dimensions. Around this mosque Mehmed built a gallery, covered with domes and overlooking an inner court with a fountain. A finer example is provided by the mosque of Sultan Bayezid II, which was built between 1501 and 1507 by the architect Hayr ed-Din.

In the sixteenth century, it was no longer a scheme or a building that laid down the law to the architects, but one individual, the master builder Sinan. He was one of those men who, by their powerful personality, succeed in stamping their hallmark on an entire century. This was not due to the quantity of his work,

Interior of Hagia Sophia, Istanbul, after an engraving by G. Fossati (c. 1850)

Inner court of the Fatih Mosque, Istanbul. Built for Sultan
Mehmed II by the Greek architect Christodoulos, 1463–69

although he left behind 318 buildings to his credit, but from the genius with which he managed to combine religion, aesthetics, and architecture. He was a foreigner whose nationality is not known for certain, any more than his date of birth, although his death, in 1578, obviously did not pass unnoticed.

Despite his foreign origin, Sinan had completely assimilated the Turkish tradition, as may be seen from his first work, the Shehzade Mosque, which recalls the Fatih Mosque. In his next great enterprise, he kept in mind the example of Hagia Sophia and the mosque of Bayezid, and produced for his patron, Süleyman the Magnificent, between 1550 and 1557, a superb complex of buildings on one of the seven hills of Istanbul. Here we encounter all the typical Anatolian constructions of earlier periods. Among the subsidiary buildings are the bathhouse, the almshouse (*imaret*), the hospital, the *caravanseray*, the *türbe* or mausoleum for the princes, and three madrasahs, with the mosque as the principal building.

In his greatest creation, the Selimiye Mosque which he built for Sultan Selim II in Edirne between 1570 and 1574, Sinan challenged the existing architectural ideas of proportions and stresses. He not only equaled the span of Hagia Sophia, but made the building light—literally and figuratively—by piercing the walls and introducing as many windows as possible. Until well into the seventeenth century, Sinan's creations served as the source from which all architects drew their inspiration, for example, the Ahmediye, or Blue Mosque, in Istanbul (1609–17) and the Yeni Valide Cami (1651), which comprise elements of the Fatih Mosque, the Shehzade, and the Süleymaniye. The influence of Ottoman architecture was to extend to Syria, Egypt, Arabia, and even to Algeria. In Cairo, its effect was felt somewhat late, but the Great Mosque, which the Greek Yusuf Bokhny built for Muhammad 'Ali, in accordance with Sinan's ideas, between 1824 and 1857, is no less imposing on that account.

The Süleymaniye Mosque, Istanbul. Built for Süleyman the Magnificent and designed by the great architect Sinan, 1550–57

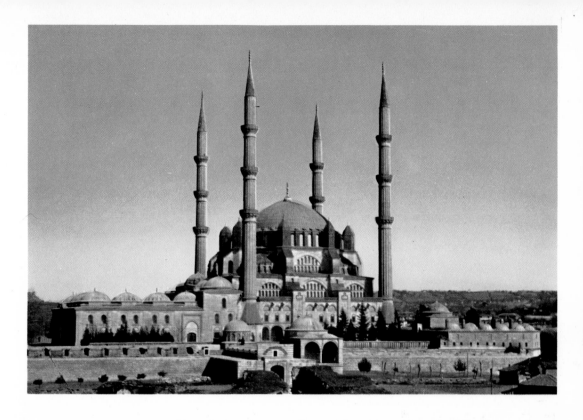

The Selimiye Mosque, Edirne. Designed for Sultan Selim II by Sinan, 1570–74

SECULAR ARCHITECTURE

Little or nothing remains of the oldest palaces. An imposing palace on which work had begun in the middle of the fifteenth century, the Topkapı Sarayı in Istanbul, was later completed and extended by various sultans. It consists of a vast complex of separate buildings and gardens. The Çinili Kiosk is the oldest of the complex, having been built in 1472 by Kemal ed-Din. The name means "faience pavilion" and is well deserved, for lavish tilework was often a feature of Ottoman art, and this building was formerly adorned with tiles both inside and out. In the other famous kiosks, those of Revan (Erivan) and Baghdad, we also find profuse tile decoration. The whole complex of buildings of the Topkapı Sarayı, however unconnected it may seem at first sight, nevertheless reveals a certain tradition—Western, on this occasion—in the concept of three inner courts, as in the Moorish style. The Bab-ı Hümayun gives access to the first court. The Gateway of Blessedness, with the apartments of the eunuchs, is the last of the three and leads to the throneroom, around which are the halls with the world-famous treasuries.

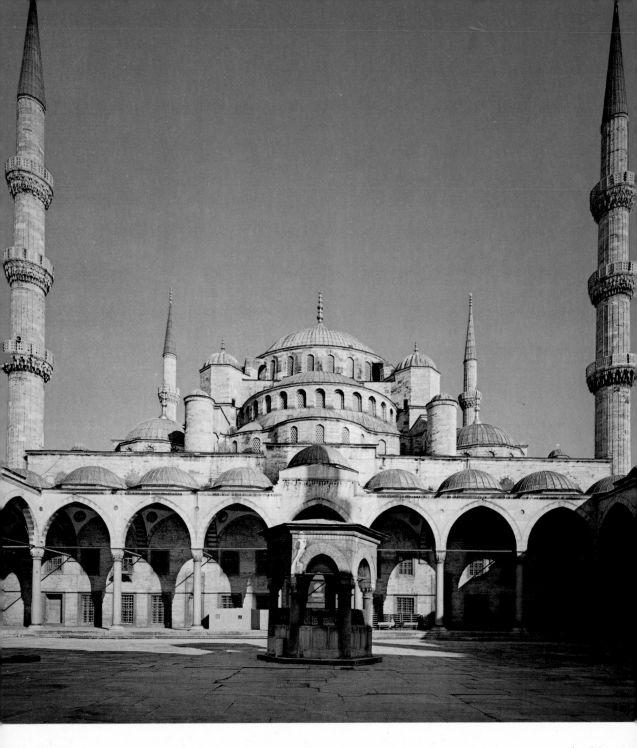

The Ahmediye Mosque, Istanbul. Built for Sultan Ahmed I by Mehmed Agha, 1609–17. It is known as the Blue Mosque from the color of the tiles adorning the interior

Interior of the Ahmediye, Istanbul. The heavy, fluted piers which support the dome have been nicknamed "elephants' legs"

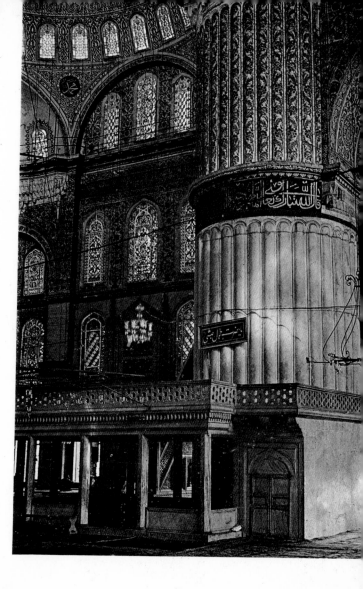

The public baths, the comfort and amenities of which have remained famous to our own day, formed a new feature in secular architecture. As in Antiquity, the bathing process consisted of three stages: first one entered the changing or rest room, then passed into the warm or tepid room, and only then into the really hot room with the sweating-baths. Often male and female bathing places were combined in one building. From the architectural point of view, there were two main types, the first built on an octagonal plan with additional niches, and the second having a cruciform plan, a dome, and four *iwans*. Among the oldest bath houses is the Eski Kaplıca, which dates from the fourteenth century.

While the influence of the Seljuks is evident in the design of early Ottoman buildings, differences in decoration soon made their appearance. The use of marble resulted in facades which were much more sober and restrained, and in interior decoration, too, marble supplanted wood. Marble lends itself more readily to linear patterns than to relief ornaments, which, when they occasionally were employed, at best took the form of designs in low relief. Stucco remained the appropriate material for relief decorations. It was still being employed in the eighteenth century, particularly when European taste found acceptance at the Turkish court and the European Baroque style became popular there, at least as far as decorative elements were concerned. From the structural point of view, this fashion was not adopted. One example, however, is the Nur-i Osmaniye Mosque in Istanbul (1746–55), in which the inner court is surrounded by semicircular arcades. In the interiors of some of the kiosks, one finds heavy stucco decorations on the walls, ceilings, niches, and chimneys.

Where wood was used at all in monumental architecture, it was handled with great care. In addition to the carved motifs, a new decorative form suddenly made its appearance. This was lacquer painting on wood, which in mosques was limited to the traditional motifs, but in houses unfolded into hitherto unexplored possibilities. Complete wall paintings came into existence in this manner, looking like miniature paintings reproduced on a large scale.

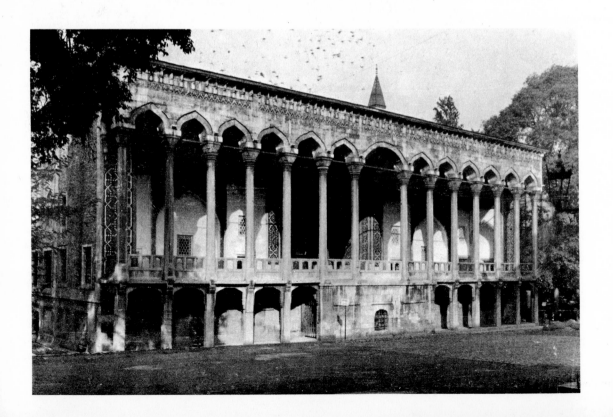

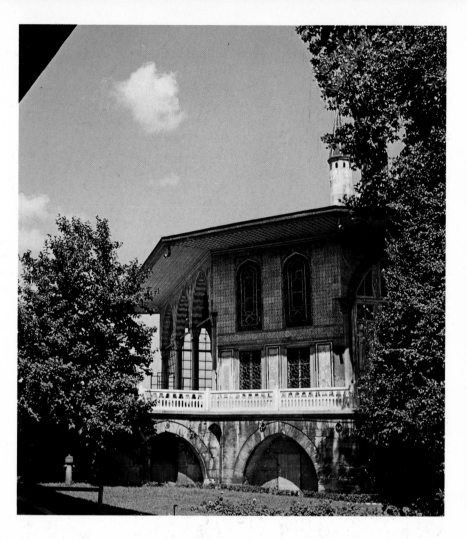

Exterior of the Baghdad Kiosk. Built by Murad IV to commemorate his conquest of Baghdad, 1638

The Çinili Kiosk, overlooking the Golden Horn. Built by Mehmed II, 1472

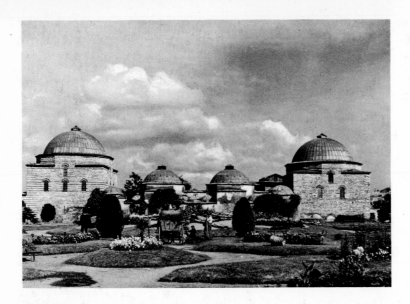

Turkish bathhouses in Istanbul, situated between Hagia Sophia and the Ahmediye

The most important decorative element, however, continued to be ceramic ornament. Early in the fifteenth century, we already have magnificent examples of tile decoration both inside and outside the building, as in the Yeshil Cami, or Green Mosque, and the accompanying Yeshil Türbe, which was built for the founder, Mehmed I, in 1421. The mosque owes its name to the turquoise-colored tiles which adorn the outside. The interior gives further justification for the name: up to a certain height, the walls are covered with hexagonal blue, green, or turquoise tiles decorated with motifs in gold. The *mihrab*, which is thirty-three feet high, is entirely composed of tilework, with a refined decoration of waving garlands of a Persian-Chinese character, together with arabesques and inscriptions in both Kufic and *Naskhi*. This *mihrab* decoration has been attributed to the "masters of Tabriz," who had brought from their country into Turkey something of the style of the Timurid period.

In the Mosque of Murad II in Edirne (1433), where once more the "masters of Tabriz" had been active, they had developed a new technique: white-bodied tiles with an underglaze painting in blue and white or in black under a turquoise glaze. After some fifty years, this style went into a speedy decline, and in the Çinili Kiosk (1472) we again see tile mosaics and gold-painted tiles similar to those in the Green Mosque

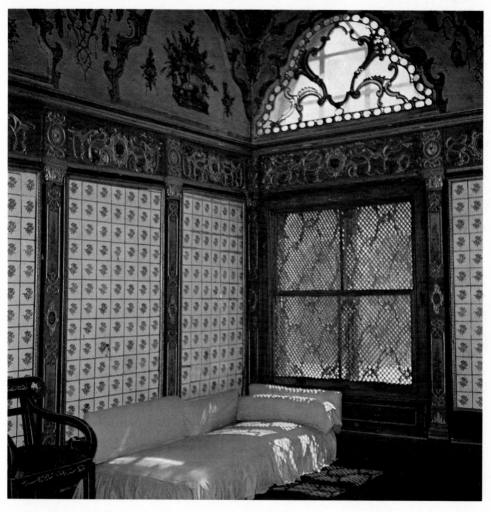

Apartment of the Valide (the official title of the reigning monarch's mother) in the Topkapı Sarayı in Istanbul

Not long afterward, the town of Iznik, the Byzantine Nicaea, began to flourish as a center of ceramic production, although at first not a great many tiles were made there. When Süleyman I set himself the pious task of restoring the dilapidated mosaics on the outer walls of the Dome of the Rock in Jerusalem, he decided that this should be done entirely in tiles. Since there were no tileworks in Turkey suitable for this task, the sultan had recourse to Persian factories. This spurred on the craftsmen of Iznik to greater efforts in the production of high-quality tiles, and before the Persians had been able to complete the work by their particular process, Iznik tiles were ready for use in the last stage of the restoration. From now on, we find Iznik tiles in Süleyman's own mosque, in the mosque of Rüstem Pasha (1561) and of Sokollu Mehmed Pasha (1571), in the Blue Mosque of Sultan Ahmed I (1609–17), in the Yeni Valide Mosque, and in numerous palace buildings.

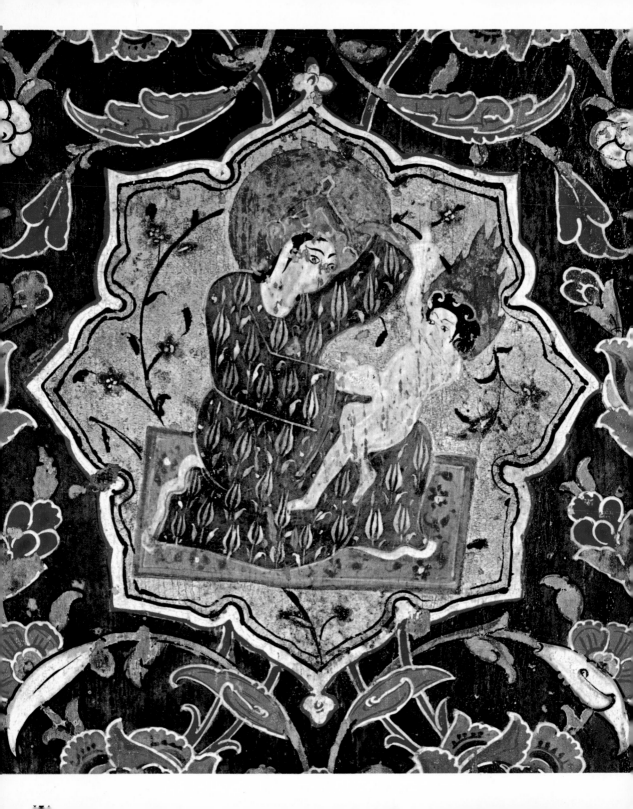

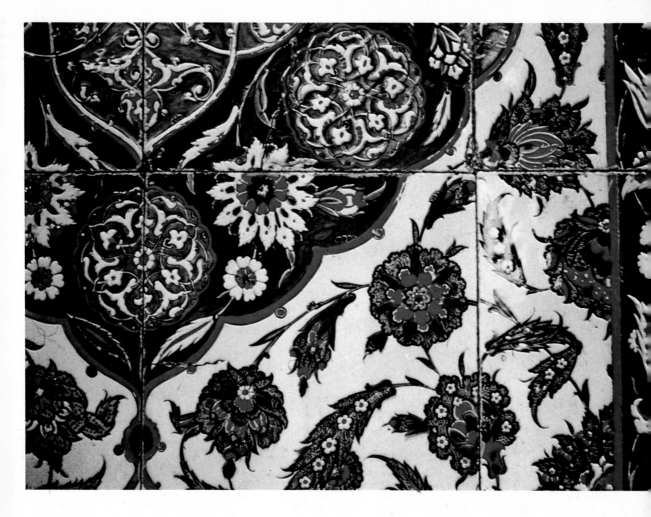

Detail of tilework in the mausoleum of Süleyman the Magnificent in Istanbul. Sixteenth century. The tiles came from the Iznik workshops

Madonna and Child; detail of one of the lacquer paintings on the walls of a reception room of a private house in Aleppo. 1600–1603. Staatliche Museen, Berlin

The history of Ottoman or Turkish ceramics has, in the main, been made by the cities of Iznik and Istanbul. The former made the more important contribution, and went through three periods of prosperity, each with a distinct style. Products of the first phase, which occurred between 1490 and 1525, are sometimes popularly confused with ware from Kütahya, probably because of one Abraham of Kütahya, a resident of Iznik, whose name was found on the base of a pot. No kilns of this period have been found in

Tiled *mihrab* in the mosque of Sokollu Mehmed Pasha in Istanbul, designed by Sinan, 1571–72

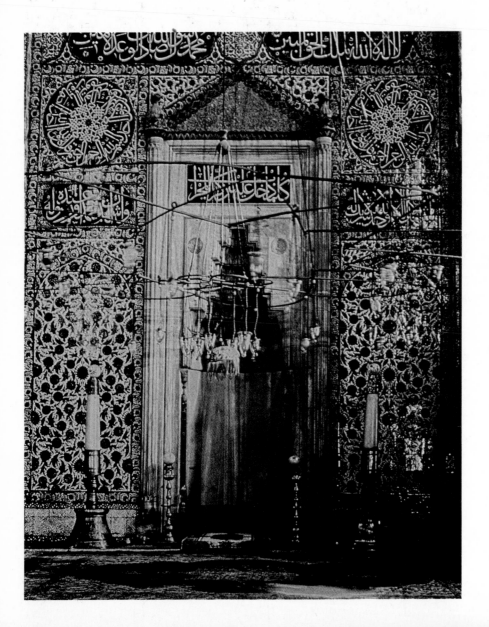

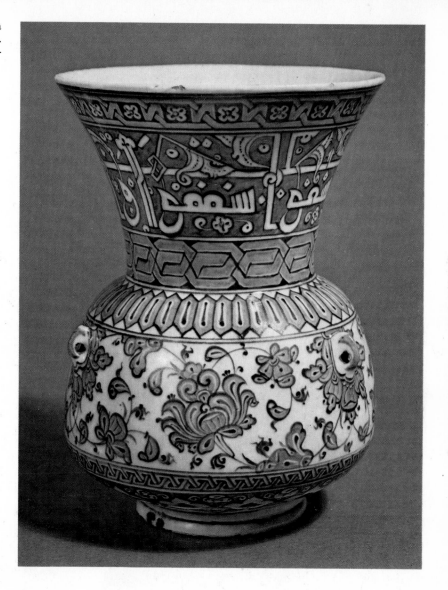

Mosque lamp. Blue painting on a white ground, height 11 3/4". c. 1500. From Iznik. British Museum, London

Kütahya, so to ascribe these fifteenth-century products to that town would appear inaccurate. The motifs consist of tendrils, arabesques, and inscriptions on a blue or white ground. The shapes of certain vessels imitate prototypes in other materials: for example, the glass ampulla of Syrian mosques is reproduced here in earthenware.

The second period of Iznik prosperity extended from 1525 to about 1555, and again the products have been given a faulty description, being known as "Damascus ware." In addition to the imitation of Chinese blue-and-white ware, the range of colors included green, blue, purple, and a greenish black. Flowers were the principal motifs, sometimes fancifully rendered and sometimes true to nature.

The ware of the third Iznik period, which continued from the mid-sixteenth century into the eighteenth, once again has been given a misleading title, being often called the "Rhodian style." This error arose

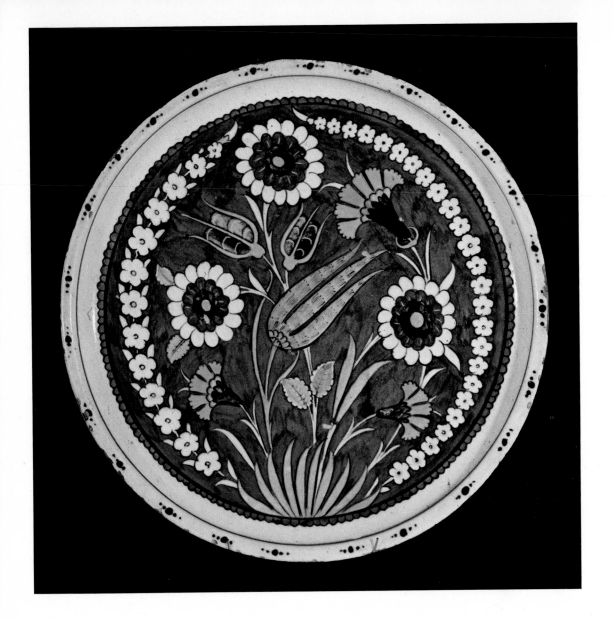

from the fact that the catalogue of 1883 of the Musée Cluny in Paris stated that the more than five hundred pieces on view had been purchased at Rhodes, and that they would have been made on the island by descendants of the Crusaders. Many new aspects of decoration were revealed in this third period. On the prescribed white ground, a number of new motifs were painted in turquoise, blue, green, purple, and brown, and these suggest to us something of Turkey's wealth of flowers. The cypress often appears, but in addition we find carnations, tulips, roses, and hyacinths as favorite motifs, and grapes and artichokes also occur in the designs. The hitherto somewhat confined circle of principal motifs now opens to include human figures, and in the seventeenth century ships become a popular theme, reflecting growing maritime interests.

Dish. So-called second style of Iznik ware, characterized by lively floral designs, diameter 10³/₄″. 1520–50. From Iznik. Victoria & Albert Museum, London

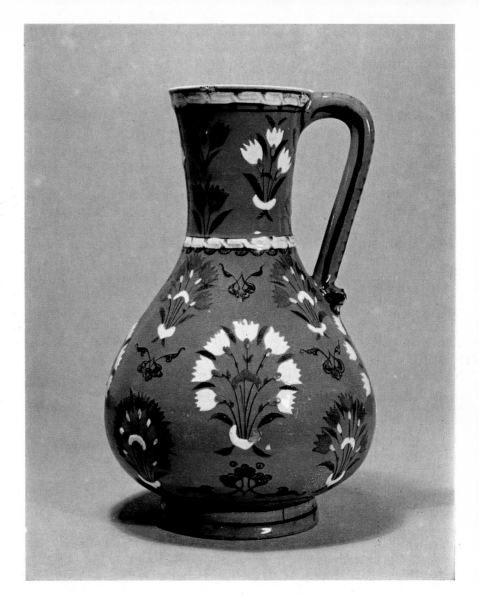

Jug. Earthenware, with floral decoration on a brown ground, height 9⁷/₈″. End of sixteenth century. From Iznik. British Museum, London

In the eighteenth century, toward the end of Iznik's long period of prosperity, the town of Kütahya began to develop as a pottery center, though in quality its wares do not match the products of Iznik. Two other centers, Istanbul and Çanakkale, flourished in the nineteenth century, mainly for local production. In particular, the potteries set up by 'Abd ül-Hamid II produced ware of fine quality, but these bring us into the twentieth century, which is outside the scope of this book.

Flask in the form of a pilgrim's bottle. Polychrome blue and white, height 7¹/₄". Eighteenth century. From Kütahya, Turkey. Victoria & Albert Museum, London

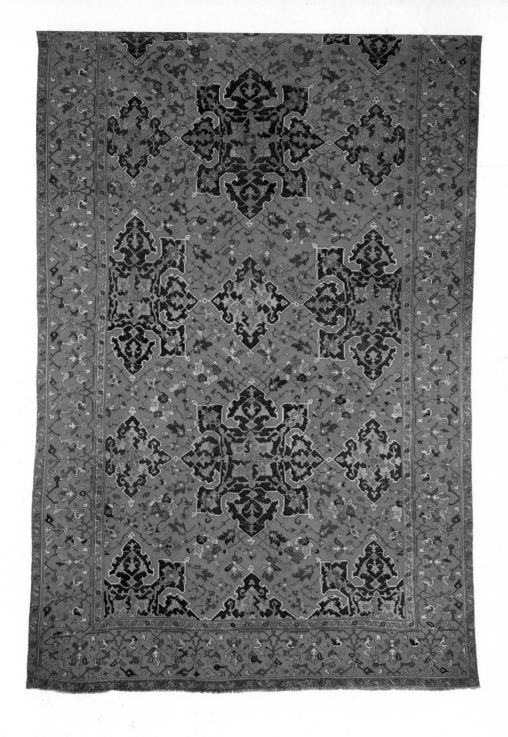

Ushak star-type carpet. Wool. End of sixteenth century. From Turkey. The Metropolitan Museum of Art, New York City. Gift of Joseph V. McMullan, 1958

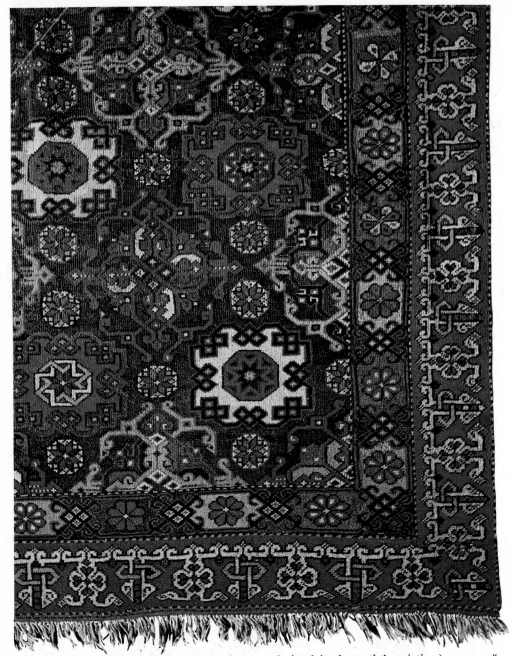

Fragment of a so-called Holbein carpet (of a type depicted in that artist's paintings). 105 x 52".
c. 1500. Asia Minor (Ushak). Piero Barbieri Collection, Genoa

Prayer rug. Silk, made in so-called Gördes knots at the Ottoman court factory in Cairo. End of sixteenth century. The
Metropolitan Museum of Art, New York City. James F. Ballard Collection. Gift of James F. Ballard, 1922

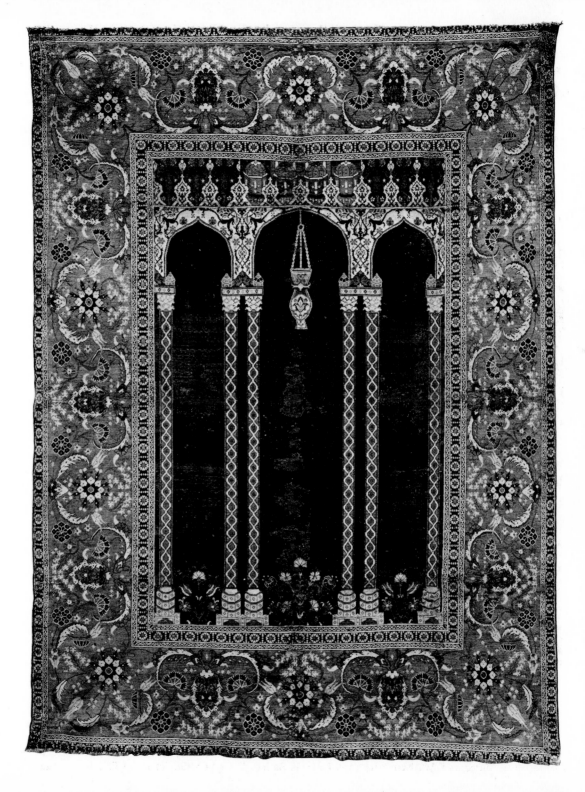

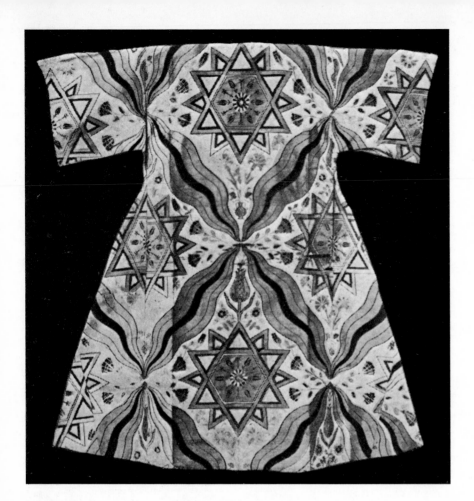

Robe of Sultan Mehmed II. Silk. Second half of fifteenth century. Topkapı Sarayı Museum, Istanbul

TEXTILES

From the very beginning of the Ottoman dynasty, a great deal of attention had been bestowed on silk, velvet, and brocades. Bursa was the main center, and here the looms were kept very busy in meeting the enormous demands of the court, weaving silks and brocades for costumes, curtains, cloth, and covers. Yellow, red, and blue formed the colors of the ground for the most part, into which were woven floral designs in black, gold, red, and blue. The motifs are largely the same as are found in ceramics, although sometimes more stylized. Carnations and tulips are often arranged in a palmette shape and other flowers set in a rosette; arabesques, borders of clouds in the Chinese manner, and tendrils of various shapes are other features of the designs. Embroidered work in gold and silver thread on velvet comes into its own in the seventeenth century.

Textile fragment. Silk brocade. Ottoman, sixteenth century. From Bursa, Turkey. Kelekian Collection

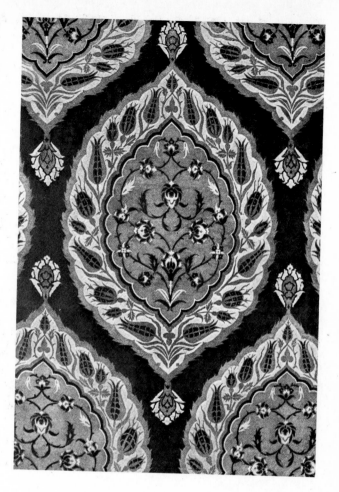

While the woven fabrics may have found a good market in Europe earlier on, it is the knotted rugs and carpets which are in demand all over the world today. Somewhere, in almost every great Western city, there is a shopwindow displaying names like Ushak, Gördes, Kula, Ladik, and Bergama. There are no examples of rugs from the early Ottoman period, the oldest known Ottoman rug being one of the Ushak type from 1584. The reason why none should have been preserved between those of Seljuk times and this one from Ushak is not clear, any more than is any idea we might form from the carpets that appear in early Italian and Dutch paintings. It seems that the well-known carpets of the sixteenth century were called Ottoman because they had been found in Turkey, but in fact they had been made in Egypt. They show a typical mixture of two styles, the Mamluk and the Ottoman.

Portrait miniature of Mehmed II by his court painter Sinan Bey. End of fifteenth century. Topkapı Sarayı Museum, Istanbul

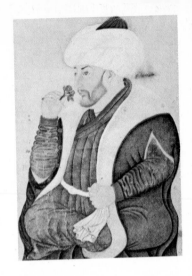

GENTILE BELLINI (c. 1429–1507): *Portrait of Mehmed II, the Conqueror.* 1480. Oil on canvas, 27½ x 20½". Painted in Constantinople (Istanbul). National Gallery, London

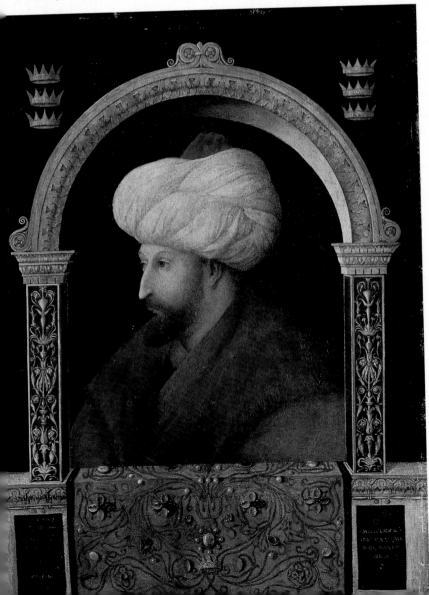

Miniature from the *Divan* of Ahmed Pasha, showing an episode from the story of Khusrau and Shirin. Sixteenth century. Bibliothèque Nationale, Paris

Leaf from the *Aja'ib al-Makhluqat,* showing praying angels. Manuscript. Ottoman, c. 1550. British Museum, London

The Mamluks had already assimilated various influences from classical patterns in floor mosaics and Coptic fabrics, while in technical matters the Persians had been their teachers. After the conquest of Egypt by the Ottomans, a mixed style came into being, in which the background and divisional arrangement of the rug can still be recognized as Mamluk, but the motifs, mainly from plants, bear the unmistakable

Leaf from the *Humayun-nameh*,
showing the miracle of the flying
tortoise (a pair of ducks who
wished to leave a pool that was
drying up could not leave behind
their friend the tortoise). Manu-
script. c. 1580. British Museum,
London

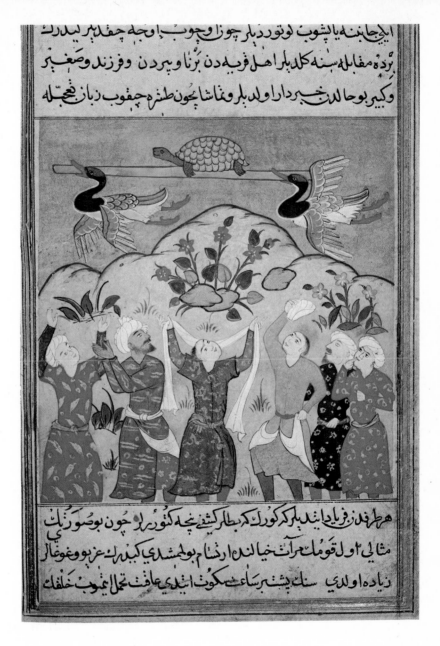

Ottoman stamp. Carpets of this kind were put on the market in Europe in the sixteenth and seventeenth
centuries under the name "Cairene" (from Cairo). The Turks themselves later made more handsome
carpets, and many orders came in from Europe, particularly for the Ushak type, as may be seen from the
carpets blazoned with the arms of Western patrons.

Portrait miniature of one of the sultan's attendants. Ottoman, eigh-
teenth century. Rijksmuseum voor Volkenkunde, Leiden

SIYAH-KALEM: *The Dance of the Black Shamans*. Miniature. Fifteenth century. From the so-called *Fatih Album*. Topkapı Sarayı Museum, Istanbul

The Ushak rugs may be divided into two groups, known as the star type and the medallion type. The latter is the larger and more important group, and its production also continued for a longer time, right into the eighteenth century. These rugs owe their name to the design of alternate lobed and indented medallions on a blue or red ground, generally filled in with stylized flowers. The star Ushaks have blue star-shaped motifs interset with diamond shapes on a red ground, sprinkled with multicolored florets. Variants of the Ushak rugs are the so-called bird type and lightning type, and their later subdivisions. As a separate group, we should mention the prayer rugs, which can always be recognized by the representation of the *mihrab* which is a feature of their design, and which the believer laid in the direction of Mecca when he prostrated himself in prayer.

SIYAH-KALEM: *Demons Making Music*. Miniature. Fifteenth century.
From the so-called *Fatih Album*. Topkapı Sarayı Museum, Istanbul

BOOKS, CALLIGRAPHY, AND MINIATURE PAINTING

Books and calligraphy went hand in hand, and the calligraphers enjoyed an almost excessive patronage. The Ottoman Sultans had proclaimed calligraphy as the loveliest and noblest of the arts, and its practitioners formed a highly favored elite, able to extract numerous privileges for themselves. In the first place, it had obviously been important to provide enough copies of the Koran. At the beginning of their dynasty, the Ottomans evidently allowed Korans to be brought in from elsewhere, and from the year 1400 almost certainly from Tabriz, a center which radiated an enormous cultural influence. Possibly a number of calligraphers from Tabriz came to work in Istanbul, as in the case of the ceramic artists; in any case, the Turks were copying the Persians until well into the seventeenth century.

To the European taste, the miniatures are of more interest. As one would expect, Persian influences predominate here to a large extent. However, the Persian and Turkish miniatures can clearly be distinguished from one another by differences in coloration, composition, clothing, and even in the portrayal of

personages. However, the subjects almost entirely correspond to Persian themes. One of the earliest dated Ottoman manuscripts, which is from 1499, is a copy of the story of Khusrau and Shirin by the Persian poet Nizami, translated into Turkish by Sheyhi. Works evidently of a somewhat earlier date are occasionally characterized by completely indigenous traits. The most accomplished painter of the fifteenth century was undoubtedly Siyah-Kalem, or "Black Pen." With a trenchant realism, this genius manages to take us inside the charmed circle of the nomads' everyday life, with all the miscellaneous details associated with it.

SIYAH-KALEM: *Procession of the Falconers*. Miniature. Fifteenth century. From the so-called *Fatih Album*. Topkapı Sarayı Museum, Istanbul

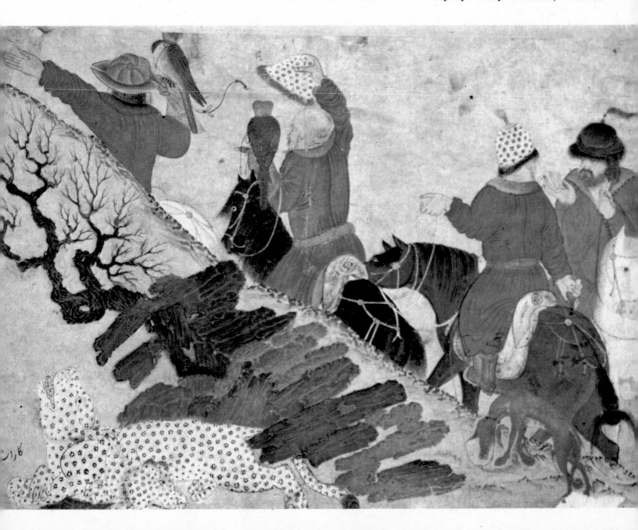

THE MONGOLS IN PERSIA: ILKHANIDS AND TIMURIDS

The Mongol invasions swept over Persia like a tidal wave. Its terrible force was very slow to diminish and it was long before the waters receded, leaving the land visible and recognizable once more, despite its ravaged features. The destructive flood came, in fact, in three waves: the first under the notorious Jenghiz Khan, between 1218 and 1222; the second under his grandson Hulagu, who in 1258 finally put an end to the 'Abbasid dynasty by murdering the last shadow caliph in Baghdad; and the third under Timur, or Tamerlane, who, despite the ruthlessness and destructive violence of his conquests, was nevertheless a great lover of art, under whose patronage new ideas and impulses soon kindled. The consequences of the Mongol conquests, which of course were felt with particular force and effect in Seljuk Persia, can by no means be regarded as calamitous in the realm of art. Jenghiz Khan's relatively short but drastically felt sojourn in Iran brought no artistic benefits, but under Hulagu, who allowed himself to be installed as the first Ilkhan of Persia, the tide already began to turn, and the first signs of the inevitable process of assimilation also became perceptible. Toward the end of the thirteenth century, numerous Mongols had already become converted to Islam, thus confirming spiritually the tendencies toward adaptation to the conquered regions. This they had already shown on a material plane.

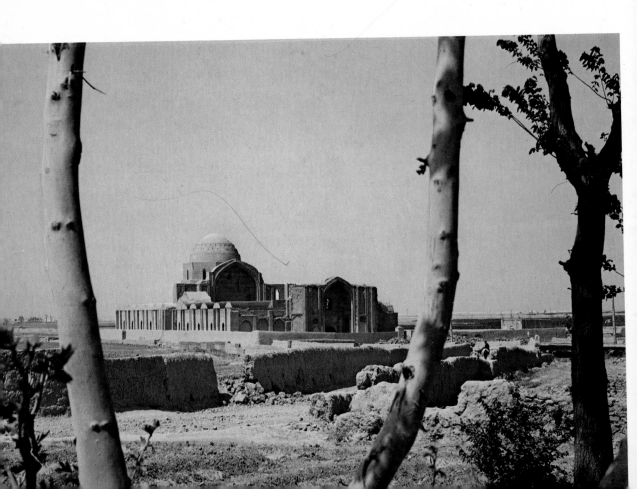

The architects in particular stressed tradition, and fully accepted what their Seljuk predecessors had found desirable. The scheme of the Seljuk mosques and madrasahs was generally followed without striking modifications. The Great Mosque of Varamin retains the cruciform plan, with four *iwans* and the domed chamber below the main *iwan*, although the huge Masjid-i Jami' of Taj ad-Din 'Ali Shah in Tabriz is somewhat different, having an open *iwan* without a domed chamber.

The first signs of a peculiarly Mongol style are visible in funerary architecture. The tomb ascribed to Hulagu's daughter in Maragheh belongs to the Seljuk style, but in the mausoleum of Uljaitu Khudabandeh Shah (1304–17), the successor of Ghazan Khan, which was built in Sultaniyah, we perceive new and characteristic details. Uljaitu's mausoleum, the only remaining monument of a great complex of buildings, consists of a gigantic domed chamber with a small chapel for the dead. The dome is of double construction, so that the visual effect is enhanced by making the outer dome as steep as possible. Originally, each corner of the octagonal base of the dome was accented by a tall, minaret-like tower.

As for secular architecture, we have to rely on accounts by early travelers such as Marco Polo, Wilhelm van Rubruk, and Ibn Battutah. Their elaborate descriptions, enriched with our own fantasy, succeed in conjuring up a scene of pomp and splendor that has inspired many a Western artist, and none better than Samuel Taylor Coleridge. In his poem, which he termed a "psychological curiosity," Coleridge evokes a lyrical vision of the palace of Qubilai Khan:

In Xanadu did Kubla Khan
A stately pleasure-dome decree:
Where Alph, the sacred river, ran
Through caverns measureless to man
* Down to a sunless sea.*
So twice five miles of fertile ground
With walls and towers were girdled round:
And there were gardens bright with sinuous rills,
Where blossom'd many an incense-bearing tree;
And here were forests ancient as the hills,
Enfolding sunny spots of greenery. . . .

The Masjid-i Jami' at Varamin. Built 1325–26

We find a new form of building in the inns, comparable to the *caravanserays*, which stood along the important roads. In general, these buildings were oblong in plan, with a large covered hall and adjoining apartments in two stories.

ARCHITECTURAL ORNAMENTATION

The decorative techniques developed to adorn palaces and places of worship during and before the Seljuk period were also employed at this time. Two elements in particular spring to the forefront, however: stucco ornament and tile mosaics. During the Mongol period, stuccowork reached a peak of achievement in a mixture of epigraphic, geometric, and floral motifs. No space is left where the eye can pause; the most elementary contours remain visible, but beyond this all the relief motifs appear intricately wedded to one another. This style is demonstrated by the interior of the Pir-i Bakran mausoleum near Isfahan, or the *mihrab* of the Masjid-i Jami', or Congregational Mosque, in Isfahan.

What one might describe as ceramic marquetry was a decorative feature particularly esteemed by the Mongols. Tileworks in various places, but especially in Kashan, had recovered from the violent aftermath

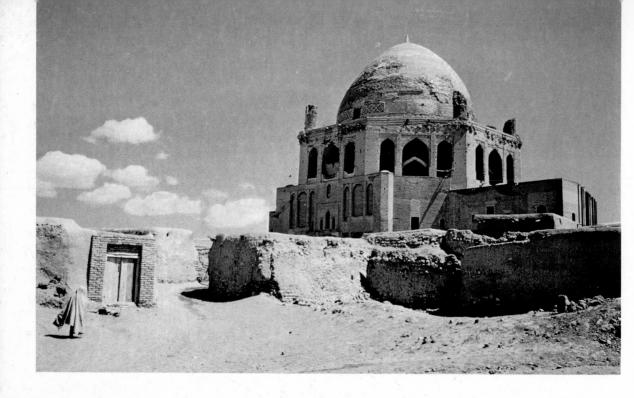

The mausoleum of Uljaitu Khudabandeh Shah, Sultaniyah. Begun in 1304

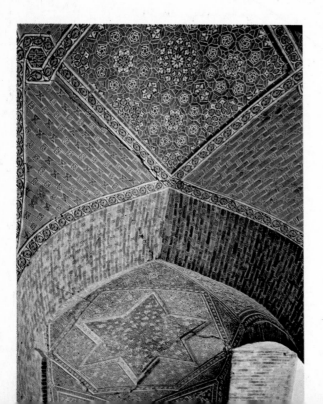

Exterior detail of the Masjid-i Jami' in Isfahan. This beautiful building (the inner court of which is illustrated on page 87) experienced numerous alterations, restorations, and enlargements in the course of the centuries. The tile decorations of this portal on the western side were renewed in Safavid times

Detail of ceiling decoration in the mausoleum of Uljaitu Khudabandeh Shah

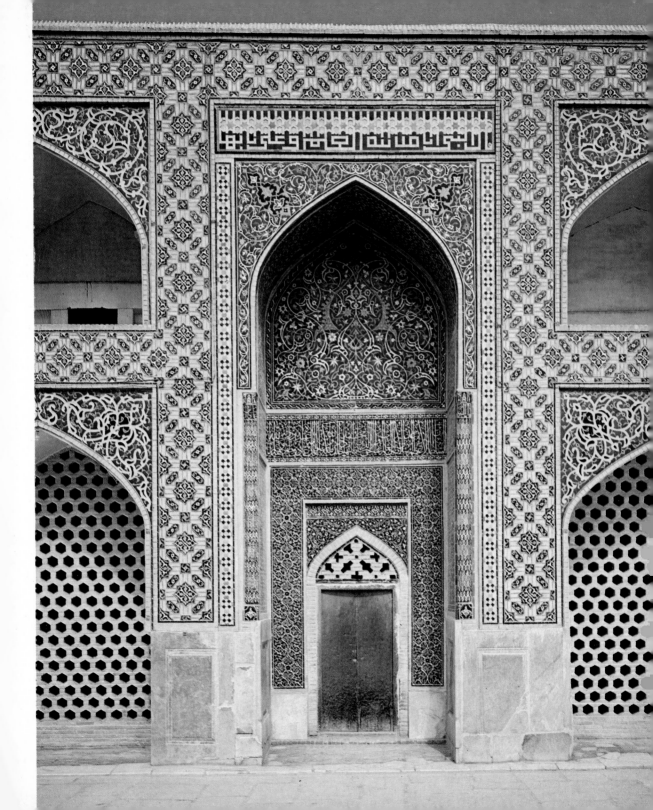

of the wars and were again producing new types of tiles to embellish the walls and *mihrabs* of the mosques. Here the motifs were still similar to those we find in the plasterwork; in the decoration of secular buildings, however, Chinese influences predominated, which may best be explained when we come to discuss painting.

Bowl. Earthenware, with blue and black motifs under a thick layer of glaze, characteristic of the so-called Daghistan pottery. Sultanabad style, fifteenth century. Haags Gemeentemuseum, The Hague

Bowl. Sultanabad type, known as "grisaille" ware, diameter 7¹/₈". Victoria & Albert Museum, London

CERAMICS

In addition to Kashan, which under the Mongols also excelled in the production of tiles, other places rose to prominence as centers of pottery making, especially Tabriz and Sultaniyah, while Saveh, too, played a significant role. It appears that Hulagu attempted to make good the damage he had caused in Rayy, but unfortunately this once so thriving city was unable to recover and fell into decay in the fourteenth century. The pottery that is popularly known as Sultanabad denotes a type of ware found in the neighborhood of the city of Iraq (formerly Sultanabad) in present-day Iran.

Two types are characteristic of this pottery, one having underglaze decoration in blue, green, and black over a yellowish slip mainly of a floral character; the other being a composition of white, brown, and gray, which is sometimes called "grisaille." Other characteristic products have a rather coarse-textured body with thickly applied motifs covered with a heavy glaze.

Miniature from the *Jami' at-Tavarikh* (Universal ▶
History) of Rashid ad-Din, showing Buddha feeding
the Devil. 1314. Tabriz. Victoria & Albert Museum,
London, on loan from the Royal Asiatic Society,
London

Figurine of a lute player. Pottery, painted and glazed.
Twelfth–thirteenth century. The Metropolitan Museum
of Art, New York City. Rogers Fund, 1922

Dish. Earthenware, with blue and black painting
under glaze, in a leaf decoration typical of Kashan
pottery. Thirteenth century. From Kashan. Haags
Gemeentemuseum, The Hague

PAINTING

The affinity between ceramics and painting in their choice of motifs, which was so marked in the Seljuk period, is less close under the Mongols. This is due to various reasons. Firstly, the development of literature brought a demand for more illustrations of a narrative kind, and secondly, the collision of ideas between the intellectual groupings in East and West, which included men of literature, calligraphers, and illuminators, was greater than that of the artisans.

Out of the union between the Chinese Yüan masters and the old representatives of the Baghdad School, a new style was born, the Mongol style, of which the cradle was Rashidiyyeh, the university suburb of Tabriz. The moving spirit of this new style at the beginning of the fourteenth century was the vizier Rashid ad-Din, both statesman and historian, whose own book, *Jami' at-Tavarikh* (Universal History) was copied and illustrated on several occasions. In these volumes, we find, among other things, the story of Muhammad and his followers, and the story of Buddha and India. About a decade older than Rashid ad-Din's history is the *Manafi' al-Hayawan* manuscript (On the Usefulness of Animals), which clearly shows how the various styles of painting influenced one another, before characteristically Chinese motifs were added to some of them. The folio with the famous painting of Adam and Eve shows how the birds which are depicted there are related to the Baghdad School and how greatly the human figures, which with great temerity are portrayed seminude, correspond to the Seljuk canon. In a copy of al-Biruni's *Chronology of Ancient Peoples*, which was made in Tabriz about 1307, Adam and Eve are depicted completely naked.

The zenith of Ilkhanid painting was reached toward the end of the dynasty. The best evidence for this comes from the pages of the Demotte *Shah-nameh*, so-called after the dealer who, at the beginning of the present century, was apparently in possession of the entire work but, out of chagrin at not receiving the offer he wanted, split up the book and (successfully) sold the pages separately to purchasers in various parts of the world. This copy, which was probably made in the second quarter of the fourteenth century and of which fifty-eight miniatures are known today, is one of the most beautiful versions of the *Shah-nameh* that has ever been made. With it, a truly Persian school of painting came into being, the development of which was to continue into the Timurid era.

قال القاوی النبذ منافع من وزن

أول بدان که چون نطفه
در رحم ماده حاصل شود
وقوی از کبد و منی از
قوت و جراین
پیدا گردد و از دماغ
و دل و جگر بیاید
و نفس کلی بدان رسد
ماند زرده خایه باشد
دم الطمث باز بندد
و هم خون سپیده خایه
یرا منر در آید چنانک

نیز مایه اندر سبیز تازه بس علقه کردد ماه اول در تدبیر زحل باشد و از بهر آنک طبع زحل و نظر

Miniature from *Chronology of Ancient Peoples* of al-Biruni, showing the Temptation. Manuscript, $7^{1}/_{2}$ x $12^{1}/_{2}''$. 1307. Tabriz. Edinburgh University Library

Leaf from *Manafi' al-Hayawan* of Ibn Bakhtishu', showing Adam and Eve. Manuscript, $13^{3}/_{8}$ x $9^{1}/_{2}''$. 1298. Maragheh. Pierpont Morgan Library, New York

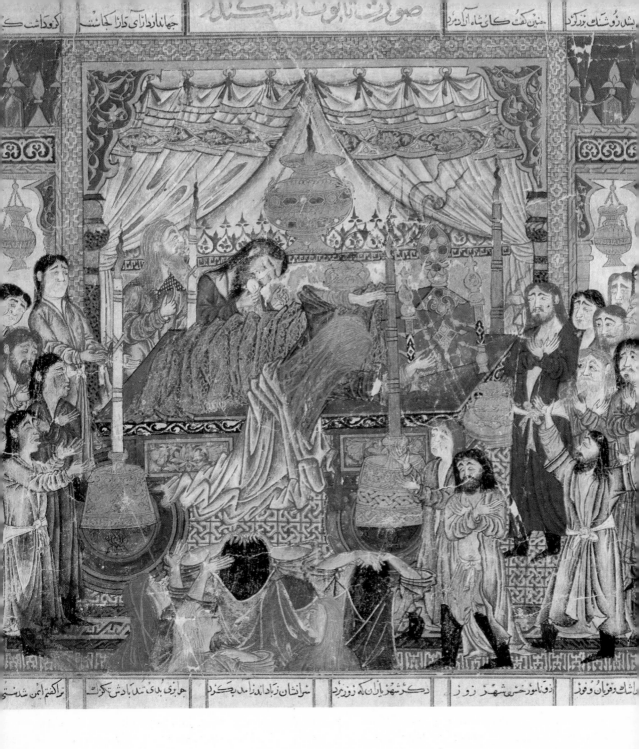

Leaf from the so-called Demotte *Shah-nameh* of Firdausi, showing the bier of Iskandar (Alexander the Great). Manuscript, 9⁷/₈ X 11″. 1330–36. Tabriz. Freer Gallery of Art, Washington, D. C.

So-called mosque of Bibi Khanum, named (probably incorrectly) for the wife of Tamerlane. Built on the site of an old mosque in Samarkand in 1399

TIMURID ARCHITECTURE

The last quarter of the fourteenth century is marked by the influence of Timur, or Tamerlane, who once more infused the Mongol Empire with expansive energy. He established his first capital in Samarkand, where his active patronage laid the foundations on which art and architecture could flourish. Unfortunately, little more than foundations remain of the buildings themselves. Nothing at all is to be found of the Great Mosque in Samarkand, which Tamerlane had built after the model of the Mosque of a Thousand Pillars in Delhi, apart from its description in ancient documents. However, in the case of the madrasah which he supposedly built for his first wife, Bibi Khanum, the monumental size of the ruins still leaves an overwhelming impression. This madrasah was built on the Seljuk model, with four *iwans*. The largest of the domed halls was in use as a mosque, and from far away proclaimed itself as such by its more than eighty-feet-high *iwan* flanked by two minarets.

On Tamerlane's death in 1405, his son Shah Rukh transferred his residence to Herat, but for a further century Samarkand continued to play a preponderant role in Timurid cultural life, in which evidently great reverence was paid to the dead. Testimony of this is given by the Shah-i Zindeh, one of the most remarkable necropolises in the Islamic world. Through the entrance portal, the way rises steeply to a narrow street, on either side of which the domed mausoleums stand closely side by side. Within them are interred

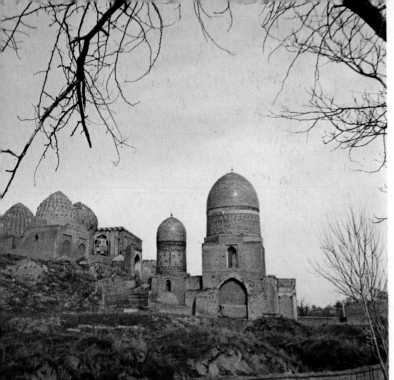

Minaret of the Kalan Mosque in Bukhara, one of the loveliest minarets of the Seljuk era. Dated, according to an inscription, 1127

View of the Shah-i Zindeh necropolis, burial place of the most important Timurid princes and their families. Fifteenth–sixteenth century. Samarkand

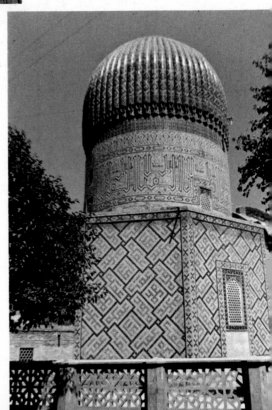

Rear view of the Gur-i Mir, the mausoleum built for Tamerlane and completed in 1434. Samarkand

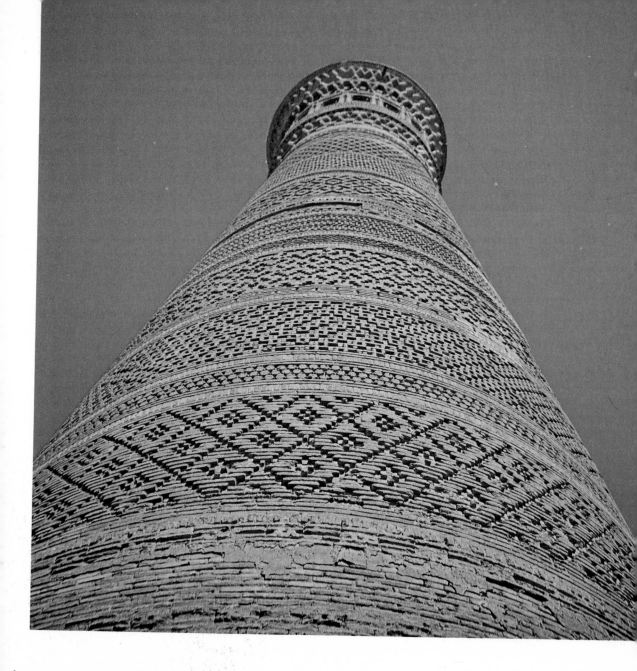

the members of the royal family and the loftiest dignitaries of the realm. Tamerlane himself is buried in his Gur-i Mir (Tomb of the Prince) which had originally been intended for his nephew but was used as a family tomb, and which was completed in the reign of Shah Rukh (1405–47). The Gur-i Mir is a tower set on an octagonal base, with a cylindrical drum crowned by a ribbed dome. The interior is cruciform, having four deep niches covered with stalactite ceilings. The whole structure points yet again to the ineradicable memory of the tents of the Central Asian steppes.

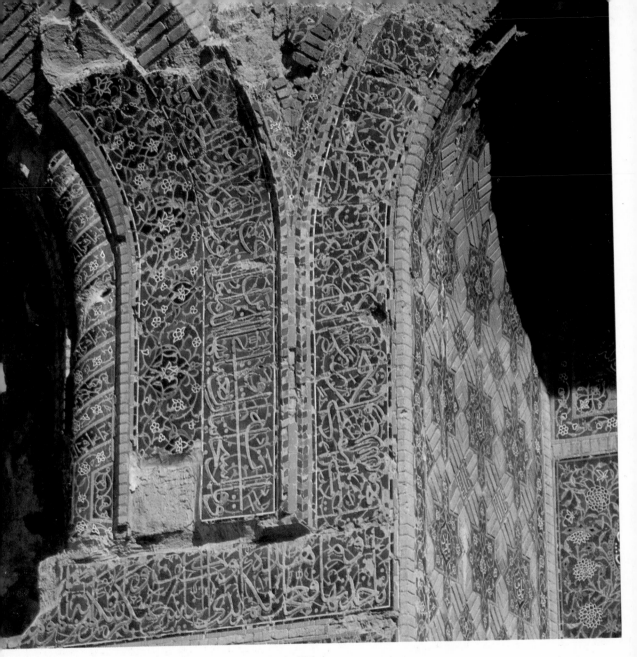

Arcades of the inner court of the Blue Mosque in Tabriz,
named for the dominant cobalt blue of the tilework. 1465

In the field of secular architecture, one must not omit to mention Tamerlane's palace of Aksaray. All that
survives of it is the ruin of the high inner portal, but the description of the Spanish ambassador Ruy Clavijo
tells us that the palace had numerous great portals opening on to the domed halls or the splendid inner
courts with their fountains, and that the beauty of the building was enhanced with decoration.

Candlestick. Bronze, with engraved decoration, c. 1400. From West Turkestan. The Louvre, Paris

ARCHITECTURAL ORNAMENTATION

The manifold application of faience decoration which had been a feature of Ilkhanid architecture was continued and increased in the Timurid period. The palette was widened to include various pastel colors. In the Shah-i Zindeh necropolis, one is overwhelmed by the wealth of decorative tilework and faience plaques, by the niches covered with relief faience, or panels adorned with arabesques and script. The most perfect harmony was achieved in the decoration of the so-called Blue Mosque in Tabriz, where calligraphy and floral designs seem as if they had been painted on with delicate brushstrokes. In a few cases, the brush appears to have been used actually in the decoration of the tombs in the Shah-i Zindeh complex, although this method was evidently highly exceptional. With the increasing use of faience decoration, stuccowork fell more and more into disfavor, and thus there are no important or striking applications of the stucco technique to record.

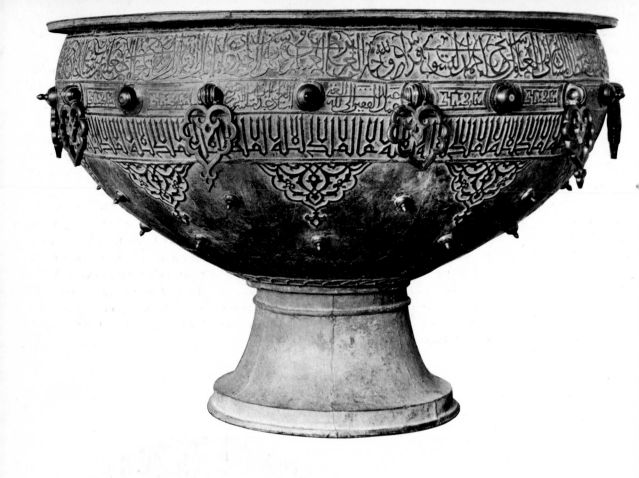

CERAMICS

The advent of the Timurids brings some new light into the comparative darkness in the ceramic industry, at least as far as wares for everyday use are concerned. We have been able to follow events in the faience and tile factories, but developments in the pottery more commonly in use are more obscure. As far as influences are concerned, one would have expected, in view of the Chinese antecedents and contacts of the Mongol rulers, that Chinese porcelain would have found its way along the trade routes to the Islamic countries just as easily as in previous centuries. The reverse seems rather to have been the case, albeit by an indirect path. Certain bronze objects with the celebrated silver inlay work found a ready market among the Mongols and were also taken into China, where in a few cases they were imitated in porcelain and earthenware. Probably these small vessels were used in the ritual ceremonies of the New Year, or "White Feast," in which the shamans offered libations of mares' milk, obtained from the thousands of white horses of the imperial stables. According to Marco Polo, the milk was cast to the winds as a sacrifice to invoke the favor and protection of gods and spirits toward the people, the animals, and the fruits of the earth.

In addition to the bronze vessels, cobalt pigments were also imported into the Yüan Empire from Persia, and for the first time the Chinese made use of a foreign technical process in the manufacture of their porcelain, in this case the so-called blue-and-white, which was to play such an important role later on in the Ming period. At the time of Shah Rukh (1405–47) the Chinese blue-and-white again came into Persia by way of ambassadorial gifts and influenced the few potteries which were still active at that period. These were probably to be found only in the town of Saveh, for no evidence has come from Kashan and Sultanabad. Very few examples survive of this early Persian blue-and-white, and curiously enough one learns more about this genre from the miniature paintings. The first time we encounter blue-and-white ware in such a miniature is in a manuscript of the poems of Khwaju Kirmani of 1396 (illustrated in D. Barrett, *Persian Painting of the Fourteenth Century*, London, 1952, Plate 8).

At a moment when Tamerlane was engaged elsewhere, hordes of White Sheep and Black Sheep Turkomans contended for an area of land, and in this disputed region of Tabriz it appears that a new sort of pottery must have been developed. It goes by the name of Kubachi, after a little town in the Caucasus midway along the western bank of the Caspian Sea, where a considerable quantity of pottery has been found, but no trace of any kiln where it could have been fired. The birthplace of the so-called Kubachi ware has not yet been found, but it cannot have been far from there. In the Kubachi pottery, we find the colors and decorative patterns current in Persia rendered in a style peculiar to this ware, and the designs range from black figures painted under a turquoise glaze to blue-and-white imitations. This type of ware continued into the sixteenth century.

Bronze basin of Tamerlane. Diameter 8′, weight c. 2 tons. 1399. Samarkand. State Hermitage Museum, Leningrad

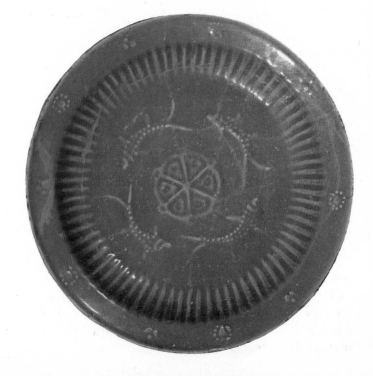

Plate. Earthenware, in imitation of Chinese celadon porcelain, with relief underglaze decoration of three fishes, the motif not immediately visible, known as *an-hua* (secret) by the Chinese; diameter 13³/₄″. Fourteenth century. Sultaniyah. Victoria & Albert Museum, London

Leaf from an early Timurid manuscript, showing King Faridun and his three sons. Late fourteenth century. Chester Beatty Library, Dublin

Leaf from a Persian manuscript of an Iskandar anthology, with the decoration occupying the most important place and the text driven into the margin. 1410. Shiraz. Gulbenkian Foundation, Lisbon

PAINTING

In discussing the previous period, we mentioned the Demotte *Shah-nameh*. It is assumed that this version of the "Book of Kings" was made for Sultan Uwais, one of the princes of the Jala'irids, who, with the Muzaffarids, ruled in the western and southwestern provinces of Persia at the time of the Timurid invasions. The last of the Jala'irids was a certain Sultan Ahmad, a great artlover and bibliophile, who commissioned a promising artist called Junaid to illustrate the poems of Khwaju Kirmani. When, some years

وبر سر دولت و اركه سلطنت ممكن مشد دخت ضحاك را در عقد نكاح آورد و در مدت دو سال و دو سال از در وبسر منولد مشد
كه به نور نام نهاد و بكر بإسلم و هره و عظیم بدخوی و لجوج و کثیر طبع و حقود بود و بعد از ان چندكاه ازن بچندكاه ابوج ازدخر
شاه مرد فارسي ابران دخانام منولد مشد و ارج جون ازفرید مهد و مدام و بند رضاعت و نظام رها یابن محال یافت هل تمیز در شال
و نظام مشد رغبت آموختن علم رمایت دراد و استقرا بادب فروست محرم طبع ومهج نفس ابود و مانند زمانی راضعا مهر استاد
و حاذق و حالاکش و جون اکثر اوقات درملازمت خدمتم بسر موطات من موده و شراط آداب در انقیاد و مطاوعت و تقدمر
می رساند وبد جون خشم و سكون در حركت و سكون و جون آب و آنه معانبه سیدید و هنوز درمقبل کار دفاته بلوغ و رعین عمر
وعنفوان جوانی بود كه اعبان ملك واشراف حضرت سقدير او درمایت حرم ونظانت رای و خافت رای وعقل وكمال
مردی ومردم مصرف مشدند ودر نصارب امور مملكت ومغالیز واباب سلطنت از انوار هدایت و انهار فضایل و مقتبس
ومعرف کشش و قربون در اعظام خلل و زبادت از فرزندان دیکری کوشید و ابن معنی ضمیمه عداوت برادر کرد
می مشد بار روی باتفاق مودان مجلس و ملازمان درکاه و مهتر ازسنا مجعی ساخت و صنع و شرفه در ان مجلس جمع كرد

خطبه بزبان خوشریک که ترجمه از لیان عرب این است اذکد اجلس المتفرد بالكمال و البقا المتوحد بالعظمة
والها المتعالی عزالاکا و النظر الجمله علی جمیع الافضال داشکه علی جزیل النوال و توکل علیه
فی جمیع الاحوال و ارغب الیه بالتضرع و الابهال ابها الناس نحزن ازباب الملك و شواس اتركا بجمیعكم من عدائكم
وبباد رای داعیكم و ازتفوتكم وتجهد فی حصول منافعكم و دفع مضارکم فلا ولی الامر الی لیكن ازدركم من حزا
ولایکاد مزتاسا انفق الحسد ورث الكلال و اجتنب العفا ترجع الی نفسه و کونوا اخوا امرادا فبن واعوانا
مساعدین و اقوا قوی هذا و استغفر الله العظیم وجون شاه قربون ازتقریر ابن خطبه بپرداخت روی مجالس
جمع و مقبابن مجلس آورد و كفت بابنیک سبری و کهن سالی زور آورده است و ضعف شبت و شیخوخیت درظاهر

JUNAID: *Bihzad in the Garden*. Miniature, from a manuscript of Khwaju Kirmani. 1396. British Museum, London

later, Tamerlane made an end of the local dynasties, Junaid entered his service, or rather that of one of his grandsons, Iskandar Sultan. This prince founded schools in Shiraz and Yezd, of which a few works have been preserved which clearly show that the old Mongol style was more and more being abandoned. An apt example of this process is given by Nizami's *Iskandar-nameh* (Alexander Epic) which, like the *Shah-nameh*, has been copied many times and illuminated in many styles.

When Baisunghur, the son of Shah Rukh, came to power in 1414, Herat was the royal residence and

Scene from the story of Laila and Majnun, from a copy of the *Khamseh* (Five Poems) of Nizami, showing Majnun in the desert. Manuscript, 7³/₄ x 5″. 1495. British Museum, London

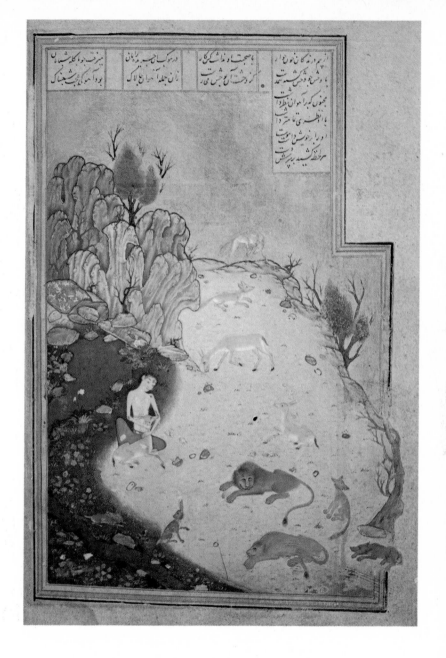

at the same time became the center of new cultural movements, a position it enjoyed until the coming of the Safavids. Baisunghur founded an academy of calligraphy and painting, under the direction of Ja'far. This Ja'far continued in the tradition of his predecessor Mir 'Ali, the greatest calligrapher of Tamerlane's day, who is credited with the invention of the *Nasta'liq* script. All the forty calligraphers at the academy had once been pupils of Mir 'Ali, so that the influence of his great mastery was felt over a long period in the School of Herat.

KAMAL AD-DIN BIHZAD: *Portrait of a Painter in Turkish Dress.* Miniature painting, 7³/₈ x 5″. Persian, late fifteenth century. Freer Gallery of Art, Washington, D.C. Possibly a copy of a painting by the Venetian master Gentile Bellini

In this period for the first time, all the important literary works of the Islamic world were copied, among them the *Shah-nameh* of Firdausi; the *Gulistan* (Rose Garden) of Sa'di; the *Khamseh* (Five Poems) of Nizami, which includes the romantic stories of Khusrau and Shirin, Laila and Majnun; and the *Iskandar-nameh*. The illustration of these themes reached its zenith under the brush of the greatest of all Persian painters, Kamal ad-Din Bihzad, who made his appearance in the middle of the long reign of Sultan Husain Mirza (1468–1506). He outlived the skirmishes with the Uzbegs, between 1507 and 1510, and afterward became court painter to the new monarch, Shah Isma'il, who founded the Safavid dynasty. Since the most productive period occurred in Safavid times, we shall discuss Bihzad in that section.

In addition to the official style of the painters and ateliers mentioned above, local schools developed at various places with a life of their own, influenced to a greater or lesser degree by the court academy. Thus, Shiraz and Isfahan were important centers in the field of manuscript illustration. To describe these as "products of folk art," as is sometimes done, is to set decidedly too low a value on them. From about 1450 to the beginning of the Safavid period, we also find the so-called Turkoman style, which flourished in South and West Persia during the Turkoman domination of those regions.

TEXTILES

The regular contacts between the Western and Eastern Mongol princes had also an appreciable influence on the production of woven fabrics. One might speak of a revival of this industry, especially in gold and silver brocades, in which typically Chinese motifs such as the lotus, the phoenix, the dragon, and stylized cloud forms are interwoven with great refinement in patterns of traditional Islamic design.

Similar developments took place in carpetmaking, so that we even hear of "dragon carpets" as typical products of this period. Presumably it was from carpets of this kind that types such as the Darband and Kuba later developed. From the beginning of the fifteenth century, medallion carpets were also being made in Persia, and a few pieces from this early phase have been preserved. The heyday of this type came, however, in the Safavid period.

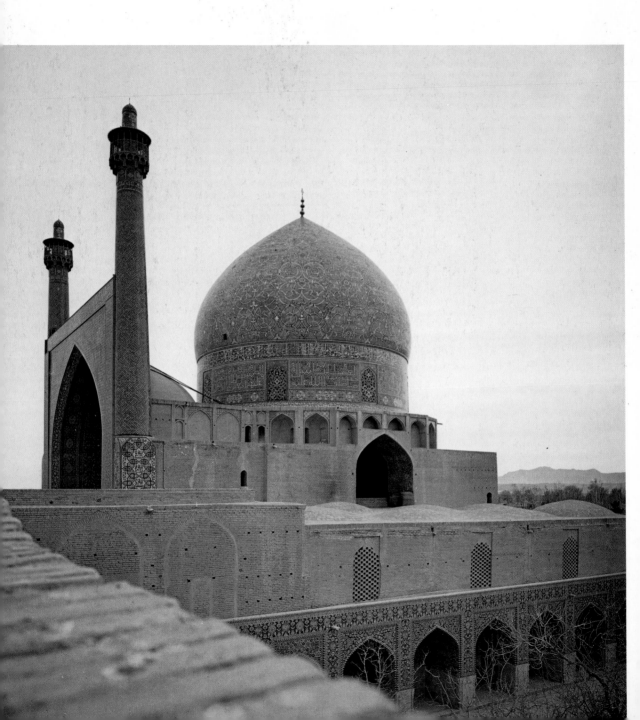

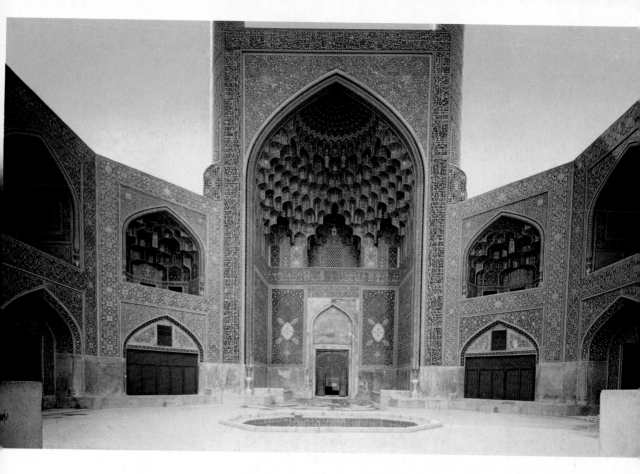

THE SAFAVIDS

The Safavids, who derive their name from their ancestor, the pious Shaikh Safi of Ardabil, succeeded under Shah Isma'il in subduing the Turkomans and the Uzbegs. The young Isma'il, who had come to the throne in 1502 at the age of fifteen, established his residence in Tabriz, so that artistic life, too, again became centered in that city. Shah Tahmasp (1524–76), who succeeded Isma'il, transferred the seat of government to Qazvin in 1549, as the Ottomans were exerting too much pressure on the Persian frontier, and Tabriz was an easy target for their attacks. Finally, in 1598, during the reign of the great Shah 'Abbas I (1587–1629), Isfahan was chosen as the capital.

Principal *iwan* and dome of the Masjid-i Shah (Royal Mosque), Isfahan. Built for Shah 'Abbas the Great, 1612–13

View over the inner court of the Masjid-i Shah (Royal Mosque), Isfahan. 1612–13 ▶

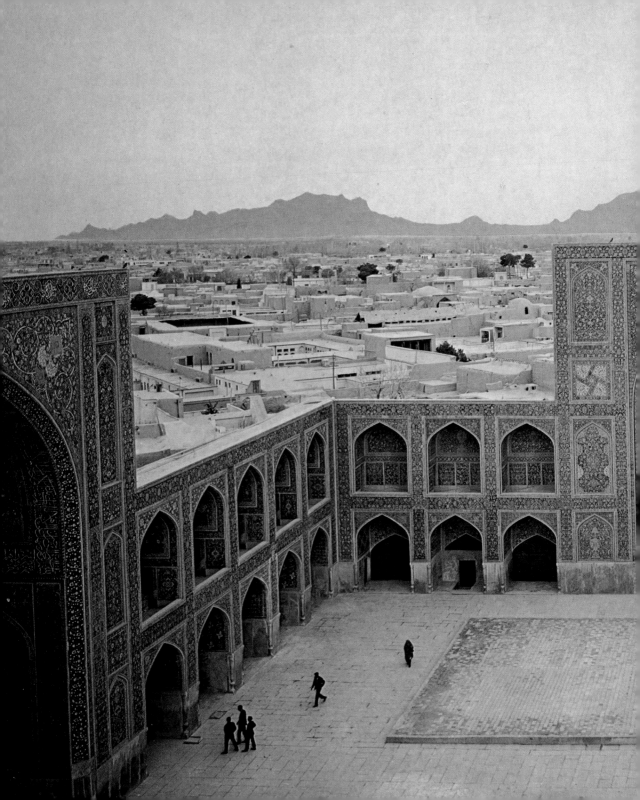

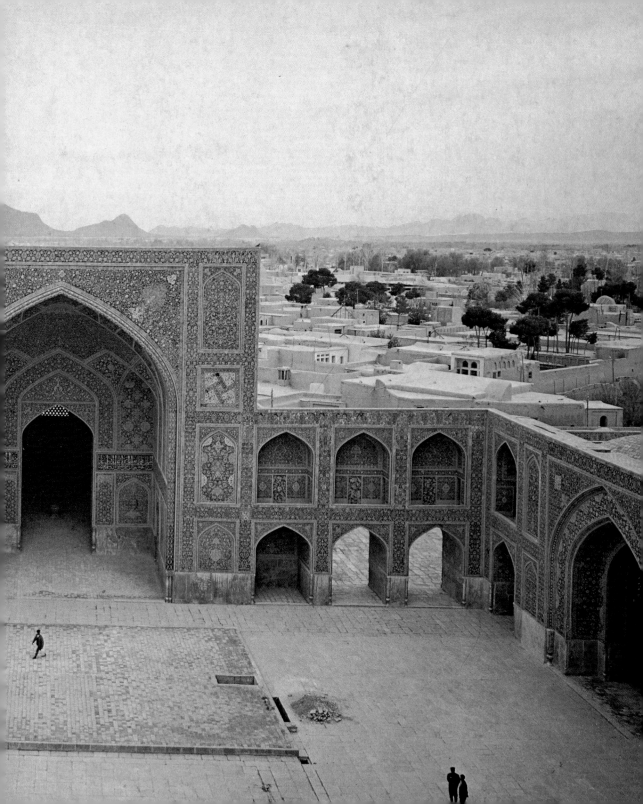

The constant disputes with the Turks brought the Safavids into an understanding with the Europeans, who were experiencing similar difficulties in this respect, while at the same time they also kept up their relations with China. The contacts with Europe proved of the greatest importance both for the Safavids and for the Europeans: for the former, however, they marked the beginning of their decline from greatness,

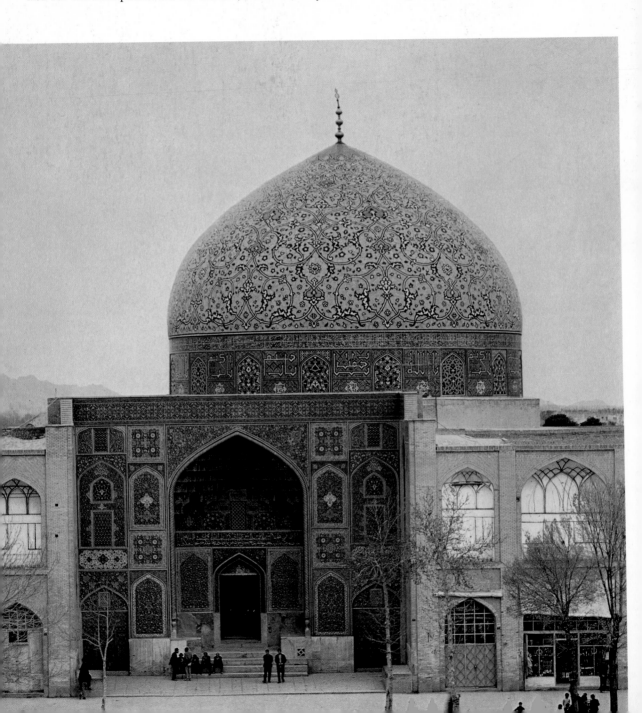

Bridge over the Zayandeh River in Isfahan, with central pavilion and
niches typical of Safavid architectural style. Early seventeenth century

while for the latter, they meant that new vistas of commercial expansion were unfolding. When the end of
the last Persian Empire in modern history came with the Afghan invasion of 1722, art was already in a
state of decline. Despite a serious attempt in the nineteenth century to raise the artistic standard of the
nation to an international level once more, Persia has only now reached the threshold of a new renaissance,
which it is to be hoped she will soon cross.

ARCHITECTURE

The true Safavid style of architecture came into its own in the reign of Shah 'Abbas I, although his pre-
decessors had also built mosques and other edifices. In Saveh, there stands a mosque from the time of
Shah Isma'il, which, with its inner court, four *iwans*, and domed chamber, is entirely in accord with the
old architectural conventions; but this was the last occasion when the architects looked back on the
Timurid and Seljuk periods. The Masjid-i Shah (the Royal Mosque in Isfahan) and the mosque of Shaikh
Lutfullah—both from the beginning of the seventeenth century—are Seljuk in scheme, but their treatment
is far more delicate, rich, and gay than the mosque in Saveh. The same may be said of the madrasah of
Shah Sultan Husain, the last great madrasah, which was built about 1710.

The burial mosque of Shaikh Safi of Ardabil is unique among sacred buildings. It was begun in the six-
teenth and completed in the seventeenth century. It is not the sixteen columns of the octagonal mosque,
nor the two-storied mausoleum, that we marvel at, but rather the porcelain house (*Chini Khaneh*) in which
Shah 'Abbas I displayed his great collection of Chinese porcelain, which even included pieces from the
fourteenth century. The walls were covered with wooden niches, the shelves of which were full of porcelain
masterpieces, which curiously enough were not set out in the magnificent palace, although similar furnish-
ings were to be found there.

◀ Dome of the Shaikh Lutfullah Mosque, Isfahan. 1602-3. The tile mosaic is among the finest of its kind

Wall paintings inside the 'Ali Qapu Palace, Isfahan. Built for Shah 'Abbas (1587–1629)

Shah 'Abbas was the builder of a vast complex around the extensive polo ground (Maidan-i Shah) which now forms the center of the city of Isfahan. The four sides of the polo ground were screened by the Royal Mosque, the Lutfullah Mosque, the Bazaar, and the 'Ali Qapu Palace with its famous entrance portico which served as a covered grandstand should the shah desire to watch any of the sporting events. Both inside and outside, the buildings were delightfully and luxuriously decorated.

ARCHITECTURAL ORNAMENTATION

The mosque in Saveh also followed the old traditions in its decorative patterns. The walls were ornamented with painted stucco panels, colored faience work, and in particular with abstract linear motifs and calligraphic inscriptions which claimed for themselves the most prominent positions in the building. In the palaces, a wider range of materials and designs was employed. Wood was in frequent use, and was sometimes gilded, but more often painted in lacquer. Carved decorations and intarsia designs were also found. In the 'Ali Qapu and the Ashraf palaces, however, we find some striking frescoes; they are said to have been the work of a certain "Jan the Dutchman," who became court painter to Shah 'Abbas at the beginning of the seventeenth century.

Dish. Earthenware of the so-called Ku-
bachi type. Sixteenth century. Haags
Gemeentemuseum, The Hague. Ware of
this kind was made in the Daghistan
province in the Caucasus between the
fifteenth and seventeenth centuries, and
should not be confused with the Daghi-
stan type of the Sultanabad style

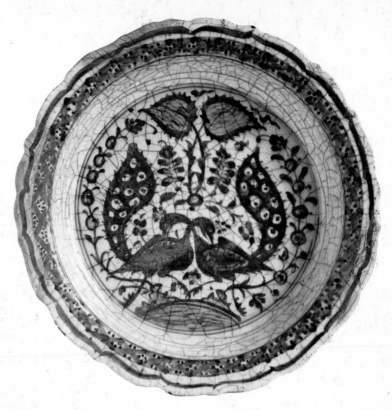

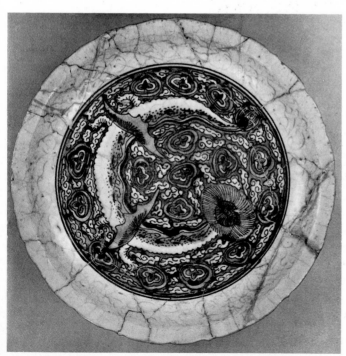

Dish. Incised motifs and blue under-
glaze painting on a white ground, imi-
tation of Chinese porcelain very popular
in the reign of Shah 'Abbas. Seventeenth
century. Rijksmuseum voor Volken-
kunde, Leiden

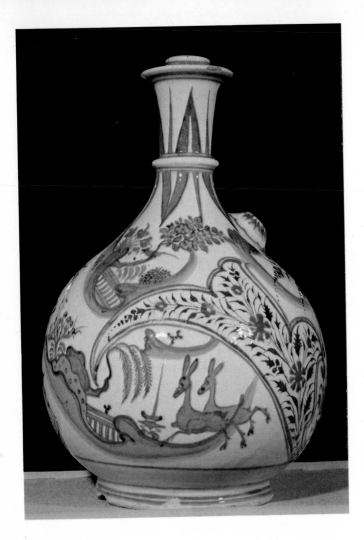

Bottle of a nargileh of the so-called Kirman type. Height 12⅝". Seventeenth century. From Persia. Victoria & Albert Museum, London. Kirman pottery was popular among Europeans, probably from its likeness to European faience wares

Bottle with relief decoration, both halves ▶ obtained from one mold and then joined. Seventeenth century. From Persia. Haags Gemeentemuseum, The Hague

PAINTING

As one dynasty replaced the other, the master painter Bihzad grafted, so to speak, his old knowledge and experience upon the new period. At all events, the Safavid School acquired a good foundation, which was the inspiration of Persian painters for a considerable time. In 1506, Bihzad moved from Herat to Tabriz, where presumably he continued to work until his death about the year 1534. Curiously enough, in his last years, during the reign of Shah Tahmasp, the great master does not appear to have enjoyed the same recognition as he did under the previous ruler, Shah Isma'il.

Bihzad's work is especially remarkable for its liberation from the academic style of the Timurids, to which originally he had made such an important contribution. He broke with the dictatorship and laws of

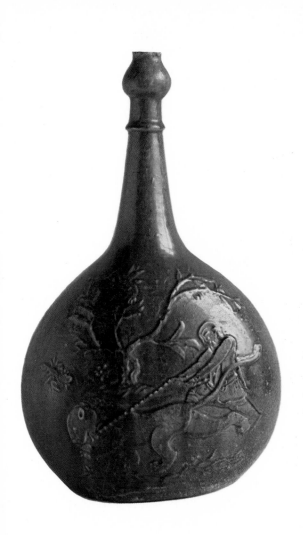

Small vase. Aubergine glaze. Eighteenth century. From Persia, probably a specimen of pottery produced at Rayy in its final period. Groenhuizen Collection. Utrecht

MIR SAYYID 'ALI: *A Prince and His Page*. Miniature. ▶ 1535. British Museum, London

the calligraphers, and made his own decisions as to the space required for his compositions, sometimes letting his illustration carry on across two pages. In his palette, too, this gifted artist diverged from the current trend. He also gave the people in his pictures more freedom of movement, and even their faces are expressive; one might speak of a psychological effect in his paintings. All these factors, to a greater or lesser degree, were transmitted to Bihzad's numerous pupils. The best known among them were Sultan Muhammad, Muzaffar 'Ali, Agha Mirak, and Mirza 'Ali. The first of these, Sultan Muhammad, was particularly concerned with the production of loose-leaf albums, in which he included works of his colleagues as well as his own. In these albums, which are known as *muraqqa'*, we find sketches and pages of beautifully written text as well as complete miniatures.

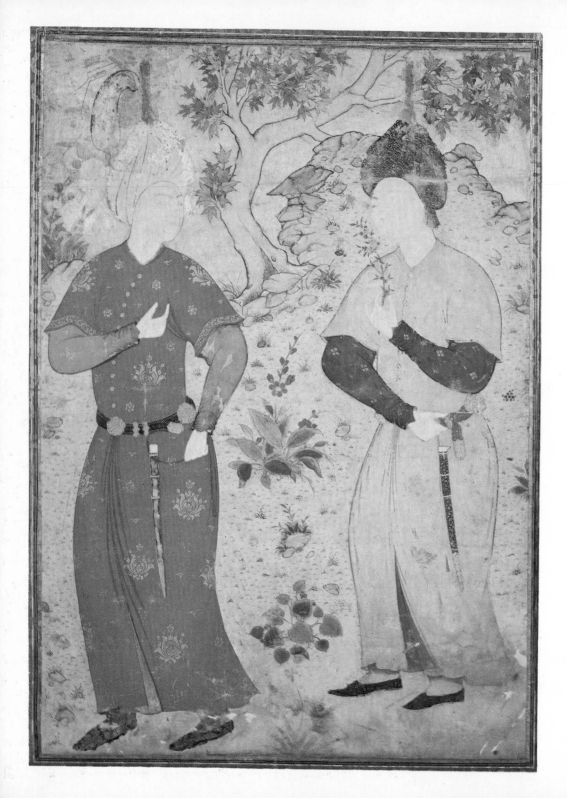

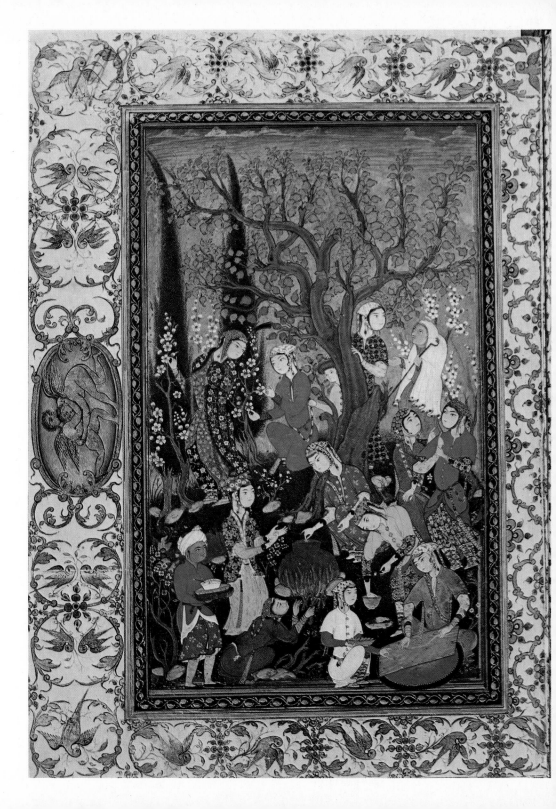

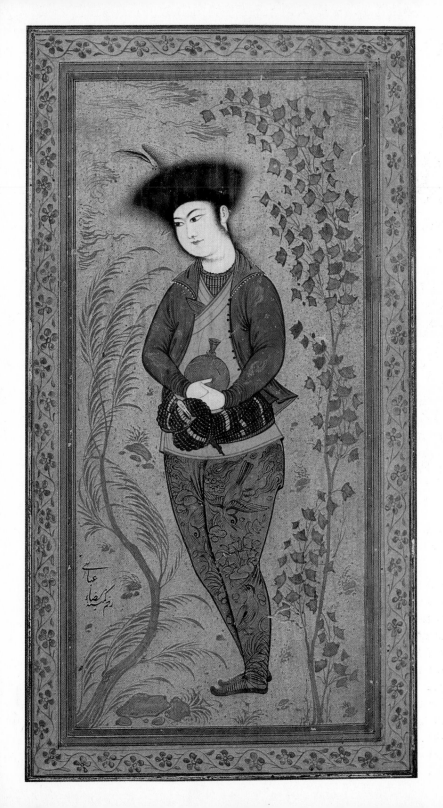

Preceding page: Miniature depicting ladies at a picnic. From the *Khamseh* of Amir Khusrau, copied in 1463. Bodleian Library, Oxford. Ms. Elliott 189, fol. 192r.

RIZA-I 'ABBASI: *A Young Man.* Miniature painting. 1630. Chester Beatty Library, Dublin

MUHAMMAD SHAFI': Probably a portrait of his father, Riza-i 'Abbasi. Drawing from a seventeenth-century album. Photograph from A. U. Pope's *Survey of Persian Art,* Part V, page 924b

The artists became more free in their choice of subjects, which no longer remained limited exclusively to great literary themes. They became increasingly aware that their rendering of the lives of literary heroes had certain aspects in common with everyday life. As an enlargement of this idea, genre scenes, landscapes, and even portraits came into existence.

With the transfer of the capital to Isfahan, that city became the center of artistic activities. Here, at the beginning of the seventeenth century, the painter Riza-i 'Abbasi taught the principles of the new artistic ideas to a horde of willing pupils. Riza-i 'Abbasi's accomplished mastery of line assures him a place among the great artists, and his exquisite, somewhat mannered figures served so long as a model for copyists that, for lack of fresh ideas, a decline slowly but surely set in. European influences, which at this time could also be noted in Persia, were nevertheless not effective enough for the encounter between the two modes of thought to generate new impulses in Persian art. Thus, the art of the eighteenth and nineteenth centuries is, above all, characterized by repetition of earlier motifs and dependence on past glory.

CERAMICS

Technically considered, the Safavid period was of great importance for the ceramic industry on account of its successful attempts at imitating porcelain. At last, all the earlier experiments at imitation which had been going on since the ninth century were crowned with success, in particular at the time of Shah 'Abbas (1587–1629). The great quantities of Chinese porcelain which had been circulating in the lands of the Near East, and in Persia particularly, through the contacts between Mongol and Chinese rulers, had spurred on

◀ Detail of the so-called Ardabil carpet, originally from the mosque of Shah Isma'il, Ardabil. 37' 9" x 17' 6". 1540. Persian. Victoria & Albert Museum, London. This immense carpet, of some 33 million knots, bears the inscription: *In the world I have no other shelter but your threshold. For my head there is no resting-place other than under this roof. The work of the slave of the Holy Place, Maqsud of Kashan in the year* A.H. *946* (A.D. 1540)

Detail of a carpet, with garden and animal scenes. Wool. Sixteenth century. From Persia. Musée des Arts Décoratifs, Paris

the local craftsmen to fresh efforts. Their preference evidently lay strongly in favor of the blue-and-white ware, which they reproduced with extreme care, employing all the Chinese decorative motifs. Their accomplishment in this field was so great that they were able to compete with Chinese products on the Levantine and European markets. Moreover, from the seventeenth century, they expanded their range of colors, and monochrome glazes were used to accentuate designs in blue, green, aubergine, and white. Here, too, the potters tried to emulate the perfection of Chinese ware. The luster technique also went through a period of renewed prosperity.

As in the case of painting, in the nineteenth century the quality of ceramic products eventually declined through repeated imitation to a level that at best merits its inclusion in the category of folk art.

Textile. Detail of a shorn velvet brocade with repeat pattern of a beggar and a youth. Seventeenth century. Probably from Kashan. Landesmuseum, Karlsruhe

METALWORK

In earlier times, craftsmen in metal had concentrated primarily on making bowls, dishes, jugs, and basins, with inlaid, engraved, or cast decorations. In the Safavid period, however, weapons were particularly prized, causing an industry to flourish, the products of which were exported far beyond the frontiers. The daggers, swords, scimitars, pieces of amor, and other martial objects are sometimes so exquisitely fashioned with gold intarsia, silver mounting, or engraved designs that it seems improbable that such articles should ever have served the purpose for which they were made. This doubt becomes stronger when one realizes that the later Safavid period was increasingly peaceloving in character. Be that as it may, the weapons of this period rightly hold a permanent place in the artistic heritage of Persia.

CARPETS AND TEXTILES

Carpets undoubtedly are among the most important products of art in the Safavid period. The long rule of this Persian dynasty afforded the opportunity for numerous local centers to evolve and flourish, so that the sixteenth century in Persia can be claimed as the "classic period" of carpetmaking. All the various influences of Turks, Mongols, and Arabs, in addition to the influence of the other arts, particularly book illumination, seem to have been blended together in Isfahan at the command of Shah 'Abbas, who established his residence there. In Isfahan were also set up the court factories for weaving the silk carpets so highly esteemed by Western Europeans. It was perhaps the richness and beauty of the large decorated areas, with their complex patterns in lovely pastel colors, often further embellished with silver and gold, that attracted "at first sight" Europeans with a taste for the magnificent. In fact, this marked the beginning of the end for the long-inviolate and noble tradition of true carpet knotting. The mixture of styles and materials enhanced the splendor, it is true, but weakened the "body" of the carpets. Nevertheless, those of the early Safavid period continue to enthrall us. The faded colors of a famous carpet such as that from the mosque at Ardabil, dated 1540 and today one of the showpieces of the Victoria & Albert Museum, give us the same sensation of beauty as that evoked, for example, by the sun-weathered windows of Chartres Cathedral. The Ardabil carpet is the example par excellence of the two types of carpet characteristic of this period: those with repeated, lengthwise motifs, and those with central decorative motifs. Endless variations are possible on both themes, and the carpets are named after the most frequently recurring designs, so that we speak of vase carpets, hunting carpets, floral carpets, etc., when talking of the products of the court factories. For the rest, the name of the local workshop is always used.

The Safavid period was also one of great prosperity for woven fabrics, in which fantasy and taste vied for preeminence. Silk materials were woven in various colors, and shorn velvet and gold and silver brocade were popular. Many examples have reached private and public collections in the West, and give us an insight into the opulence of the Safavids.

The so-called Qutb Minar at Lalkot, Delhi, part of the Quvvat al-Islam Mosque (end of twelfth century). Height 243′. The upper stories were added in the fourteenth and sixteenth centuries. The minaret served both as a lookout tower and a victory column. In the foreground is the 'Ala'i Darwazah, the south entrance of the mosque built by Sultan 'Ala' ad-Din in the fourteenth century as part of a great extension plan

Detail of the Qutb Minar ▶

INDIA

In the chapter on new dynasties and old influences, we spoke of the conquest of India and of the Ghaznavids in particular. The illustrious Sultan Mahmud (997–1030), patron of Firdausi, had subdued Northwest India and even the Punjab. Yet it was the usurper and one-time Mamluk, or slave, Qutb ad-Din Aybak (1192–1206) who first succeeded in establishing a short-lived but flourishing dynasty there, the dynasty of the sultans of Delhi. This state of affairs was, however, quickly disturbed by the Mongols, who carried out their scorched-earth tactics here as elsewhere. The aftermath of the Mongol terror led to the division and breaking apart of India, so that in the fifteenth and sixteenth centuries war was still being waged between Hindu states and sultanates. At length, out of this struggle emerged a direct descendant of Tamerlane, Prince Babur, as victor and founder of a new empire, that of the Moguls. In 1526, he won a decisive battle against the sultan of Delhi, though his four remaining years of life left him with little time to devote to art, which nevertheless he loved. A less gifted, and certainly less vigorous, ruler was his son,

Humayun, who consequently became an easy prey to the foes who beset his frontiers. He was hemmed in closer and closer, in the west by Bahadur Shah and in the east by Shir Khan, who finally, in two decisive battles, smashed Humayun's army and put him to flight. Shir Khan was proclaimed Shir Shah of Delhi, and in a short time succeeded in building up a perfect government administration which was to prove the mainstay of the empire when, after reigning for five years, he lost his life in an accident. Commonplace family quarrels brought three princes to the throne in the space of four years, and then the exiled Humayun seized the opportunity of reconquering his former realm with a small Persian army, and restored the Mogul dynasty.

His son Akbar at first succeeded, by his diplomacy in marrying a Rajput princess, in restraining his antagonists from action. Later, however, he attacked the Rajputs and as a result had to fight to the end of his days to maintain and extend the Mogul Empire. Akbar's son, Salim, known as Jahangir, had a favorable influence on the art of the Mogul period through his marriage to a Persian adventuress. As well as being a mistress of intrigue, his wife, whom he called Nur Jahan, "Light of the World," was a great patroness of the fine arts and herself an accomplished artist in embroidery. Shah Jahan ruled the

The Great Mosque at Jaunpur. Built 1438–78 in imitation of Timurid architectural style, characterized by the high entrance building and the use of tile-mosaic decoration

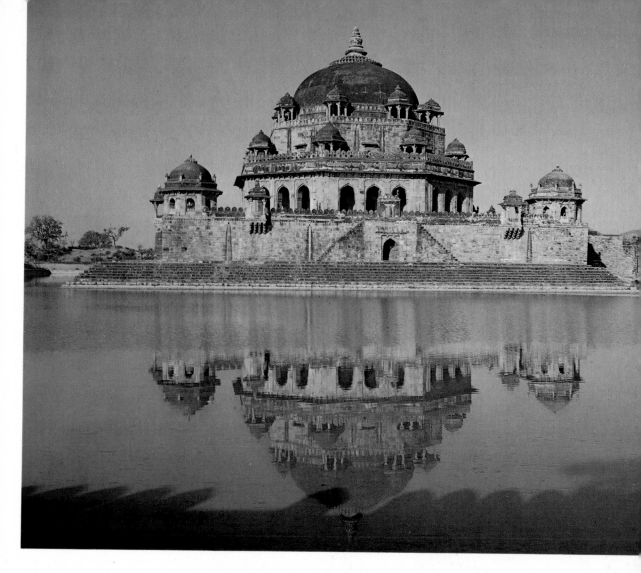

Mausoleum of Shir Shah at Sasaram. Built in 1545. Nothing remains of the original decoration of glazed tiles

empire between 1628 and 1658 with varying success, yet he, too, acquired such renown in the realm of art that in his own day his name already was resounding as far afield as Europe. The decline began in the reign of his successor, Aurangzib, and European influence, especially British, became so great that India now entered a new era, and the role of the Moguls was exhausted. Yet it was not until 1858 that a definite end was made to the Mogul dynasty, though all that this actually meant was the deposing of the last of a series of petty kings, who for more than a century had done nothing but lead a tedious existence on a state pension. Art had spent its force long since, and became moribund in the first quarter of the eighteenth century.

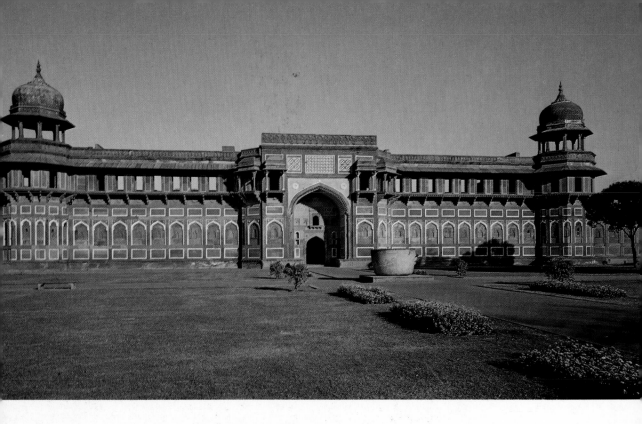

The so-called Jahangiri Mahal, country seat of Jahangir (1605–27). Built c. 1610 in a typical blend of Indo-Islamic styles

ARCHITECTURE

Although, in their conquest of India, the Muslims had inexorably imposed their own values, there was nevertheless a mutual exchange of influence between the existing Hindu culture and that of the Muslim intruders. Professor Hermann Goetz has vividly painted the contrasts between Hindu and Muslim art: "Islamic art reveals the greatest imaginable contrast to Hindu art. In the background we see, not fields and the jungle, but desert and oases." And again: "For the Hindus, the rhythm of time is defined by the seasons of country life, the birth and death of the generations, the slow pace of foot soldiers and elephant drivers; the Muslims' measure of time, however, is marked by the reckless gallop of horses and the infinity of God. . . . Hindu architecture is a fragment of nature, Islamic architecture shuts nature out. The Hindu buildings discount and conceal their construction; the Islamic, on the contrary, are masterpieces of daring technique."

Detail of a portal of the mosque ▶
of Wazir Khan, Lahore. 1634

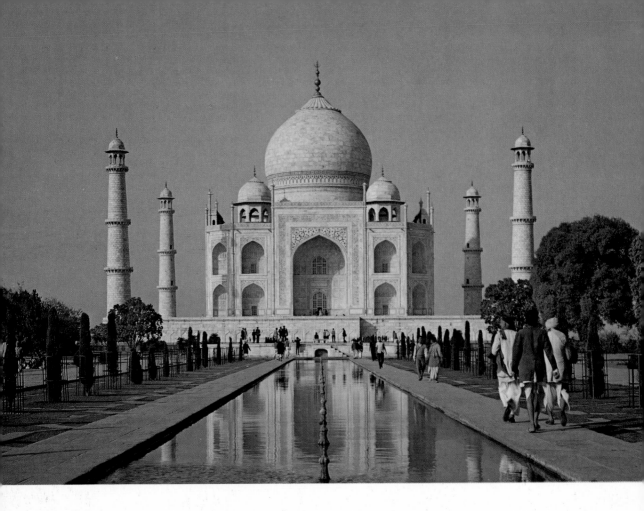

The Taj Mahal, mausoleum for the wife of Shah Jahan. Built on the Jumna River in 1648 by the Persian architects Ustad Ahmad and Ustad Hamid, who succeeded here in designing a building Persian in aspect and Indian in character

In no other region had the Islamic artists been so exposed to the almost feminine wiles of the indigenous culture in a conquered land as they were in India, and thus it is not surprising that nearly every art form shows signs of the flirtation. In the mosque of the Mogul period, for example, we find the same characteristic arrangements and properties that had been laid down by Islamic tradition elsewhere, only the execution evinces a style of its own. The Great Mosque of Bijapur has a vast domed central hall and is surrounded by a gallery covered with small domes resting on quadrants of columns. The mosque in Fatihpur Sikri is distinguished by an immense entrance building on its longer side and a sequence of three halls of prayer on the shorter side. Other highly characteristic mosques are those of the Great Moguls in Agra, Lahore, and Delhi, the last having a mighty *iwan* on the Persian model, with fluted minarets at the corners of the building, which is crowned by three onion-shaped domes. The Pearl Mosque, built in red sandstone by Shah Jahan, is entirely covered inside with white marble, its mood being further accentuated by flowing, waving arches.

The most characteristic buildings of the Mogul period are perhaps the tombs, of which the early examples from the sixteenth century, such as the tomb of Shir Shah, evoke memories of the *stupa* (Indian sepulchral monument) by the resemblance of the shape of the dome. The onion dome of the widely celebrated Taj Mahal, the mausoleum erected by Shah Jahan, may indeed be counted as the loveliest expression of this particular form.

In palace building, the Hindu influence is dominant. It is true that Islamic architectural principles were taken into account, but the character of palaces and houses is clearly Indian, and is distinguished by

Interior of the Moti Masjid, or Pearl Mosque. Built for Shah Jahan in the palace complex in Agra, 1648–55

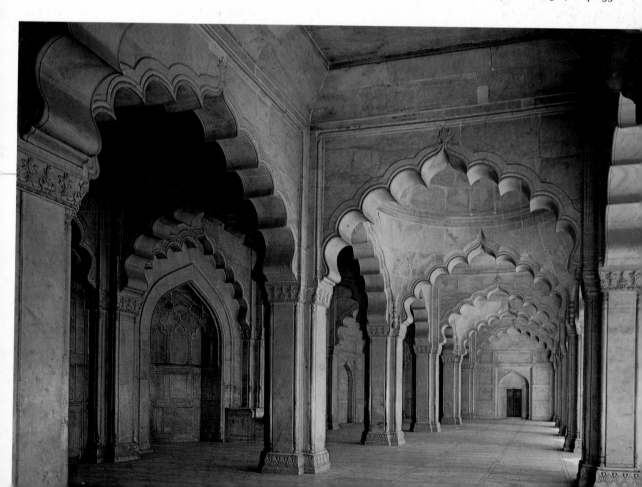

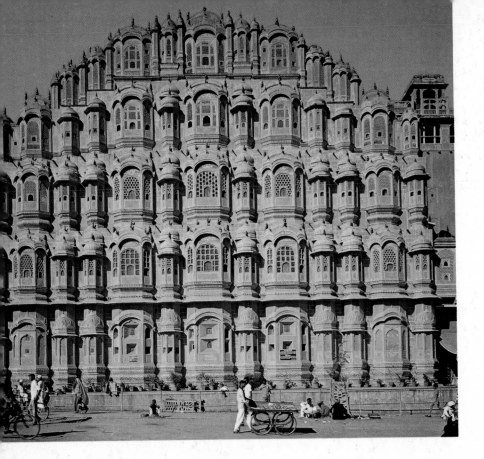

The fort in Gwalior. Restored in the eighteenth century in the tradition of the forts built by the Mogul emperors in Agra and Fatihpur Sikri ▶

The Hawa Mahal, or Palace of the Winds, one of the most remarkable monuments of the so-called Mogul Baroque. First half of eighteenth century. Jaipur

apparently irregular and uncoordinated construction. Among the indispensable features of the palaces were the throne room and the audience hall, the so-called *Divan-i Khas*, generally a rectangular room of which the ceiling was supported by one mighty central stalactite column. Monumental examples of Indo-Persian palace architecture of the Mogul period include the Red Fort in Agra, which was built by Akbar, and the palace in Ajmir, which was this prince's favorite residence. In addition to its color, distinguishing features of the fortress in Agra are the beams in the ceiling, made of stone in imitation of wood, and the projecting consoles, again in a form adopted from wood, which support the ceiling. The palace in Ajmir recalls the Persian *caravanseray*, with its octagonal towers at the corners of a simple courtyard which encloses a kind of villa. Needless to say, Delhi also served as a residence of the Great Moguls, but here the palace halls have fallen into ruin, and only the outlines can bear witness to past splendor. The last phase of Mogul architecture, which we might term Mogul Baroque, is reflected in the palaces of Amber, which attract attention by reason of their excessive interior ornamentation, and the Hawa Mahal, the Palace of the Winds, in Jaipur.

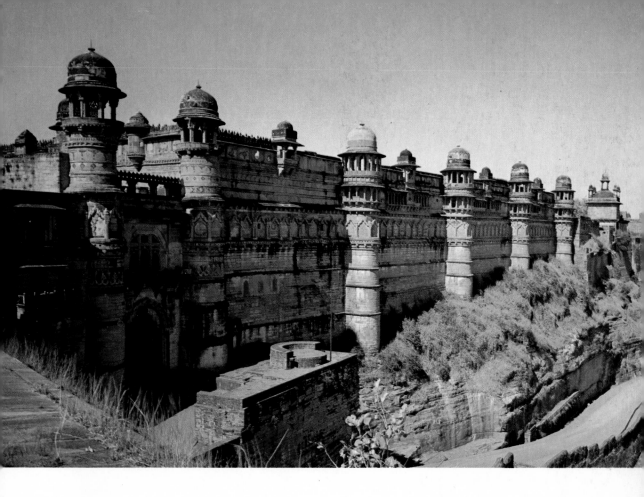

ARCHITECTURAL ORNAMENTATION

The Mogul princes, with their love of splendor, managed to impose their taste, not only on the miniaturists and other artists, but especially on the architects. Effective use was made of the natural resources which the country offered, such as red sandstone and marble. Exteriors often show a sculptural play of lines that was achieved by carving linear patterns in the building stone and then filling the grooves with a layer of stucco. Sometimes the stucco layer was also gilded. In a later phase, greater delicacy was given to the exterior decoration, as we see in the Taj Mahal and the citadel of Ahmadabad, where openwork patterns are carved in the marble grilles of windows and skylights. Interior ornament displayed a comparable magnificence, sometimes achieved by glass mosaics, as in the Shish Mahal.

In quantity and quality, ceramic decoration lagged far behind that found in Persia. In the later Mogul period, we first come across a few typical examples of naturalistic and stylized motifs, sometimes painted on sheets of marble and sometimes done in faience. Occasionally, lacquer painting was also employed as interior decoration.

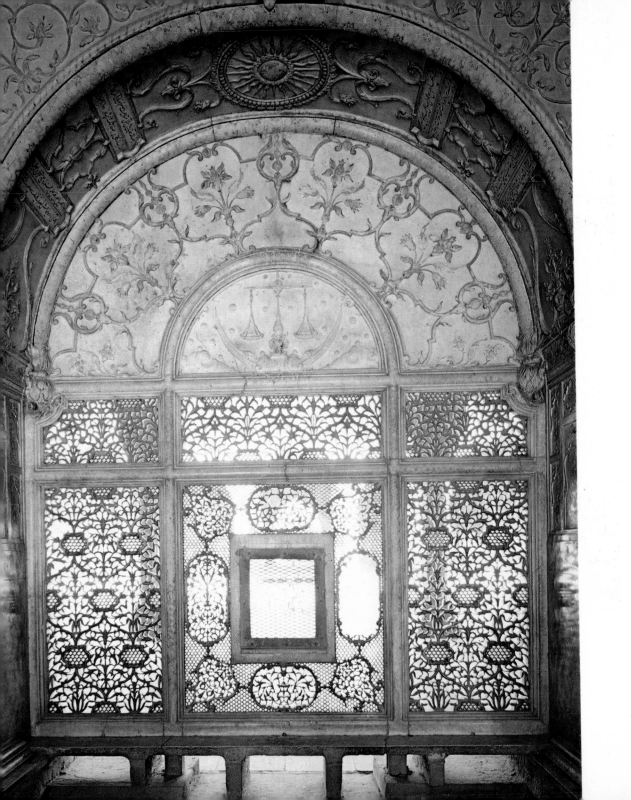

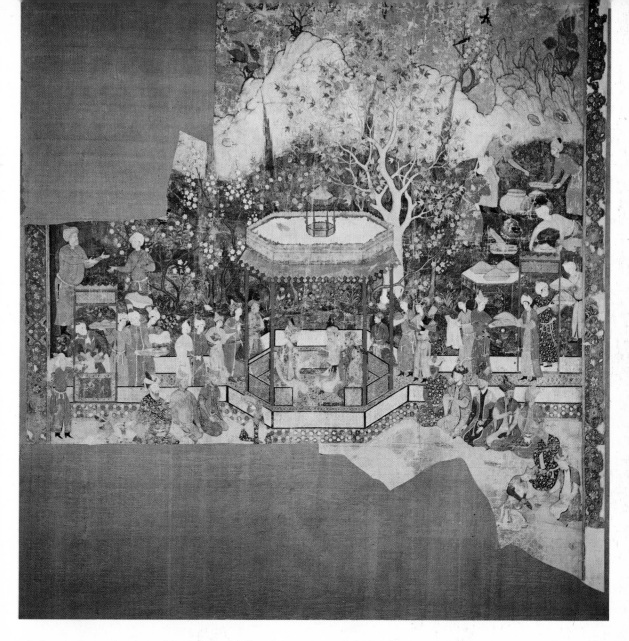

Painting on linen, showing princes of the family of Tamerlane. Height 45″. c. 1555. By an anonymous painter of the School of Humayun. British Museum, London

◀ Interior of the Toshbi Khana in the Red Fort in Agra

Kisu Das: *St. Matthew the Evangelist*. Miniature painting, height 7¼″. Dated A.H. 996 (1587/8). School of Akbar. Bodleian Library, Oxford. Ms. Douce Or. A 1, fol. 41v.

A scene from the *Baharistan* (Garden of Spring), a collection of moral tales by Jami (c. 1492). Miniature painted by Mushkin, height 9½″. End of sixteenth century. School of Akbar. Bodleian Library, Oxford. Ms. Elliott 254, fol. 42

PAINTING

More than any other art form, painting reflects the rich world of Indian thought and feeling, and, since the earliest expressions of the art, love has been one of the most important subjects for the Indian painter. The Islamic notion that unfulfilled love is the highest was refuted by the Indian miniaturists in many ways. The purely indigenous art goes so far that sound is translated into color, and poetry into line.

The Indian has the capacity of juxtaposing things, or joining them together, without assimilating them. Contrasts will always be found and continue to exist. Abundant wealth stands face to face with dire poverty, the outward desire for plenitude confronts the striving after the inward void, and alongside exuberant eroticism stands the severest asceticism. Not only on this account are the Indian miniatures so important, but above all for the spiritualized imagination which had such a strong effect on Mogul art. "Their paintings are above our comprehension of things," said one writer of Mogul times, and by "our" he meant his Islamic coreligionists who, in Akbar's royal ateliers, were laying the foundation for a distinctive phase in the history of Indian art.

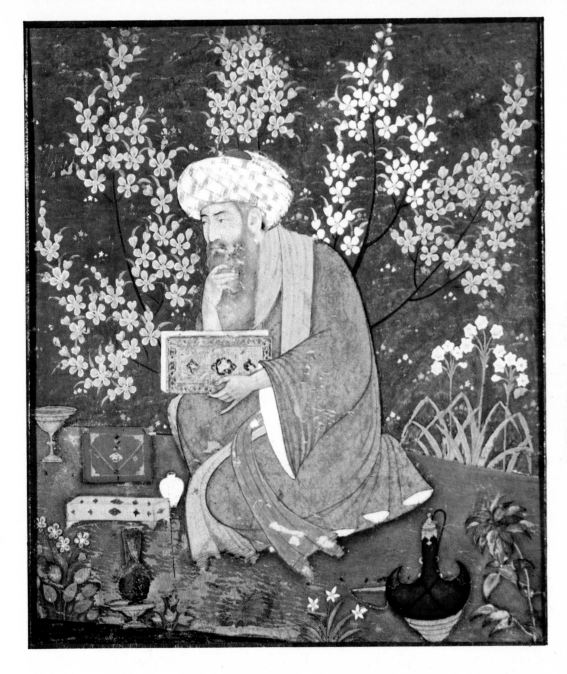

Painting of a pensive poet on a midsummer night in a garden in
Kashmir. Miniature, height 4″. c. 1630. Museum of Fine Arts, Boston

◄ MANSUR: *A Zebra*. Miniature, height 7¹/₈″. Dated A.H. 1030
(1620). School of Jahangir. Victoria & Albert Museum, London

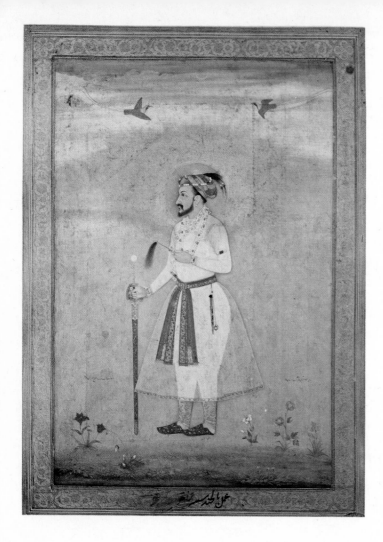

Portrait miniature of Shah Jahan. Seventeenth century. Victoria & Albert Museum, London

The Mogul style may really be subdivided into as many schools as there were great kings. The father of Akbar laid the basis for an atelier with a distinctly Persian bias, since, after his fifteen years of exile at the court of Shah Tahmasp, he was able to bring back with him none other than the renowned artists Mir Sayyid 'Ali and 'Abd as-Samad, under whose guidance the Indian painters could study. When, after the death of Humayun, Akbar established his court in Fatihpur Sikri, he took upon himself the principal supervision of the activities of the royal atelier. We are indebted to this prince not only for the preparation of numerous illuminated manuscripts and loose pages which were preserved in albums, but especially for the introduction of the portrait.

The most popular subjects were the various histories, such as the *Babur-nameh*, the *Timur-nameh*, and the *Akbar-nameh*. Akbar also had the *Mahabharata* translated from the Sanskrit, calling it the *Razm-nameh*. This epic, which numbers more than one hundred thousand couplets, is not in fact comparable to Firdausi's *Shah-nameh*, since the text, in addition to epic narrative, comprises numerous contemplative passages embracing the religious and philosophical beliefs of Hinduism.

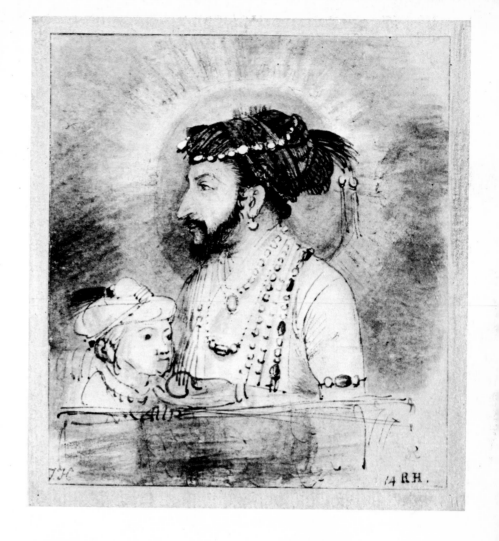

From descriptions of travelers who visited India in the sixteenth century, we know that Akbar's palaces were adorned with frescoes, and that, in this mode of painting, the influence of the Jesuits was particularly noticeable in the depiction of Christian themes such as the Madonna and Child, saints, and angels. Occasionally we are also reminded of this influence in the miniatures. Jahangir had inherited an eye for painting from his father, and distinguished himself as a collector and connoisseur. In addition to courtly themes, he particularly encouraged studies of nature and above all advocated the most faithful possible renderings. The influence of European graphic art led to experiments with colored grounds and minutely elaborate marginal decorations. Under Jahangir's rule, calligraphy once more attained great heights. These pronounced trends were continued in the reign of his son, Shah Jahan, but this was the period when artists became particularly adept at handling portrait painting. Foreign relations were briskly promoted and the resulting interchange of influences above all affected the study of the portrait. Thus it comes about, for example, that Indian portrait miniatures found their way into European collections and became the inspiration of Western artists.

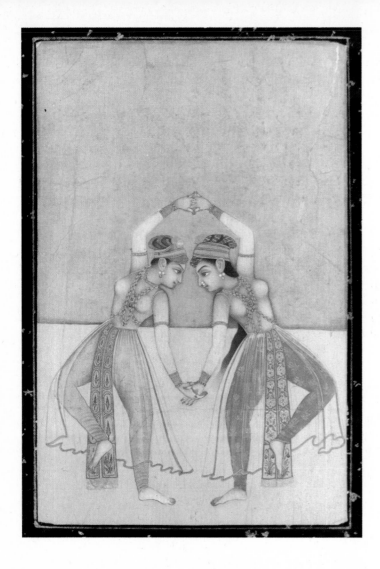

Miniature painting of dancers. 5½ x 3¾″. Period of Aurangzib, end of seventeenth century. Bodleian Library, Oxford

The fanatical Aurangzib, who came to power in 1658 after having removed all the rival members of his family, was no sensitive artlover. He looked at art, and gave it his support, solely from the utilitarian aspect, and had little or no interest in painting. After his death, the art of the miniature experienced a revival of sorts in the eighteenth century, the themes preferred being religious and martial, together with romantic scenes. Hindu and Islamic influences were completely assimilated in the common image of the Indian schools of painting. In the second half of the eighteenth century, however, the Mogul School had come to the end of its resources, and the remaining great and regional schools, such as the Rajput style, the Schools of Mewar, Malva, Bundi, Kotali, and Kishangarh, had sufficient energy to take them into the nineteenth century before decadence set in and the old familiar motifs were endlessly copied. Miniature painting on ivory was adopted after the European model, and to the present day is still employed for depicting the routine designs.

Compared with architecture and painting, the minor arts have remained underdeveloped territory. Weapons and ornaments have been preserved for posterity, since these were made of jewels and precious metals, but ordinary objects of everyday use were of perishable material and not important in the eyes of the Indians themselves. Yet the mineral wealth of the Indian cultural region has manifestly inspired many craftsmen, for example, the jade boxes with gold fittings, the carved semiprecious stones, and crystal vessels that might or might not be inlaid with rubies and emeralds. More important, however, was the continuation of the Islamic tradition in the textile industry, in which, in addition to brocades and velvets woven in pleasing designs, the carpets are particularly striking. Although subject to Persian influences, a special style developed in which the carpets resembled miniature paintings on a large scale, and the industry kept pace with the prosperity of the classic period of Mogul art.

From the foregoing chapters it will clearly have been seen that the art of Islam occupies a quite distinct position in the art of the world in all its varied expressions. The indivisible unity with Allah marks all the Muslim's actions on this earth and forms the rationale of his art. The Muslim artist needs only to draw from one store of potentialities, as it is written in the Koran, *Surah* 15–21:
And no one thing is there, but with Us are its storehouses, and We send it not down but in settled measure.
This religious stamp has always imprinted the art of Islam, and it is a mark that it will bear for all time.

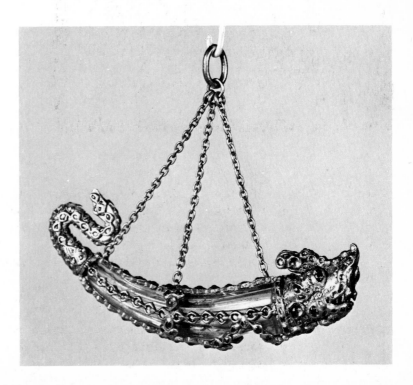

Pendant in the form of a dolphin. Rock crystal mounted in gold. Mogul period, sixteenth–seventeenth century. Rijksmuseum, Amsterdam

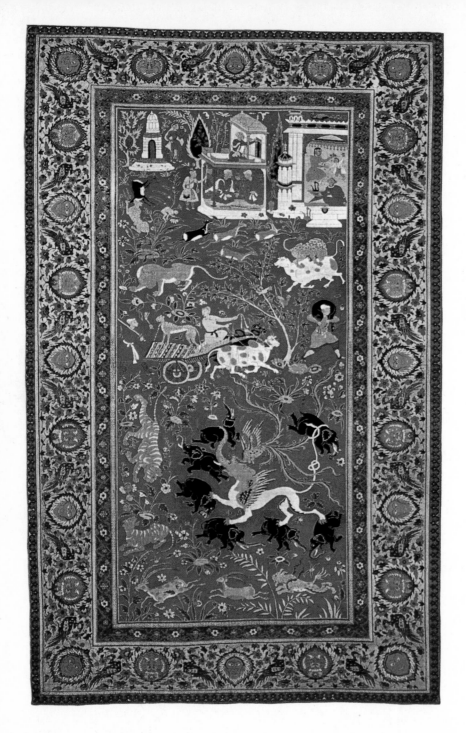

Carpet, clearly showing how Safavid influences in India also affected this branch of arts and crafts. Mogul period, sixteenth century. 87³/₄ x 69″. Museum of Fine Arts, Boston

Bibliography

GENERAL WORKS

ARNOLD, T. W., *Painting in Islam: A Study of the Place of Pictorial Art in Muslim Culture*, Oxford, 1928

CRESWELL, K. A. C., *A Bibliography of the Architecture, Arts and Crafts of Islam to 1960*, New York, 1961

DIMAND, M. S., *A Handbook of Muhammadan Art*, New York, 1958

GLÜCK, H., and DIEZ, E., *Die Kunst des Islam*, Berlin, 1925

KOECHLIN, R., and MIGEON, G., *Cent planches en couleurs d'art musulman: Céramique, tissus, tapis*, Paris, 1928

KÜHNEL, E., *Islamic Art and Architecture*, London and Ithaca, New York, 1966

KÜHNEL, E., *Islamische Kleinkunst*, Brunswick, 1963

MARÇAIS, G., *Manuel d'art musulman: L'architecture*, Paris, 1926–27, 2 vols.

MAYER, L. A., *Islamic Architects and Their Works*, Geneva, 1956

MAYER, L. A., *Islamic Armourers and Their Works*, Geneva, 1962

MAYER, L. A., *Islamic Metalworkers and Their Works*, Geneva, 1959

MAYER, L. A., *Islamic Woodcarvers and Their Works*, Geneva, 1958

MIGEON, G., *Manuel d'art musulman: Arts plastiques et industriels*, Paris, 1927

OTTO-DORN, K., *Art of Islam*, New York, 1967

POPE, A. U., and ACKERMAN, P., *Survey of Persian Art from Prehistoric Times to the Present*, London, Oxford, and Teheran, 1965–67, 14 vols.

TALBOT RICE, D., *Islamic Art*, New York, 1965

WILSON, R. P., *Islamic Art*, New York, 1967

MINOR ARTS

ARNOLD, T. W., and GROHMANN, A., *The Islamic Book: A Contribution to Its Art and History from the VII–XVIII Century*, New York, 1929

ARSEVEN, C. E., *Arts décoratifs turcs*, Istanbul, 1937

BINYON, L., WILKINSON, J. V. S., and GRAY, B., *Persian Miniature Painting* (cat.), London, 1933

BLOCHET, E., *Les peintures des manuscrits orientaux de la Bibliothèque Nationale*, Paris, 1914–20

BODE, W. VON, and KÜHNEL, E., *Vorderasiatische Knüpfteppiche aus alter Zeit*, Brunswick, 1955

ERDMANN, K., *Oriental Carpets: An Essay on Their History*, London, 1961

ETTINGHAUSEN, R., *Arab Painting*, New York, 1962

FALKE, O. VON, *Kunstgeschichte der Seidenweberei*, Berlin, 1913, 2 vols.

GRATZL, E., *Islamische Bucheinbände des 14. Jahrhunderts aus den Handschriften der Bayerischen Staatsbibliothek*, Leipzig, 1924

GRAY, B., *Persian Painting*, Cleveland, 1961

KOECHLIN, R., *L'art de l'islam*, I: *La céramique* (cat.), Paris, 1928

KÜHNEL, E., *Catalogue of Dated Tiraz Fabrics: Umayyad, Abbasid, Fatimid*, Washington D.C., 1952

KÜHNEL, E., *Islamische Schriftkunst*, Berlin and Leipzig, 1942

LAMM, C. J., *Mittelalterliche Gläser und Steinschnittarbeiten aus dem Nahen Osten*, Berlin, 1930, 2 vols.

LANE, A., *Early Islamic Pottery: Mesopotamia, Egypt and Persia*, London, 1958

LANE, A., *Later Islamic Pottery: Persia, Syria, Egypt, Turkey*, London, 1957

SARRE, F., *Islamic Bookbindings*, London, 1923

SARRE, F., and TRENKWALD, H., *Old Oriental Carpets Issued by the Austrian Museum for Art and Industry*, Vienna and Leipzig, 1926–29, 2 vols.

SCHMIDT, H., *Alte Seidenstoffe*, Brunswick, 1958

UMAYYAD ART

CRESWELL, K. A. C., *Early Muslim Architecture*, I: *Umayyads, A.D. 622–750*, Oxford, 1932

CRESWELL, K. A. C., *A Short Account of Early Muslim Architecture*, Baltimore, 1960

JAUSSEN, A. J., and SAVIGNAC, *Les châteaux arabes des Quseir Amra, Haraneh et Tuba*, Paris, 1922

SCHLUMBERGER, D., *Les fouilles de Qasr el-Heir el-Gharbi*, Paris and Damascus, 1939

STRZYGOWSKI, J., "Mschatta" in *Jahrbuch der K. Preussischen Kunstsammlungen*, XXV², 1904, pp. 205–373

'ABBASID ART

BELL, G. L., *Palace and Mosque at Ukhaïdir: A Study of Early Mohammadan Architecture*, Oxford, 1914

CRESWELL, K. A. C., *Early Islamic Architecture*, II: *Abbasids, Umayyads of Cordova, Aghlabids, Tulunids and Samanids, A.D. 751–905*, Oxford, 1940

GODARD, A., "Les anciennes mosquées de l'Iran" in *Athar-E-Iran*, I, 1936, pp. 187–210

HERZFELD, E., *Die Malereien von Samarra*, Berlin, 1927

LAMM, C. J., *Das Glas von Samarra*, Berlin, 1928

SARRE, F., *Die Keramik von Samarra*, Berlin, 1925

HISPANO-MAURESQUE ART

MARÇAIS, G., *L'architecture musulmane d'occident: Tunisie, Algérie, Maroc, Espagne et Sicile*, Paris, 1954

MARÇAIS, G., *Manuel d'art musulman: L'architecture: Tunisie, Algérie, Maroc, Espagne, Sicile*, Paris, 1926–27, 2 vols.

FATIMID ART

BRIGGS, M. S., *Muhammadan Architecture in Egypt and Palestine*, Oxford, 1924

CRESWELL, K. A. C., *Muslim Architecture of Egypt*, I: *Ikshids and Fatimids*, Oxford, 1952

KÜHNEL, E., *Islamische Stoffe aus ägyptischen Gräbern*, Berlin, 1927

MONNERET DE VILLARD, U., *Le pitture musulmane al soffito della Capella Palatine in Palermo*, Rome, 1950

SELJUK ART

DIEZ, E., *Churasanische Baudenkmäler*, Berlin, 1918

ERDMANN, K., *Das anatolische Karavansaray des 13. Jahrhunderts*, I, Berlin, 1961

GABRIEL, A., *Monuments turcs d'Anatolie*, Paris, 1931–34, 2 vols.

MEYER-RIEFSTAHL, R., *Turkish Architecture in South-Western Anatolia*, Cambridge, Mass., 1931

SARRE, F., *Der Kiosk von Konia*, Berlin, 1936

SARRE, F., *Sammlung F. Sarre; Erzeugnisse islamischer Kunst*, II: *Seldschukische Kleinkunst*, Berlin, 1909

TALBOT RICE, T., *The Seljuks in Asia Minor*, London and New York, 1961

MAMLUK ART

CRESWELL, K. A. C., *Muslim Architecture of Egypt*, II: *Ayyubids and Early Bahrite Mamluks, A.D. 1171–1326*, Oxford, 1960

ERDMANN, K., "Kairener Teppiche" in *Ars Islamica*, V², 1938/40, pp. 179–206, VII¹, 1938/40, pp. 55–81

KÜHNEL, E., *Cairene Rugs and Others Technically Related, 15th Century–17th Century* (cat.), Washington D.C., 1957

WIET, G., *Lampes et bouteilles en verre émaillé* (cat.), Cairo, 1929

WIET, G., *Objets en cuivre* (cat.), Cairo, 1932

OTTOMAN ART

ANHEGGER, R., *Beiträge zur frühosmanischen Baugeschichte*, Istanbul, 1953

ARSEVEN, C. E., *L'art turc depuis son origine jusqu'à nos jours*, Istanbul, 1939

OTTO-DORN, K., *Das islamische Iznik*, Berlin, 1941

VOGT-GÖKNIL, U., *Türkische Moscheen*, Zurich, 1953

YETKIN, S. K., *L'architecture turque en Turquie*, Paris, 1962

PERSIAN-MONGOL ART

COHN-WIENER, E., *Turan: Islamische Baukunst in Mittelasien*, Berlin, 1930

SARRE, F., *Denkmäler persischer Baukunst*, Berlin, 1901–10, 2 vols.

STCHOUKINE, I., *Les peintures des manuscrits timurides*, Paris, 1954

WILBER, D., *The Architecture of Islamic Iran: The Il Khanid Period*, Princeton, 1955

SAFAVID ART

SARRE, F., *Denkmäler persischer Baukunst*, Berlin, 1901–10, 2 vols.

STCHOUKINE, I., *Les peintures des manuscrits safavis de 1502 à 1587*, Paris, 1959

INDIAN ART

ARCHER, W. G., *Indian Miniatures*, Greenwich, Conn., 1960

BINYON, L., and ARNOLD, T., *The Court Painters of the Grand Moguls*, London and Oxford, 1921

BROWN, P., *Indian Painting Under the Moghuls, A.D. 1550–1750*, Oxford, 1924

GOETZ, H., *India: 5000 Years of Indian Art*, London, 1965

KÜHNEL, E., and GOETZ, H., *Indian Book Painting from Jahangir's Album in the State Library in Berlin*, London, 1926

STCHOUKINE, I., *La peinture indienne à l'époque des grands moghols*, Paris, 1929

Index